SWANSEA COLLEGE LIBRARY
LLWYN-Y-BRYN
77 WALTER RD., SWANSEA SA1 4QN

SWANSEA

NOT TO
FROM THE LIBRARY

D1493378

770.92

SWANSEA COLLEGE OF
LLYFRGELL · LIBRARY

NOT TO BE REMOVED
FROM THE LIBRARY

SWANSEA COLLEGE LIBRARY
LLWYN-Y-BRYN
77 WALTER RD, SWANSEA

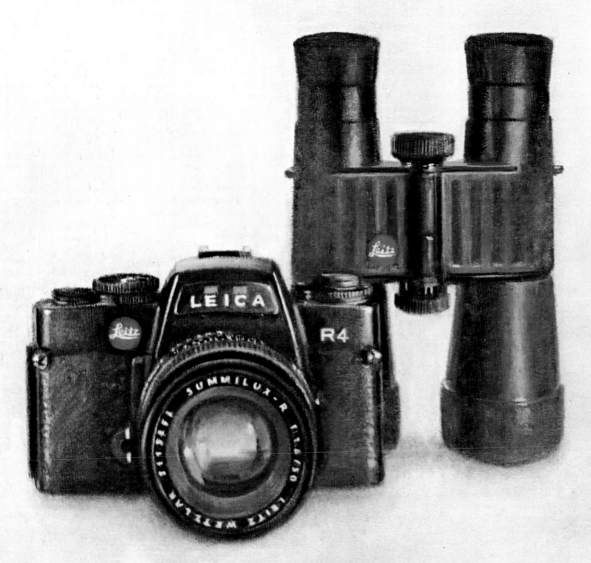

CLOSEST TO PERFECTION.

Acknowledged worldwide for precision, optical perfection and total reliability, the Leitz reputation extends beyond the acclaimed Leica cameras, lenses and quality photographic accessories to Focomat enlargers, Pradovit projectors and Trinovid binoculars. Visit an appointed Leica specialist near you and see the world's finest.

Leitz means precision worldwide.

E Leitz (Instruments) Ltd., 48 Park Street, Luton, Beds. LU1 3HP. Telephone No. 0582 413811.

i

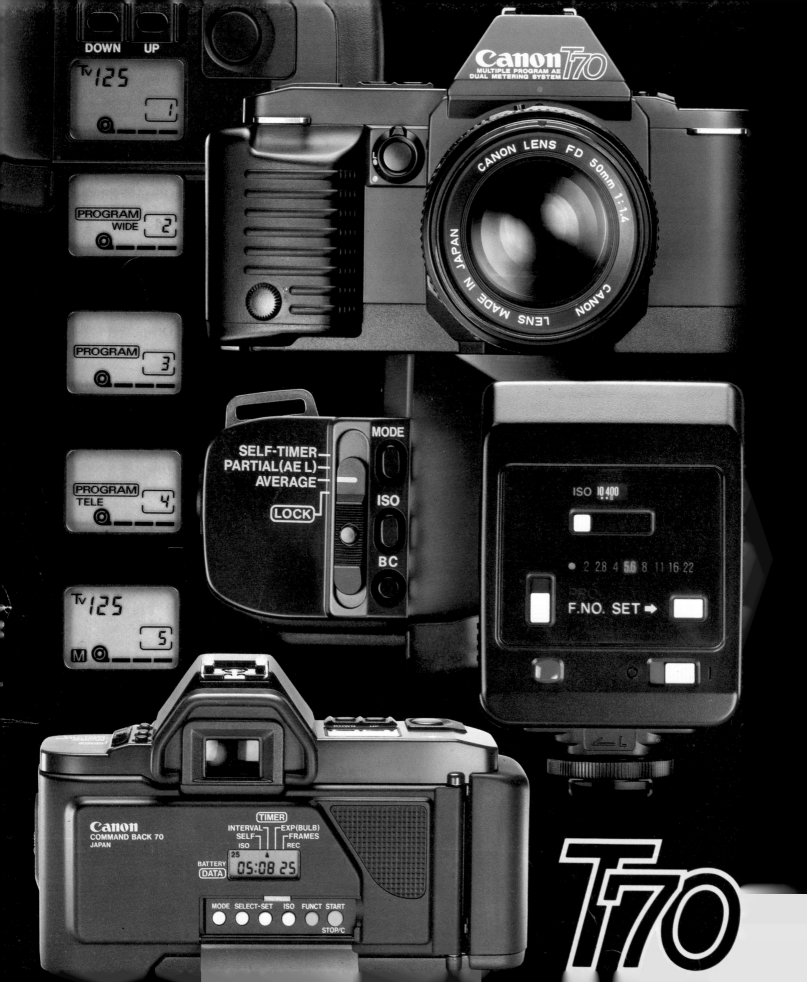

The new camera concept that's so advanced, it's simple.

T70

The T70's microcomputer does all the calculations. You are left to do as much or as little as you want.

An 8-bit microprocessor was specially built to take on the extra work. For computer buffs, it's equipped with 21K of ROM and 16 bytes of RAM. For the rest of us it offers more automatic and electronic functions than any camera before it.

Some are more obvious than others. An LCD (Liquid Crystal Display) screen shows what the camera is thinking and doing at any moment. This screen and the buttons replace all the knobs, levers and dials that clutter an ordinary camera's surface.

Pick up a T70, it is beautifully balanced and compact with all the push button controls at your fingertips. A moulded grip houses a built-in auto-winder.

Rest your thumb on the mode selector lock button and slide it up. There are three settings. Average for centre weighted metering; partial with AE lock for selective area metering; and selftimer.

Most cameras have only one metering system. The T70 adds a second for light reading in a localised area. AE lock means that an exposure can be held even though a subject is not centre screen.

You can now key in your film speed and which mode you require. The T70 has eight. Standard Program, where everything is calculated and controlled for you. Wide program gives extra depth of field to your panoramic views. Tele Program is specially for movement, it keeps the shutter speeds high to avoid the possibility of camera shake and blurred pictures. If you need more control to emphasise a blurr or to freeze very fast action, you can use shutter priority and choose the speed.

Close up photography has its own Stopped Down mode and when you want to take everything into your own hands the T70 can be operated on Manual. Surprising for a camera so obviously from the computer age.

Frame counter number
Self-timer countdown
Bulb (time exposure)
operation count-up

Calculated shutter speed value
Shutter speed setting
ISO film speed

ISO film speed

Shutter-priority AE

Stopped-down AE

Standard program AE

Tele program AE
Wide program AE

Manual

Film-load check
Film rewind completion

Frame counter function

Film transport operation
Battery check
Time exposure (30 sec units)

Tv **1000** ISO
PROGRAM
TELE WIDE 24
M

But remember it is just as suited to the expert as to the beginner.

For flash photography indoors and out, in darkness or for fill-in light during the day, just fit the new programmed Speedlite 277T to the camera.

Set the 277T to its program setting and let the camera work everything out, or select the aperture yourself. Either way the exposure is automatic.

The T70 can be used with a vast array of Canon equipment including almost sixty FD lenses. Zooms, fish eyes and telephotos are included and all can be locked easily into place. You gain a lot from a well designed lens, superior sharpness, carefully controlled colour balance, handling, and guaranteed mechanical compatability with our cameras.

Within the T70 lies a mass of electronic control and monitor devices which, you may think, must consume power at a frightening rate.

This isn't the case. Power conservation was given a high priority and only two penlight AA batteries are needed for all functions. The EMAS II shutter is unique in consuming virtually no power with the shutter open. Now long time exposures don't keep flattening your batteries.

However inexperienced, the challenge of getting the best from your T70 will be difficult to resist. It is similar to an automatic gearbox. You can just slip into 'drive' and cruise along in comfort or you can use the gearing for maximum effect. Of course, unlike a car, the T70 can always change into manual.

Your nearest dealer will have a T70 for you to enjoy. After a while you'll find it as easy to use as a pocket calculator, with infinitely more rewarding results.

Canon
Official Camera
of The Football League

The Official 35mm Camera
of the 1984 Olympic Games

Canon
The ultimate camera choice.

Canon – Manufacturers of Cameras, Calculators, Copiers, Computers, Copyphones, Typewriters and Micrographics.

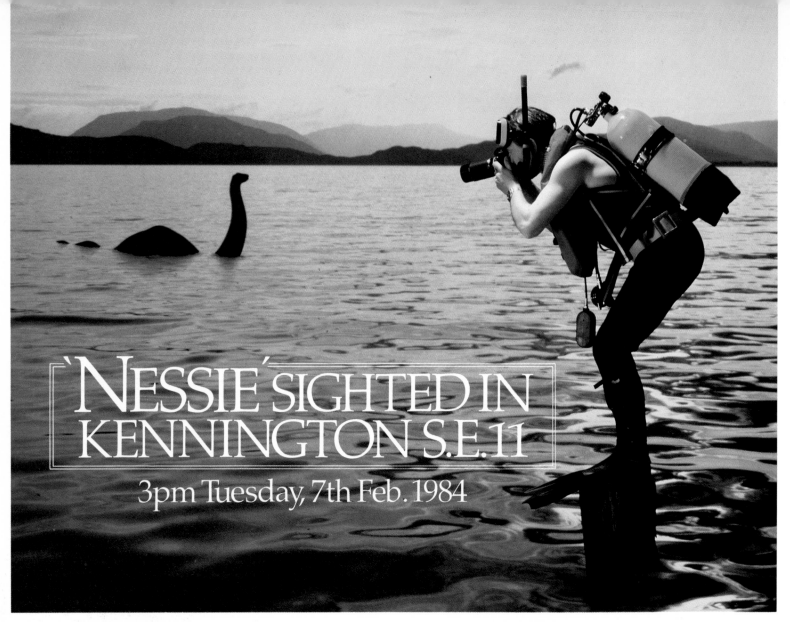

'NESSIE' SIGHTED IN KENNINGTON S.E.11

3pm Tuesday, 7th Feb. 1984

A grey afternoon in South London is the last place on earth you would ever hope to photograph the Loch Ness Monster.

But, thanks to Front Projection, you can create the most unlikely situations and in the comfort of your own studio.

We believe your best professional introduction to Front Pro is through our own Hardy Haase, who will be pleased to demonstrate and advise you on the best equipment available.

Fulfilling the needs of professional photographers is an art we have pretty well perfected at KJP. No one else provides such a complete range and flexibility of services the busy pro' requires.

Besides our same day delivery service operated in London by our fleet of vans and messengers, there's our unbeatable Trade Counter – the largest in London.

The Hire, Repair and Export Departments provide valuable back-up services too.

At KJP House you will also find under one roof the most comprehensive range of professional photographic equipment and materials. And ask about our special 9 months interest free credit scheme.

KEITH JOHNSON PHOTOGRAPHIC LTD
KJP House
11 Great Marlborough Street
London W1V 2JP
Tel: 01-439 8811 Telex: 24447

AND AT:
28-30 Pelham Street, Nottingham NG1 2EP 0602 586888

Distributors of Professional Photographic Equipment

Photographed by Robert Elsdale at Focal Point Studios London

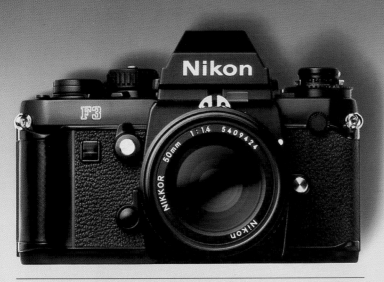

The Nikon F3 is built tough. It's as reliable in the tropics as in the arctic, as precise at 8 seconds as at 1/2000 sec. Known for its rugged dependability, the F3 is a true thoroughbred.

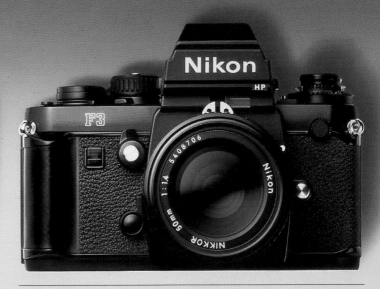

The F3 High Eyepoint has a larger viewfinder eyepiece, enabling you to see the entire frame at a glance. And so it's ideal for photographers who wear spectacles, or for those who shoot fast action.

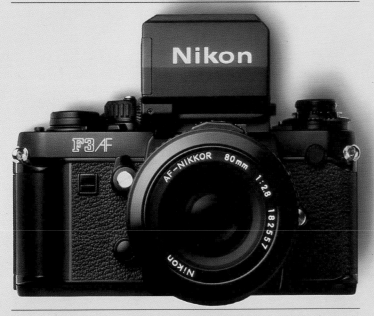

The Nikon F3AF is built to take great shots automatically exposed and automatically focused. It will enable action photographers and photojournalists to keep fast-moving subjects pin-sharp.

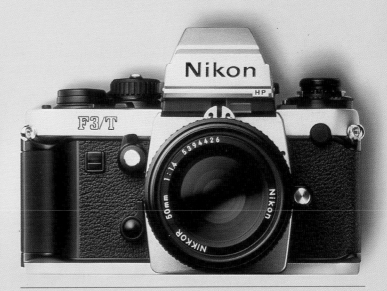

The F3T uses titanium in its construction. Capable of withstanding corrosion, impact and extremes of temperature, it is the ultimate 35mm camera and can truly be called the toughest of the tough.

ONE LEVEL OF EXCELLENCE. FOUR WAYS OF ACHIEVING IT.

NIKON UK LIMITED, 20 FULHAM BROADWAY, LONDON SW6 1BA. TEL: 01-381 1551

Build your reputation on ours.

Over the years, the name Durst has become synonymous with quality in colour laboratory equipment.

Today, as part of the International Group of Durst Companies, Durst (UK) is able to offer a range of products covering the entire field of laboratory operation. Products from leading manufacturers with a proven record of performance and reliability.

With top quality products and a nationwide network of factory-trained technicians and technically experienced sales personnel, Durst can help you meet the challenges of a highly competitive industry.

That is why you can safely build your reputation on ours. Whether planning a new venture or expanding your present facilities, consult us first and take advantage of our unique

experience to help ensure the successful development of your business.

Think Colour. Think Durst.

Durst (UK) Ltd.,
Felstead Road, Longmead Industrial Estate,
Epsom, Surrey KT19 9AR
Telephone: Epsom (03727) 26262 Telex: 24593

Distributors of Durst enlarging, printing and processing equipment, Macbeth densitometers,
Photo Engineering automatic finishing systems and Chromapro transparency duplicators.

ZEISS
the first name in optical quality

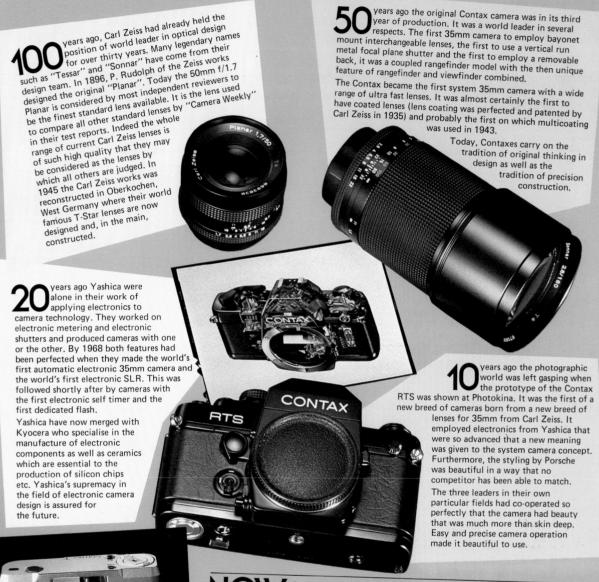

100 years ago, Carl Zeiss had already held the position of world leader in optical design for over thirty years. Many legendary names such as "Tessar" and "Sonnar" have come from their design team. In 1896, P. Rudolph of the Zeiss works designed the original "Planar". Today the 50mm f/1.7 Planar is considered by most independent reviewers to be the finest standard lens available. It is the lens used to compare all other standard lenses by "Camera Weekly" in their test reports. Indeed the whole range of current Carl Zeiss lenses is of such high quality that they may be considered as the lenses by which all others are judged. In 1945 the Carl Zeiss works was reconstructed in Oberkochen, West Germany where their world famous T-Star lenses are now designed and, in the main, constructed.

50 years ago the original Contax camera was in its third year of production. It was a world leader in several respects. The first 35mm camera to employ bayonet mount interchangeable lenses, the first to use a vertical run metal focal plane shutter and the first to employ a removable back, it was a coupled rangefinder model with the then unique feature of rangefinder and viewfinder combined.

The Contax became the first system 35mm camera with a wide range of ultra fast lenses. It was almost certainly the first to have coated lenses (lens coating was perfected and patented by Carl Zeiss in 1935) and probably the first on which multicoating was used in 1943.

Today, Contaxes carry on the tradition of original thinking in design as well as the tradition of precision construction.

20 years ago Yashica were alone in their work of applying electronics to camera technology. They worked on electronic metering and electronic shutters and produced cameras with one or the other. By 1968 both features had been perfected when they made the world's first automatic electronic 35mm camera and the world's first electronic SLR. This was followed shortly after by cameras with the first electronic self timer and the first dedicated flash.

Yashica have now merged with Kyocera who specialise in the manufacture of electronic components as well as ceramics which are essential to the production of silicon chips etc. Yashica's supremacy in the field of electronic camera design is assured for the future.

10 years ago the photographic world was left gasping when the prototype of the Contax RTS was shown at Photokina. It was the first of a new breed of cameras born from a new breed of lenses for 35mm from Carl Zeiss. It employed electronics from Yashica that were so advanced that a new meaning was given to the system camera concept. Furthermore, the styling by Porsche was beautiful in a way that no competitor has been able to match.

The three leaders in their own particular fields had co-operated so perfectly that the camera had beauty that was much more than skin deep. Easy and precise camera operation made it beautiful to use.

NOW there are three Contax SLRs to choose from. Each one is advanced in concept and has its own particular character to suit individual requirements — yet the vast system accessory range is largely interchangeable among them. Whether you choose the Contax RTS II with its ultra-accurate titanium shutter, the Contax 137MA with its unique micro-motor or the compact Contax 139 you will have the reassurance of quartz timing of ALL functions.

And in 1984 Contax comes full circle with the introduction of a totally new rangefinder camera that is miniscule in dimensions but gigantic in quality. The **Contax T** will fit into a small pocket yet it is capable of large prints fit for any photographic exhibition.

CONTAX
the last word in precision cameras

DE VERE/
SITTE

Whatever your darkroom needs…

Divomat mini 1000

Continuous dip and dunk film processor. Reliable trusted design with latest solid state electronic control, automatic replenishment, built in air burst and nitrogen valve. Available without drying cabinet if required. Available for C41, E6, B/W and Agfa.

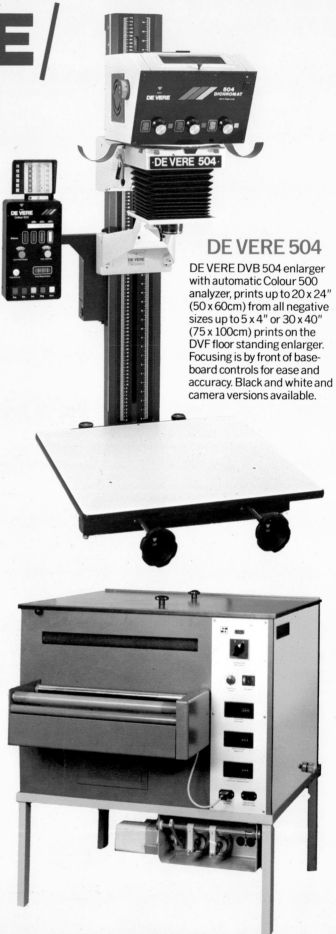

DE VERE 504

DE VERE DVB 504 enlarger with automatic Colour 500 analyzer, prints up to 20 x 24" (50 x 60cm) from all negative sizes up to 5 x 4" or 30 x 40" (75 x 100cm) prints on the DVF floor standing enlarger. Focusing is by front of base-board controls for ease and accuracy. Black and white and camera versions available.

Constamat R mini M

Continuous fully automatic paper processor with a reputation for consistent reliable results. Self cleaning economic, with roll paper option, paper widths 12" or 20" (30cm or 50cm).

DE VERE the leaders in darkroom technology bring you an unbeatable combination of equipment and service. A range of models to suit your requirements and your pocket. The perfect partnership.

DE VERE

Manufacturers and Suppliers of Precision Photographic Equipment

Head Office: DE VERE (Kensington) Limited,
De Vere House, 100-108 Beckenham Road, Beckenham, Kent BR3 4RH.
Telephone: 01-658 7511. Telex: 946252. Telegrams: Deverequip Beckenham.

viii

Super Field Camera

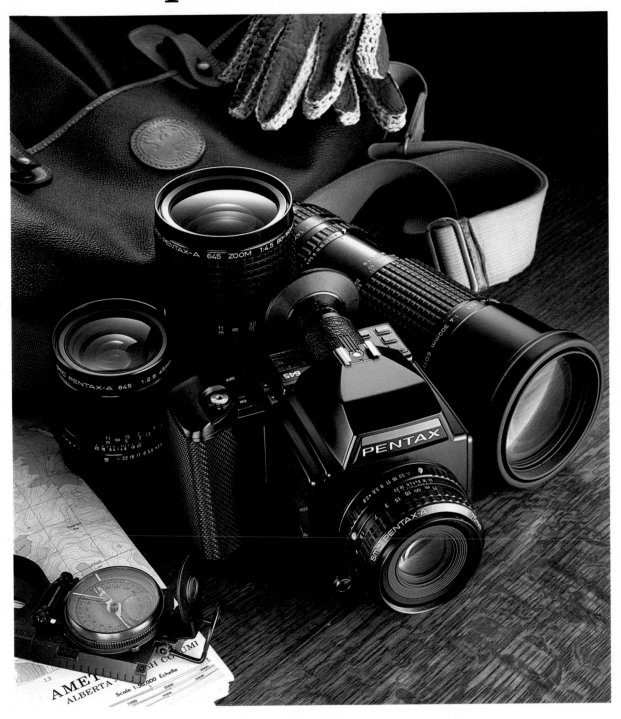

The exquisite combination of medium format high quality pictures
with the portability of multi-mode electronic 35mm SLR.
Write to Pentax (UK) Ltd, Pentax House, South Hill Avenue,
South Harrow, Middlesex HA2 0LT.

PENTAX
645

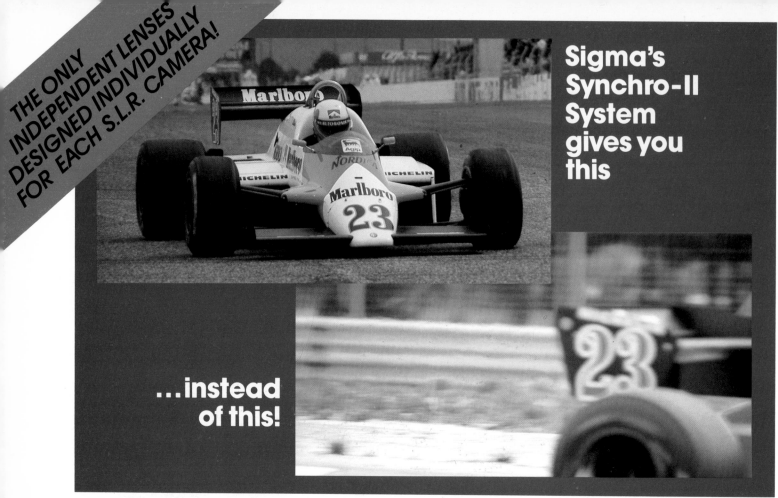

THE ONLY INDEPENDENT LENSES DESIGNED INDIVIDUALLY FOR EACH S.L.R. CAMERA!

Sigma's Synchro-II System gives you this

...instead of this!

It's an even chance, when you choose your next lens for your S.L.R., that you will choose an independent brand. After all, they are designed by lens experts, not camera experts, and they do offer, generally, that little bit extra in specification and that bit extra value for money than lenses bearing your camera's name.

Only trouble is, it's an even chance that the lens you choose won't be designed, mechanically, for your S.L.R. camera! Different S.L.R.'s focus different ways, have aperture rings which differ in their settings. No independent lens manufacturer, surely, can design one lens to fit ten different S.L.R.'s and get everything right for all of them?

Wrong! One, **and only one!** can and has—SIGMA, in their new Synchro-II series!

CANON, OLYMPUS, CONTAX/YASHICA, MINOLTA, PRAKTICA

PENTAX, NIKON, FUJI.

...designed for speed and ease of operation!

Sigma Synchro-II lenses have been designed, mechanically to operate in the same way as the majority of S.L.R. camera manufacturers... you no longer have to sacrifice speed of use, ease of operation and that essential 'feel' upon which so many successful pictures depend...all your lenses will operate in the same way—a great advantage with all S.L.R.s, an essential feature with any camera having "arrow aids" for focussing or exposure!—and if you don't have one now, you may well change to one in the future.

SEE WHICH MAJOR LENS BRANDS ARE COMPATIBLE WITH YOUR S.L.R. CAMERA...

	CANON	OLYMPUS	CONTAX	NIKON	PENTAX	MINOLTA	KONICA	FUJI	PRAKTICA
Focusing direction	INFINITY CLOSE-UP	INFINITY CLOSE-UP	INFINITY CLOSE-UP	CLOSE-UP INFINITY	CLOSE-UP INFINITY	INFINITY CLOSE-UP	INFINITY CLOSE-UP	CLOSE-UP INFINITY	INFINITY CLOSE-UP
Aperture direction	22 1.8	1.8 22	22 1.8	1.8 22	1.8 22	22 1.8	22 1.8	1.8 22	1.8 22
	SIGMA	SIGMA TAMRON TOKINA KIRON VIVITAR *Compatible with OM-4	SIGMA	SIGMA *Has cut-out for FA with longer focal lengths.	SIGMA	SIGMA	SIGMA	SIGMA	SIGMA TAMRON TOKINA KIRON VIVITAR

If you want to maintain the continuity of your camera system then a Sigma Synchro-II lens is an essential...you'll be buying just about the best optically too! Sigma lenses have come out at or near the top consistently over the years...Sigma also give you a lens hood, a case and a three-year guarantee at no extra charge!

Drop us a line or ring us on 01-953 1688, we'll be pleased to send you Sigma's fully-illustrated booklet and the name of your nearest Sigma Retail Centre...

Σ Sole U.K. distributors:
C.Z. Scientific Instruments Ltd., P.O. Box 43, 2 Elstree Way, Borehamwood, Herts. WD6 1NH.

x

Photo Unit 3

Roy Bowden

Clive Shayler

ANY OLD QUANTITY. BUT VERY SPECIAL QUALITY...

Gary Williams

Jon Graeme Photography

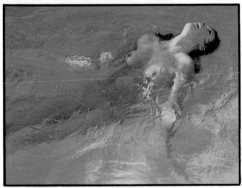

I.C.A. Studio

If you're a Colab customer, you're special. And you want special quality, regardless of quantity.

That's what we'll give you. Density and colour balance perfectly matched from one print size to the next.

We'll print any neg. from 35mm upwards. We'll print any quantity from one to literally thousands, in any print size from mini prints to 12 foot x 12 foot.

And we'll do it fast — in hours if necessary — that's what we call special service.

The prices are pretty special, too.

Only Colab can produce such quality, such quantities, in such a quick time, and at such economical prices.

So never mind the quantity. At Colab, it's the special quality that counts.

You get the picture

Colab Colour Processing Laboratory Ltd
Herald Way, Binley, Coventry CV3 1BB **Tel Coventry (0203) 440404**
24 hr answering service

PHOTO-GRAPHIC DISPLAY MATERIALS FROM JOHN BLISHEN

metone

A new media for Exhibition and workshop use.
Bromide emulsion on Aluminium Plates of different thicknesses and surfaces.
Printing and Processing as ordinary Bromide paper.

db

Autone is a registered trade mark.

autone

pre-coloured Enlarging Paper

Introduced by us in 1966, this range of specialised Bromide enlarging paper is available in a wide range of colours on a resin coated base.
Handled as ordinary Bromide paper, Autone has met with great success and is used by Exhibition Designers/Contractors and Graphic specialists all over Europe.
Available in rolls 125cms wide. All RC colours are also available in cut sheets sizes 20.3 x 25.4 cms. and 40.6 x 50.8 cms.
Send for full details and free colour chart NOW.

JOHN BLISHEN AND COMPANY LIMITED

75 Kilburn Lane, London W10 4AW
Telephone: 01–969 0071
Telex: 291569 BLISH.G

photo linen

A fast high contrast Bromide emulsion on Linen base which will withstand severe punishment without affecting the image and may be re-soaked and cleaned to restore original brilliance...ideal for special display purposes and Trade Exhibitions ...can be back illuminated for special effects.

xii

BRITISH JOURNAL OF PHOTOGRAPHY

1985
ANNUAL

EDITOR
Geoffrey Crawley

ASSOCIATE EDITOR
Tim Hughes

PICTURE EDITOR
Anna Tait

BOOK DESIGN AND PRODUCTION
Anna Tait

© 1984 Henry Greenwood & Co Ltd
ISBN 0 900414 31 6
Published by Henry Greenwood & Co Ltd
28 Great James Street, London WC1N 3HL
Distributed in the USA by Writer's Digest Books
9933 Alliance Road, Cincinatti, Ohio 45242

Printed and bound in Great Britain by
Manor Park Press Ltd, Eastbourne

SUCCESSIVE EDITORS OF THE ANNUAL:

1861-62	Samuel Highley
1863	James Martin
1864	Emerson J. Reynolds
1865-79	J. Traill Taylor
1880-86	W. B. Bolton
1887-96	J. Traill Taylor
1897-1905	Thomas Bedding
1906-1934	George E. Brown
1935	H. W. Bennett
	P. C. Smethurst
1936	H. W. Bennett
	Arthur J. Dalladay
1937-67	Arthur J. Dalladay
1968-	Geoffrey Crawley

PICTURE EDITORS:

1964	Bryn Campbell
1965-67	Norman Hall
1968	Ainslie Ellis
1969	Anna Körner
	Geoffrey Crawley
1970-71	Anna Körner
1972-73	Mark Butler
1974-76	Anne Owen
1977-78	Judy Goldhill
1979	Geoffrey Crawley
1980	Jan Turvey
1981-82	Christine Cornick
1983-	Anna Tait

THE ANNUAL'S HISTORY

The *British Journal of Photography Annual* is the oldest photographic yearbook in the world. It appeared first in the form of a wall calendar for the year 1860 and was published as a supplement to *The British Journal of Photography* issue of 15 December 1859. In the following year the *British Journal Photographic Almanac,* 1861, as it was then titled, with the sub-title *Photographer's Daily Companion,* appeared as a pocket book, 4 × 2½in in size, issued free of charge to subscribers of the *Journal.* The 1886 issue was produced in the Crown 8vo format, 4½ × 7in, and sold as a separate publication with 118 pages of text and 44 of advertising, priced 6d. This format remained unchanged for 97 years until the 1964 issue, when the book was enlarged to 8 × 11in, enabling photographs to be properly displayed, selected by a picture editor also responsible for the layout of the book. With the 1980 edition, the book adopted a new, 255 × 240mm, format.

CONTENTS
ANNUAL 1985

SWANSEA COLLEGE
LEARNING CENTRE
LLWYN-Y-BRYN
77 WALTER RD., SWANSEA SA1 4RW

OF

ACCESSION No: C 245 86
SWANSEA COLLEGE
LEARNING CENTRE
CLASS No: 770·92

FOREWORD
ANNUAL 1985

WITH the 1985 edition the *British Journal of Photography Annual* reaches its traditional majority with the 21st issue of the enlarged format, introduced in 1964. For over a hundred years it had been published in the octavo size and for most of the time was known as the *British Journal Photographic Almanac*. That title derived from the fact that the very first issue was a simple wall calendar for 1860, given away with the *British Journal of Photography,* the weekly magazine itself. The calendar, a single sheet, was surrounded by formulae for making, processing and printing photographic plates and prints. At that time there were few secrets in photography and photographers were only too delighted to tell each other the latest improvements they had made in the process. If you follow the story of photography through the old *Almanacs,* you will find that it was in the 1880s that how to prepare light sensitive plates began to become industrial secrets. Nevertheless the old tradition of providing formulary for photographers to make up and process their own films has continued right through until today and in the processing section of the *Annual* you will find the modern equivalent: a formulary for current colour reversal, colour negative, colour print, black-and white positive and negative processing — the only publication in which they can all be found. Early on the *Almanac* became a depository for a technical retrospect of the year and the most important new processes and techniques which had been the subject of articles in the weekly *Journal* were abstracted for the *Almanac*. This section was first called the Summary of Progress and this too has its counterpart in the modern *Annual*. Pictures first made their appearance in the old almanacs as part of the developments, and some of them were actually prints such as three-colour Carbro, Woodburytype, and various makes of bromide paper tipped in — lightly glued — in the book. Eventually it was realised that a selection of good pictures which had come to the fore during the year would add to the *Almanac*'s interest. This section was printed in the beautiful Van Dyck brown gravure process.

Broadly speaking the photographic scene, although much technical progress had been made, did not change essentially until the end of the 1950s and it was probably the availability to everyone of first-class slide and colour print processes which effected the changes which became pronounced in the early 60s. Photographers began to use the 35mm camera as standard equipment since it was the simplest and least expensive way of taking colour photographs. The new freer approach and sociological changes brought a decay of the affiliated club system which had ruled amateur enthusiast photography. Camera users were now content to be loners and far fewer wanted to join in club activities which began to be regarded as old fashioned. This change in photography became very evident in the sales of the old *Almanac* which began to fall away and we realised that a new type of year book was required for the new conditions. Thus it was that in 1964 the *British Journal of Photography Annual* came before the public in an enlarged format, allowing full display of photographs, and the picture section became the core of the new book. Photography had become simpler and it was now no longer necessary to learn the complicated details of processes, how to decide on exposure and so on. Trade processing of colour and camera-linked exposure meters and automatic exposure control were taking over.

Looking back over the 21 years of the new-format *Annual,* you gain the impression that the convulsion that society went through in the 1960s had its counterpart in photography and since then the photographic world both in technology and image making has been following up the new directions which were started then. In technology it is fascinating to notice that most of the developments of the past 20 years are along lines initiated in a short period from 1962 to 1965. Those years, for example, saw the first electromagnetically controlled shutter for small cameras, and its linking to an exposure meter. The cadmium sulphide cell was the first light sensor small enough to be built into a camera to provide through-the-lens exposure metering which came out in 1965. These innovations — electromagnetic shutter crosslinked to an exposure meter built in to the camera together with through-the-lens metering — have formed the nucleus of camera evolution in the past 21 years. The CdS sensor was later replaced by the still smaller, more sensitive and more rapidly-acting silicon photodiode, quartz clocks replaced the batteries of resistors which controlled shutter speeds in the early electronic-magnetic shutter, and in 1974 microprocessors found their way under the top plate, to control the camera functions and later, with more sophisticated chips, to provide the remarkable array of functions sophisticated in the latest camera. Just how far the development from that nucleus of 20 or so years ago has gone, without changing the basic ideas, will be best understood when you have read the article in this *Annual* entitled 'The Intelligent Camera'.

Elsewhere in the technical field the past 21 years have seen a steady improvement in photographic lenses and the major step here was the advent of the high-speed computer into lens design. Just as the quartz-controlled wristwatch in a few years swept aside the developed hand craftsmanship of most of the world's watch and clock industry, so in a similar few years in the 60s the whole craft of traditional lens design was swept away by computers. No longer did a company of mathematicians sitting at mechanical calculators laboriously work through abstruse formulae, possibly for a year or two, before coming up with a few suggested lines on which prototype lenses might be usefully made for testing. Now the computer could in a matter of a few days explore every single possibility and permutation and combination of a particular design complete with a full prediction of the image quality it would give. The old-style lens

designer, working on painfully accumulated experience and inspiration, became a respected but obsolete figure and the new skill required was that of knowing how most effectively to programme the computer. The result has been a general evening-off of lens performance, the products of some manufacturers no longer showing the distinct advantages over others as before. The best result has been the fact that the lenses even in inexpensive cameras today are capable of very fine quality, and a relatively cheap compact viewfinder 35mm camera will have a lens better than an expensive one of 25 years ago. This does not mean that all lenses are the same: if the computer has simplified design it can do nothing to invent new optical glasses to make new lens capabilities possible. The leading optical firms nowadays put considerable resources into discovering new types of optical glass. If you have new glass of exceptional characteristics and patented, then you can keep ahead of rivals, even though their computer methods may be just as good. The new glasses discovered over the past ten years or so have mostly helped to make wider apertures possible, particularly with wideangle lenses for 35mm cameras. The impression should not be gained that the continuing publicity for new lenses as they come along means that those of a few years ago are outclassed although, as must mentioned, wider apertures have come on the market. If you do not need those apertures, then you will find no major difference in performance between lenses produced over the past 20 years. The critical should, however, find that the colour balance of lenses of the past ten years or so is more neutral than their predecessors, due to improvements made in the anti-reflection coating.

Just as in apparatus, so in materials we can look back to those few years in the 60s to find the course set for what we have today. For example instant colour photography was introduced by Polaroid in 1963 and all the basic types of colour material we use today were generally available. A major, perhaps *the* major, step towards bringing photography to the masses was taken in 1963 by the introduction of the Kodak 126 cartridge load system. In a few years this transformed the snapshotter and provided a base from which large numbers upgraded to real photography with 35mm cameras and then larger formats. Later the same philosophy was to be carried on with the 110 cartridge load compact cameras and more recently the latest move in catering for the mass market has been the Kodak disc system. This brings high technology to the original 'Instamatic' philosophy and prepares for a future in which photographs can be held in the hand as a print or shown on the domestic TV set.

The change in the *Annual* in 1964 was part of this same new look in photography and by being centred on a display of photographs was a token of the increasing interest in the end product, the picture, rather than the processes which produced it, which were increasingly becoming automated. The atmosphere of the 60s held through into the early 70s and that was the era of the photojournalist, whose work attracted the general public and photographers alike. The freer approach to photography no longer required that a good picture must be sharp in the right places, fine grained, beautifully composed and so on. People began looking for impact and message.

The desire to make photography a message carrier particularly excited the new generation and it became the fashion to use the camera virtually as a propaganda tool. Those who collect the *BJ Annual* have at their disposal a year-by-year history of picture trends that is fascinating now to look back on over 20 years and realise the changes that were occurring. In the early 70s a new movement began to appear, not really interested in photojournalism, but more concerned with photography as a means of self-expression and the term 'artist' began to be applied to photographers. Part and parcel of it was a simultaneous awakening of interest by the general public in photography as a medium to view in galleries. Hitherto, photographic exhibitions had been rather rare events — compared with today that is — and the two regular ones were the Royal Photographic Society International exhibition and the London Salon. Art galleries began to show photography and specifically photographic galleries began to open up all over the country; most have, happily, remained open until today. This change in picture making was really a reawakening of the original Victorian view, which saw photography as one of the fine arts. New waves tend to go to excess and looking back through *Annuals* of those years, the new freedoms were occasionally abused. Nevertheless the new art movement in photography has come as a heartening counterbalance to the increasing automation of the process and of its apparatus. During the 70s public money through the Arts Council began to be poured into photography mainly into this new art movement. With the sterner realities of the 80s, some of this is being redirected happily to a more general 'education' and organisation of photographic activities.

Looking back over the 21 *Annuals,* it is also possible to see the reawakening of interest in photographic history which has been a most encouraging feature of this time. Young photographers began to develop a genuine interest in the work of their predecessors going right back to the early Victorians and have found inspiration and encouragement in historical studies. It has not been surprising that this preoccupation with photographic history has been reflected in a commercial way by the emergence of the photographic collectors. Prices for early photographs and apparatus soared in the mid 70s and as economic inflation forced people to look for sound investments, the photographic collector's market was a natural development.

This then is something of the weave and texture of the evolution of photography over the 21 years that the new *British Journal Annual* has been in existence.

Geoffrey Crawley, Hon FRPS, DGPh, MBKSTS

Walter Nurnberg *shows how the work of the last sixty years demonstrates both the essence and the modes of*

Portraiture and its Riddles

I

OVER recent decades we have seen an increasing number of specialised exhibitions and many lavishly illustrated books featuring portrait photography from all over the world. Only relatively few of the photographers who were thus featured have succeeded, by their very personal and exceptional talents, in sustaining not only the acclaim of their peers, but also in holding the interest of a larger, ever-changing public which often seems to be more interested in the importance of the portrayed rather than in the achievement of the portraitist.

Photographic portraiture is particularly difficult to assess beyond the measurements of 'likes' and 'dislikes' because concepts, tastes and attitudes change with each new generation, increasingly influenced by the mass media. The approach to portraiture, by photographers and the general public alike, changes perpetually and is by no means based only on individual likes and dislikes but on fundamental, psychological precepts, concerned with what portraiture is all about.

Within the modest frame of this essay and the accompanying illustrations, I shall consider portraiture beyond its role as a mere commodity, and look at its very nature across time. Living in the modern world of 'Visual Communications', where semantics have become more and more equivocal and uncertain, it is not always easy to remember that portraiture is not fiction, nor that it is a mere symbolic device.

The human image confronts us continually from the television screen, theatre boards, advertisements and other propaganda material and often impresses us with a great sense of realism; it takes some effort to realise that these images are (with rare exceptions) *not* portraits, even if they sometimes make us forget that they are not.

Portraiture has always been exclusively concerned with the personality of one particular individual with the aim of introducing, indentifying or memorialising this personality and also, in its highest form, of illuminating the inner nature of the portrayed.

It may seem too obvious to restate what has been knowledge for thousands of years, namely that the purpose of a portrait is the creation of a *likeness*, yet it is at this point that we find one of the most puzzling conundrums. Even if we believe that we know what a portrait is, do we know what is a likeness?

Likeness is both fact and illusion. As fact it exists only if we are in a position to compare the simile with the original and are thus able to recognise an outward similitude, an outward likeness. As an illusion, likeness is the *belief* that we actually know and *understand* a person, even to a point where we may feel as if we were actually in this person's presence, although we have never met or seen the person before.

This dichotomy of likeness, and the portraitist's attitude towards it, can be seen to have been one of the most crucial factors in the development and change of modern photographic portraiture. Taking a much simplified view of the outer frontiers of portrait practice, we see two opposing poles.

On one side we find likeness produced by an automatic machine which makes nothing but copies of the human exterior. These most impersonal of photographs facilitate instant identification without carrying any of the hidden innuendos that are normally added by the photographer's interpretative skills. At the same time, the machine produces images which — like the psychologists' ink-blot tests — enable the viewer to form his (or her) very own, free and introspective associations of thought.

At the other extreme, stand the most revealing, quintessential — albeit often subjective — views offered by the great portraitists. These relatively few truly great masters (sculptors, painters and photographers alike) are committed to a deep personal involvement. They will add to their keen diagnostic disciplines and flawless technique, the priceless gift of an exceptional sensitivity and insight. In doing this, they face an extraordinary challenge to the *integrity of their intent* and to their sense of interpretation. Their reward however, is great: they will experience a compelling, inexplicable and unspoken understanding which they will be able to pass on to others by often deeply affecting images.

In between these extremes lies the work of the majority of photographers whose portraits are of an astonishing variety, displaying a multitude of modes and styles which are directly influenced by the fundamental approach and by the degree to which each particular photographer is able and willing to solve the eternal enigma of likeness.

II

For this short essay, which is concerned with describing the nature of portraiture and its development, as well as with the changing attitudes towards it, I have chosen to look back over the past sixty years.

It was in the 1920s that the traumatic aftermath of World War I brought a period of searching re-examination of fundamental philosophies and attitudes. With them came a burst of new concerns, arguments and fresh ideas, all of which needed to be expressed: literature, music and all the visual arts found a new language.

Photography too, found new horizons. As the world of architecture and design witnessed the birth of the radical new concept of the 'Neue Sachlichkeit' (the 'New Rationality' or 'New Realism') photography was led inescapably to the discovery of the practically uncharted territory of 'applied photography' which over the years, had now achieved its unique and unrivalled diversity of applications.

It is significant that it was about this time that a young photography teacher, Werner Gräff wrote his radical book entitled *Es kommt der Neue Fotograf*[1] ('Here comes the New Photographer') a slender volume in which he expressed vividly not only the spirit of the time, but also forecast the future direction of photography as a whole and the vital role it was to play within human society.

Albert Renger Patzsch opened up a new visual experience by his photography of the most ordinary inanimate objects which photographers, hitherto, had not considered worth their attention, and thus created a new awareness of tactility.

Photojournalism which, in the past, had the sole task of *reporting* on the world's happenings as fully and as objectively as possible, suddenly stood on the threshold of moving progressively into the far more subjective and socially orientated medium of *comment*.

One of the most dramatic developments at the time, however, was the photographers' new attitude to the use of light. Encouraged by Moholy-Nagy and a few other photographic thinkers, the manipulation of light became gradually accepted as part of the creative process and one soon saw a rapid increase of photography made with a multiplicity of variable *lighting combinations*.

These new lighting techniques were introduced and developed by the Hollywood photographic giants, such as Janes Abbe, Fred Allen, George Hurrell and Ernest Bacharach, by creating their 'Pseudo-Portraiture' in order to serve the needs of the film industry.[2]

Fashion and advertising photographers followed their lead and eventually also theatrical photography, notably through the great contribution of Angus McBean, brought about a prodigious range of new and original images. These extended the power of photography to serve visual abstractions and symbolism.

Portraiture proper was much slower in taking up the challenge and disengaging itself from the influence of 'art-photography' and the 'pictorialists'. Although many young photographers were soon greatly influenced by the all-pervading and powerful influence generated through the extaordinary interest shown by the thinking public of Western Europe in psychology and psycho-analysis, it took nearly another ten years for this to be clearly reflected in portrait photography.

Left: Auto-portrait by photo-booth 1984.

III

The scope of this discourse allows me to show only some of the most fundamental developments within portrait photography over the past sixty years which followed the inspiring years of the 1920s.

I am most conscious that this restraint has meant many important omissions particularly in the reference to certain great photographers such as Hugo Erfurt, Irving Penn, Snowdon and others who made their own significant contribution to portraiture.

I have deliberately confined myself to the work of seven photographers who, in my view, indicate most clearly and in the smallest possible compass, the major points within the evolution of portrait photography and, moreover, who show by word and illustration, the significant influence which different concepts and different personal attitudes have on the work of the portraitist.

At the threshold of the 1920s stood Alfred Stieglitz[3] one of the truly great photographers of his day. His portraiture, only a part of his life's work, is amplified by his revealing and unmannered portraits, such as those of Paul Strand (1917), Margaret Tradwell (1921) and John Marin (1922), which in my view, form the bridge between portraiture created during the first seventy-five years of photographic history and the new era which was just to begin.

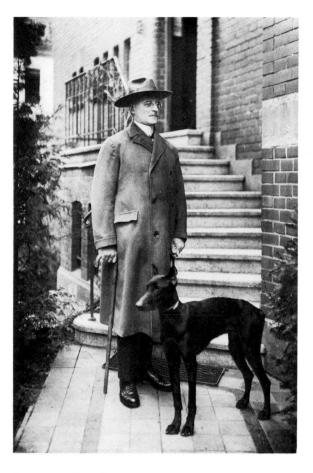

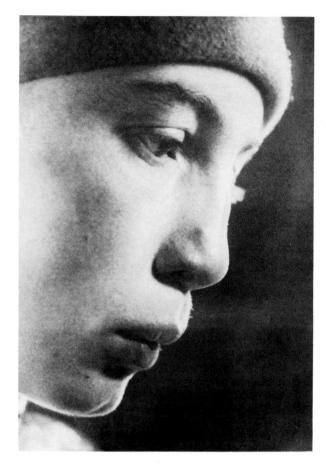

Right: August
Sander — Notary,
Cologne, 1924.

Centre: Helmar
Lerski — late
1920's.

Far right: Helmar
Lerski — late
1920s.

August Sander

In the mid-1920s August Sander[4] introduced the new idea of identifying a person not as an *individual* but as a *type,* and it is significant that Sander photographed his subject not as he, Sander, saw it, but as — so he believed — the portrayed saw himself.

In consequence, the facial expression as well as the photographer's interpretative messsage gave way to the prime significance of apparel and pose (chosen by the portrayed himself), as the main means of character-isation.

Sander's portraits were very popular at the time and have their own curious fascination even now, although it is rarely possible to identify Sander's people and their way of life without referring to his short descriptive captions. Sander's ideas found their echo forty years later when some photographers made deliberately expressionless and straight-on figure portraits, as part of their allegedly *avant-garde* work.

Helmar Lerski

At the end of the 1920s Helmar Lerski produced his great masterpiece *Köpfe des Alltags*[5] ('Everyday Faces'), which still stands alone in photographic history. It is this work, more than any other, which in its book

form of 1931, motivated young people to drop what they were doing in order to become practising photo-graphers; it continued to have a profound effect on photographic thinking for many years to come.

The book (sadly, long out of print) contains eighty dramatic close-ups of people who remained anonymous for ever; all we know about them is their way of life as the 'Wife of a Chauffeur', 'A tramp from Saxonia', 'A Reporter' or 'A Charwoman' and so on.

In contrast to August Sander, Lerski did not 'see' and feature them as *types* and, to start with at least, he did not consider them as *individuals* either. In fact he saw them all simply as raw material.

It may now seem amazing that Lerski, at the time, did not intend to make portraits at all, but to use his subjects merely to explore the parameters of photography in general and of lighting, in particular. He was trying to find out what he could discover within the human face without changing its set expressions between exposures; and, moreover, what could under these conditions, be visually expressed by means of close-ups, camera tilts, unusual viewing-angles and different lighting effects.

What Lerski actually achieved in the end, was much more: he created true portraits which, even now,

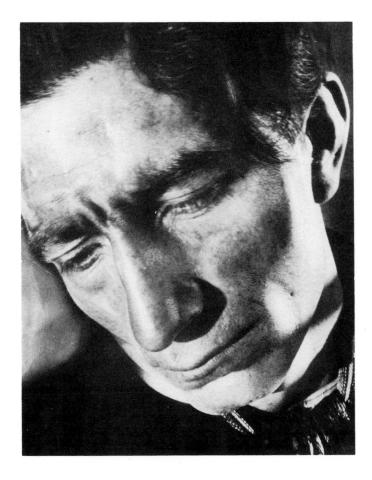

concepts and technical modes and, as they did so, their divisions were seen immediately as a far-reaching event with all their implications.

The scene was now set for a new generation of photographers who believed and proclaimed that Man should be seen to be one with his environment, and thus be so portrayed. They were convinced that this kind of new portraiture would lead to a more spontaneous sense of 'identification' and to a greater credibility of portraiture as a whole.

At the same time, studio photography also attracted a new breed of photographers who, by contrast, were convinced that it was the utter concentration on facial expression, sometimes supported by small unconscious gestures, which would most eloquently disclose the essence of the personality before their lens, without being disturbed by extraneous visual distractions.

Whatever the difference of approach, all photographers of this period shared the common commitment to dissociate themselves from the sycophancy which had marked the work of so many professional portraitists in the past.

Three great, very different photographic personalities stood out amongst those who initiated *Environmental Portraiture*. Apart but yet jointly, they set the signposts for the development for this form of photography, in all its intellectual, visual and technical contexts. All made their indelible impact on future generations of photographers.

Henri Cartier-Bresson

Cartier-Bresson approached environmental portraiture with an integrity and insight which has rarely been matched. It is astonishing that his outstanding work as a portraitist has been allowed to be buried for so long under the fame for his illustrative and photojournalistic achievements and that the first monograph on Cartier-Bresson's portraits was published as recently as 1984[6]. Cartier-Bresson's exceptional ability to recognise instantly the rare, fleeting moment of an inner enlightenment and his skill in transfixing this experience upon his work, has produced over the years, many portraits which are not only of great eloquence; his astonishing degree of self-effacement has also given his work its very special credibility.

Bill Brandt

Bill Brandt, the sensitive observer and evocative chronicler of humanity and its habitat, made a fresh impact when, adding a new dimension to his work, he turned his attention, rather belatedly, to portraiture in 1941.

Some of his portraits must have been quite startling at the time and still continue to convey, often dramatically, his probing concentration and his sympathy. Brandt's view of his 'sitters' is markedly subjective and the

suggest the immediacy of a real personal presence. Even after five decades, his work still offers an experience of spontaneous understanding and personal knowledge of people unknown.

The influence of Lerski on photography was enormous. Following his own dictum that for the photographer the only medium of creation is light, and following his original experiments with daylight and mirrors (for spotlight effects), he opened up a new formative use of light and shadow. He rekindled a fresh awareness of three-dimensionality and tactility and in so doing brought to photographers freedom to interpret and to express what they saw.

In England in the 1930s it was, perhaps, only the straightforward, often low-key male portraiture of Howard Coster which reflected by its directness some of the convincing simplicity of the 'Neue Sachlichkeit'. It was as late as the beginning of the 1940s that portrait photography caught up with the events with a bang: the *dichotomy of portraiture* had arrived to stay with us forever.

Portrait photographers suddenly found that there were two distinctly different paths by which to reach a common goal — the creation of likeness. To implement their beliefs, each group formed its own distinct

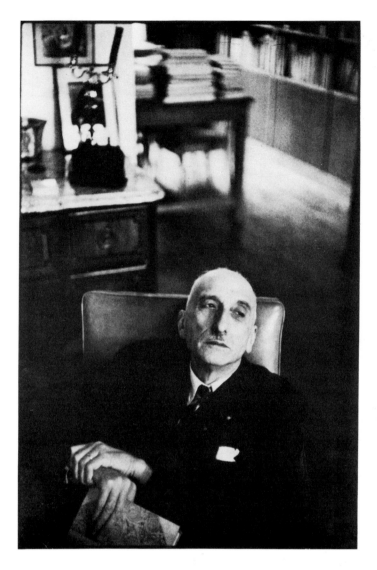

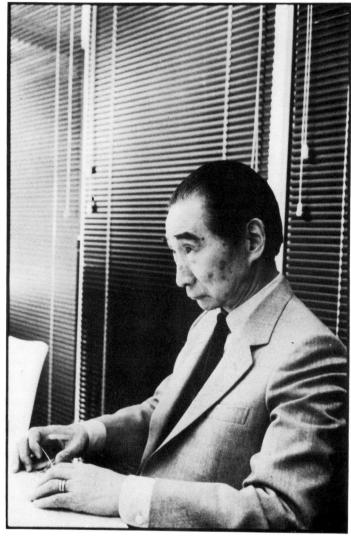

Left: Cartier-
Bresson —
François Mauriac,
1953.

Right: Cartier-
Bresson — Kenzo
Tange, 1982.

idiosyncratic manner of his visual presentation reflects the intensity of his interpretative drive.

Arnold Newman

Arnold Newman, in contrast to both Cartier-Bresson and Brandt, was committed to portraiture right from the beginning of his professional career and was determined to change the long established face of conventional portrait photography. Looking at his work, it is quite evident that he knew from the start that the nature and contents of 'background', as well as his very own way of juxtaposing background and personality, would be his major resource of communication.

I believe that Newman was, at the time, the first photographer to combine the aspirations of the traditional studio portraitist with those of his 'environmental' colleagues.

It is fascinating and illuminating to compare not only the differences between the personalities of these three great masters but also those of their approach towards the environmental content of their portrait work.

The placing of Cartier-Bresson's figures within their environment are made to appear accidental and the backgrounds usually give little factual information which would help the viewer to read the character or occupation of the portrayed. Yet the background, often visually chaotic, always seems to fit the 'sitter' like a glove and helps to convey a strong illusion of the individual's 'reality'. Most of these portraits appear to be unposed by the photographer (and probably are), although Cartier-Bresson was always much concerned to find positions which would enable him to get the best possible effect from the 'natural' light available.

Bill Brandt also selected his environmental backgrounds with great care but his choice was ambivalent, ranging from conventional settings to quasi-architectural

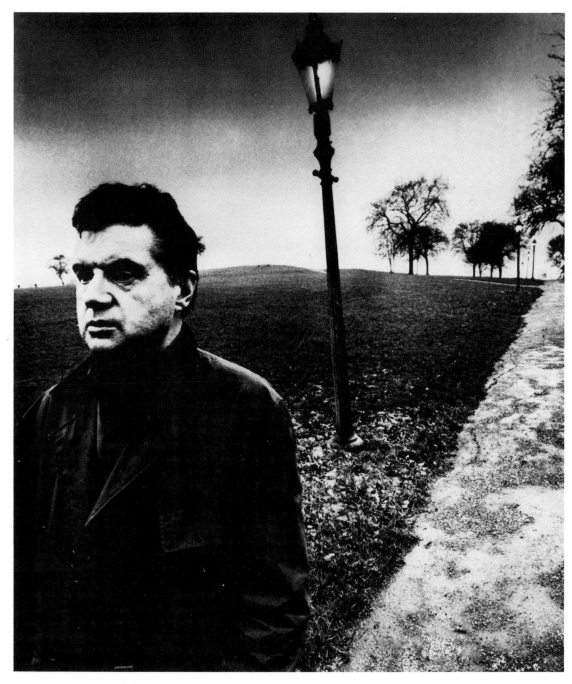

Left: Bill Brandt —
Francis Bacon,
1963.

or scenic segments. The former usually convey a more relaxed, familiar atmosphere, whilst the latter express his most subjective, sometimes disturbing, interpretative views and a vague sense of symbolism.

Arnold Newman, to judge by his work, differed basically from both his contemporaries. He looked at environmental portraiture in a most practical manner — not as a philosophy but as a tool to serve him in his task. He implemented this, I believe, by producing stimulating and, above all else, informative images which would communicate as much knowledge of a particular personality as could possibly be visually achieved, without necessarily delving into deep and searching insights.

To Newman, the idea of *environment* did not necessarily equate with natural *surroundings*, but also included, at times, constructed background elements such as quasi-architectural forms and texture images.

Although, in fact, most of his work showed his subjects in their natural surroundings of home or working place, Newman used originally contrived, often abstract, backgrounds in order to convey a more personal, subjective view of his subject's personality.

These differences of basic tenets and modes within environmental portraiture are still visible today in its present use.

Environmental portraiture, however, is only half the story, and as I have already indicated, traditional studio portraiture also brought about its own renaissance at the same time.

This was heralded by Philippe Halsman and Yousuf Karsh, both keenly conscious of the very particular impact of monochrome photography and its position as a creative medium within the visual arts. They knew that they could significantly affect sensory responses by manipulating the distribution of light and shadow areas within the image frame and also by controlling their size and contrast ratios. In addition, both photographers, but particularly Halsman, introduced into traditional portraiture, the big close-up with its dramatic and immediate effectiveness.

The influence of these two photographers upon studio portraiture was enormous and long lasting, but was, by no means, easily achieved. At that time, it required great personal courage, since both photographers had to confront established conventions and traditional photographic practices.

Philippe Halsman

Philippe Halsman, self-taught and influenced by the intellectual climate of Paris of the 1930s, and inspired by the literature of Tolstoy and Dostoievski who, as he noted, 'exposed human nature with psychological insight and honesty', decided there and then, to follow their example in his portrait work. We know now that his work never ceased to reflect his quest for insight. The task he then set himself involved him in a lifelong search for new methods of psychological assessment.

To transplant this new mental perspective and, consequently, his deepening insight into his imagery, required a constant analysis of his own perceptions and a never-ending experimentation with cameras and light; all this gave Halsman's portraiture its own vivacity and diversity. His work embraces extreme close-ups as well as full-figure studies — literally arrested in flight. This wide range of his notions created a kaleidoscopic view of those he photographed. Halsman was able to show the face of tragedy with the same veracity as that of frivolity or humour.

Left: Arnold Newman — Adolph Gottlieb, 1970.

Right: Arnold Newman — Alfred Krupp, 1963.

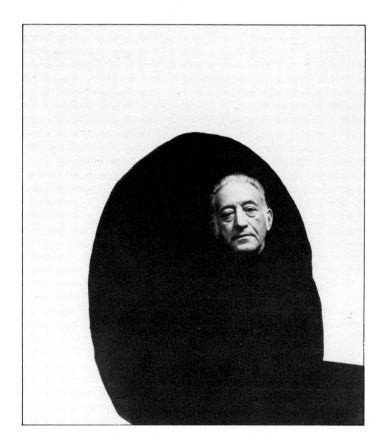

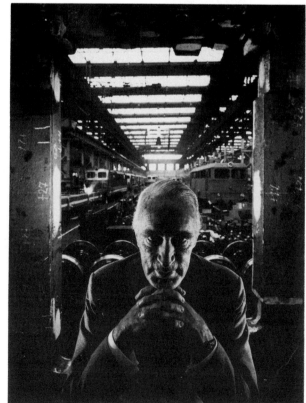

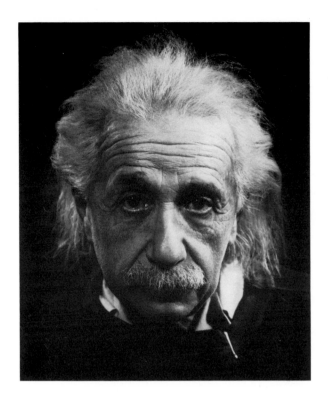

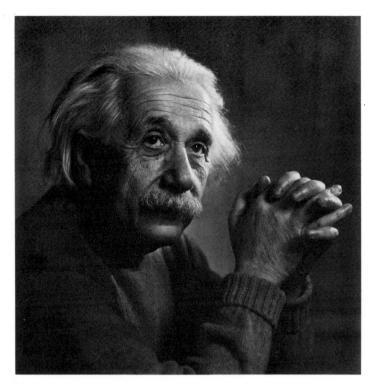

Left: Phillipe
Halsman — Albert
Einstein, 1947.

Right: Yousuf
Karsh — Albert
Einstein, 1948.

Right from the beginning of his career, Halsman realised that his probing into the mystery of human expressions had to be matched by a fluid and adaptable technique. He designed his own 9 × 12cm twin-lens reflex camera which aided him to react more spontaneously and which also suited his experimental working method. His lighting technique remained basically simple although he used it in a wide range of different combinations by which he produced an extraordinarily wide spectrum of different tonal contrasts; he treated the tonal grey-scale either like a line-spectrum or as a subtly fading continuous one, to suit the nature of each of his subjects and also his own interpretative intent.

Yousuf Karsh

Karsh, at about the same time, following a long professional apprenticeship in the traditional ways of studio portraiture, also realised that the time had come to take portrait photography out of any 'arty' pretensions and give it a new and direct look, and to create images of strong impact and precision.

Like Halsman, he set out to give, apart from a perfect outer likeness, a revealing glimpse of his subject's inner personality. His most urgent motivation, however, went even further. He was beset, right from the start, by a very special challenge, namely to portray not only Man but to portray also the Greatness of Man. This greatness which he pursued so passionately and which he always

endeavoured to reflect in all his portraits, was not the greatness of fame and adulation, but that of Man's genius, achievement and service to mankind.[10]

It is only natural that this underlying notion decisively influenced his approach, as well as his technique. He programmed himself, I believe, not so much by a constant intuitive probing, but by factual background information received before each 'sitting' which he then complemented by a tacit understanding during personal contact.

Whatever he may have discovered by these means and through the subject's facial expression or his own intuition, the hallmark common to all his portraits was always the manifestation of the subject's inner strength and, not infrequently, of a sense of heroism. These characteristics were heightened by his skilful use of *precision lighting* and by the use of black or sombre backgrounds, all of which commanded the viewer's concentrated attention.

It is evident that the vital difference between these two photographers, working broadly in the same cultural environment within the same time-span frequently photographing the same people, clearly demonstrates that it is the particular 'focus' of a photographer's personal involvement which directs the development of his individual style as well as the interpretative message of his artefact. If there is no such focus, studio portraiture, probably like any other kind of photography, is a rather uninspiring affair.

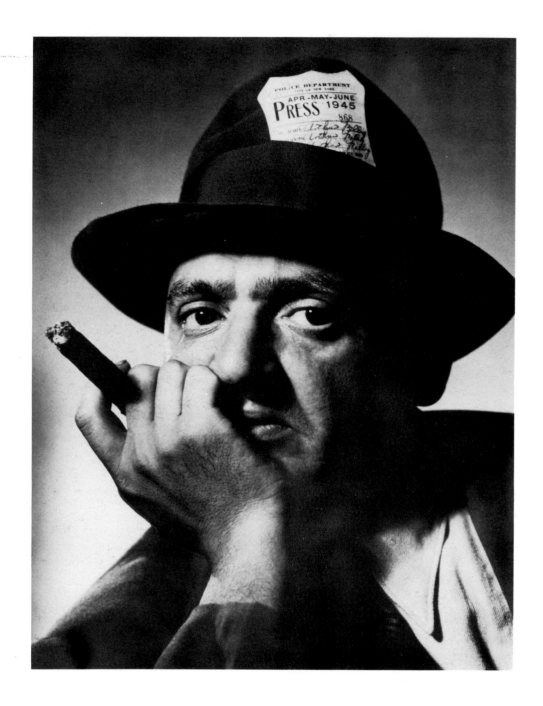

Right: Phillipe Halsman — Weegee The Famous,
1961.

In poignant contrast to Karsh's image of the
'Greatness of Man' stands Diane Arbus's portraits, of
which those of New York's outcasts which she began in
the 1950s, are perhaps the most compelling.

Diane Arbus

Her deeply moving and intensely disturbing work
manifests the 'Tragedy of Man' — the expression of
utter separation and of inner loneliness. Her photo-

graphs, however, are not merely a document of a social
calamity. They are portraits of distinct, individual —
albeit unnamed — personalities, all revealing their own
very particular tragedy. The unvarnished simplicity of
Arbus's photographs, linked to an inescapable
impression of the photographer's own involvement,
gives the portraits a heightened pathos.

Unlike many other photographers of her time, she
appears to have seen light only as a means for producing

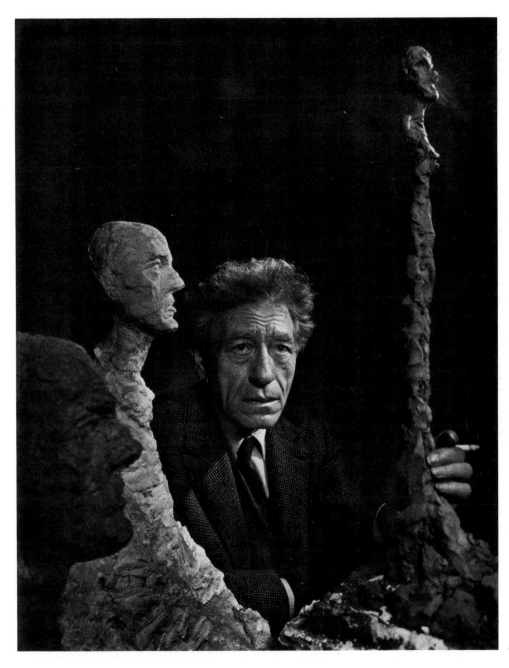

Left: Yousuf Karsh — Alberto Giacometti, 1965.

a photographic image and the camera only as a means of reproduction; and yet, she was able to convey a sometimes alarming illusion of her subjects' actual presence, and by doing this, to make us comprehend, however dimly, their very personal hell.

Whenever I return to her work, I never cease to wonder whether I face in her portraits the image of her doomed subjects or whether I see the reflection of the photographer's tortured mind — or both?

IV

It is evident, even by my few examples, that the twenty years between 1940 and 1960 brought a vigorous reappraisal and abundance of original ideas and styles. This was seen in all branches of photography including photographic portraiture. What then, has happened to portrait photography in the following decades?

Most of the masters of the 1940s and 1950s (including Brandt, Cartier-Bresson, Halsman and Karsh) con-

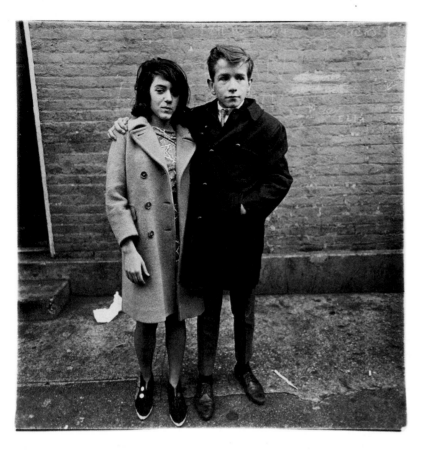

Above: Diane
Arbus — Teenage
Couple on Hudson
Street, NYC 1963.

professional portraitists — whether studio portraitists or environmentalists — appeared to lose, during the 1960s, the imaginative thrust of the preceding era. They seemed content with imitating the styles created by established masters without investing their own work with a similar degree of insight and without contributing new modes of interpretation. The result was inevitable — a progressive decline into mediocrity barely hidden by the occasional displays of technical brilliance.

The symptoms of this and the reasons behind them, were and still are, clearly seen.

The environmentalists, but for a few notable exceptions, were not slow to see in 'environment' very little more than an easy means of type-casting, to be content with giving obvious visual information, usually related to the 'sitter's' profession, trade, social status, ethnic origin and so on, whilst abandoning their proper but more difficult task of portraying individuality.

The studio portraitists, whilst improving generally their technical panache and by achieving a more sophisticated manner of presentation, slipped into a cosy photographic cuckoo's nest by adopting some favoured master's style, as well as a package of well-tried and repeatable lighting combinations — a pleasant and familiar mixture that was easily accepted by a large, not always very discriminating, public.

More fundamentally, there can be little doubt that the best talents within the ranks of the younger generation of photographers have not identified themselves to any significant degree with the established underlying tenets and the true purpose of portraiture, and thus have failed to contribute to its further progress.

The many reasons for this are very complex and I am here able to indicate only a few.

Leaving aside the relatively modest and more mundane aspirations of the average, mainly commercially motivated, studio practitioner, it is evident that the interest of most of the progressive and creative photographers of Man, has been transferred from their earlier aim of disclosing the 'nature' of a particular personality to producing a broader, albeit anonymous view of humanity, a view seen in terms not of individuals, but of specific groupings, types or clans. The individual has thus become, all too often, a symbol in the photographer's mind, a mere representative for any specific grouping worthy of the photographer's attention at a particular time.

There can be no doubt that the real reason behind the change in the fundamental attitude of many young photographers towards portrait photography stems from dramatic changes within the very structure of human relationships. In addition, there is the motivation provided by a sincere and growing concern with the wider aspects of an uncertain and turbulent world, a concern which fuels their search for a cause and a new raison-d'être. Although all this has certainly benefited

tinued to work until the present day or, at least, up to the very recent past and consolidated their styles and their reputations. Apart from anything else, their influence encouraged a higher *technical* level of achievement of those engaged in professional, day-to-day practice.

Looking back, it appears that twenty-five years ago — in the 1960s — photography began to be struck by two cataclysmic, accelerating waves of development. One wave was that of Technology, and the other that of Ideology, and although both were very different by nature, they were not always separated in their effect upon the photographer.

Some areas of photography gained by these events. Photography serving mass-communication such as photojournalism, advertising, propaganda and documentary illustration received new concepts and new ideas which strengthened their powers of visual suggestion and subconscious insinuation.

Likewise, photography applied to the sciences (such as the natural sciences, medicine and space exploration) benefited not only by a rapidly expanding technological sophistication, but also by an often staggering new range of truly exciting images.

It is therefore all the more disappointing that portrait photography, in stark contrast, did not share in the general progress of photographic creativity. The

other branches of photography, portraiture has been most detrimentally affected by these developments.

The apparent paralysis of new thought and of new creative initiative was also due to other factors which, although serious, could — given the will — have been avoidable. Most of the decline is rooted in the streak of human inertia which modern technology has so successfully encouraged in recent years. Here are just two examples.

The introduction of the motor-driven camera which, in many ways has proved to be a most useful tool, has led many portraitists, by its misuse, into a happy-go-lucky world of hopeful expectations.

We have seen that portrait photography, at its best, was created by photographers who were firmly committed to find in each of their subjects a revealing synthesis of their particular personality; they achieved this by allowing for some passage of time — whether brief or extended — in order to listen, not only to verbal interchange but also to the quiet voice of their own instinct. Particularly those who have experienced the rare and precious moments of 'fulmination', the minute, unexpected flash of an inner recognition (in which Cartier-Bresson has so firmly believed), know only too well that the work of the portraitist has always been one of patient and sensitive pursuit of understanding.

The thoughtless use of the motor-driven camera, particularly when linked to a 'safe' (read: 'standardised') flash illumination, has led to a naive, even cynical reliance on the bounties offered by an uncertain law-of-averages. In other words, it has induced many photographers to move from the world of creative *intent* into the often arrogant world of easy *afterthought*.

The universal introduction of colour into portrait photography has proved to be a worldwide popular success and a commercial bonanza, but — in contrast to most other kinds of photography — it has failed to stimulate a new, hoped-for burst of creativity or to enrich portrait photography by fresh ideas and new stylistic modes.

Whilst many photographers developed a truly impressive virtuosity in producing their colour images, most were apparently unaware that colour photography had introduced, almost insidiously, a new superficiality into portraiture which seductively obscured the need for those deeper insights into human nature which the great black-and-white portraitists were able to communicate so successfully.

The simple fact that colour perception — because of our lifelong familiarity with it — has become for most people an unexceptional, even subconsious, experience, explains why the viewer usually believes that he is offered what he 'naturally' expected to see and also why a relatively superficial image-appeal is so easily produced and accepted. A further consequence has been that neither the viewer nor the photographer has felt particularly encouraged to delve further into the depth of discovery and understanding.

One could have expected that, after a short honeymoon period with colour photography, the portraitists would have emerged from the anaesthetics of popular applause to search, once again, for a fresh approach to their work. Particularly, one had hoped that a new generation of photographers would pursue, with some enthusiasm, experiments leading to new ideas for lighting-combinations; these paired with the photographer's mastery of colour content and colour contrasts would have produced a new and wide range of effects, giving the portraitist an added interpretative capability. Alas — none of this has apparently happened.

Now, at the time of writing, still photography is in the midst of yet another unprecedented technological revolution, the exact effects of which are still speculative; their impact on photographic portraiture, on those who practice it and also on those who support it, will remain unfathomable for some time to come.

It would be most interesting to come back in another sixty years to have another look. ■

©Walter Nurnberg 1984.

Short bibliography

1 Gräff, Werner: *Es kommt der Neue Fotograf* Publ: Hermann Reckendorff, Berlin (1929)

2 *The Art of the Great Hollywood Portrait Photographers 1925 to 1940* Publ: Allan Lane (1980)

3 Stieglitz, Alfred: *Alfred Stieglitz — Photographs and Writings* Publ: Callaway Editions, New York (1984) English Distributor: Fountain Press

4 Sander, August: *August Sander, Photographer Extraordinary* Publ: Thames and Hudson, London (1973)

5 Lerski, Helmar: *Köpfe des Alltags* Publ: Hermann Reckendorff, Berlin (1931)

6 Cartier-Bresson, Henri: *Cartier Bresson — Portraits* Publ: Collins, London (1984)

7 Brandt, Bill: *Bill Brandt Portraits* Publ: Gordon Fraser, London (1982)

8 Newman, Arnold: *Artists* Publ: Weidenfels & Nicolson, London (1980); *One Mind's Eyes* Publ: Secker & Warburg, London (1974)

9 Halsman, Philippe: *Sight and Insight* Publ: Doubleday Inc, New York (1972); *Halsman Portraits* Publ: McGraw Hill, New York (1983)

10 Karsh, Yousuf: *In Search of Greatness* Publ: University of Toronto Press & Alfred A. Knopff *Karsh — A Fifty Year Retrospective* Publ: Secker & Warburg, London (1983)

11 *Interviews with Master Photographers,* Interviews by James Danziger and Barnaby Conrad III Publ: Paddington Press, London/New York (1977)

12 *Lighting for Portraiture* by Walter Nurnberg (1st Ed 1948 and 9th Ed (1978) Publ: Focal Press (Butterworth), London

Picturing food so that it appears compellingly appetising is a highly skilled and specialised art. **Tim Imrie** *explores the small intricate world of*

Food Photography

IF THE progress of civilisation can be compressed into the three questions 'How can we eat?', 'What can we eat?' and 'Where shall we have lunch?', the story of food photography could be summarised by art directors asking first 'Who do we know who is able to photograph food?' then 'Which food photographer shall we use?' and finally 'Where shall we go for a radically innovative concept in the presentation of the consumer nutritional intake factor?'

But where the history of civilisation has been long, erratic and generally unsatisfactory, that of food photography has been brief and rather meritorious.

Before the late Fifties, there was almost no food photography in Britain. Today it services a huge market that embraces advertising campaigns, package design, magazine editorial and cookery books, and though it is still a comparatively small world of about twenty photographers all operating in and around London, it has come a long way fast in twenty-five years. Social changes have certainly played their part in creating a consumer market that was more interested in food, especially exotic food, than ever before, while simultaneously two things happened that were of immense consequence for all photography, but which were essential to food photography. One was the development of electronic flash units that did away with the crudities of pop-and-blink flash bulbs, and the problems of melted ice cream and shrivelled meat caused by the heat of tungsten lighting. The other was the arrival of widely available good quality colour printing that could cope with long runs for magazines and forty-eight sheet posters for advertising hoardings.

There was another factor too, often overlooked but equally significant. There were now photographers who regarded still-life as being just as important and interesting as the photography of people, which until then had been the *sine qua non* of the profession. Len Fulford, who now directs television commercials, was at that time one of the first of the new breed of still-life advertising photographers whom art directors turned to when food photography was still a blank page: 'We were very influenced by American photographers, by Irving Penn and Richard Avedon, and in *McCalls* magazine there was marvellous food photography; they always had a centre spread that was very good indeed.'

At the same time as Fulford was setting up, Davis Cecil was starting Strobe Equipment, and, as many other photographers have done since, he used Cecil's technical knowledge to produce the kind of lighting units food photography required, here too inspired by the delicate style of lighting of Irving Penn. Even so, techniques had to be devised from scratch: 'I started by having to shine flash tubes through frosted glass and we had to work out all the exposures mathematically. Flash meters didn't come in until later: photographers today would be astonished at how primitive it all was.'

Yet the results were not only effective then, they have had a lasting influence. One of the biggest campaigns of the time, and one which Len Fulford worked on, was for the Egg Marketing Board, a campaign which kept going for years seemingly, and on which even the current campaign is based, which is perhaps not so surprising since many of the same people are still working on it.

Other major campaigns followed, but the biggest growth in food photography was in magazine and book publishing, and these still provide by far the largest amount of work, with *Good Housekeeping* leading the magazines and Octopus the books. The growth was swift and dramatic. Between 1960 and 1965 *Vogue* moved from black-and-white shots taken by the then-unknown Duffy and printed so small so as to be almost indecipherable, to full page, full-colour photographs of steaming, bubbling, glowing dishes taken straight from the top of the Aga to be placed in front of the lenses of some of the world's leading photographers, Irving Penn and Norman Parkinson among them.

Other women's magazines were also generating work, but the great jump in the market, the real creation of food photography as a world in itself, came in the late Sixties with the arrival of cookery part-works. Roger Phillips had gained his initial experience in food photography as an art director on the egg campaign, but in 1968 he decided to become a photographer himself just when the first part-work, BPC's *Cordon Bleu Cookery* was about to be launched: 'I had been set up for about two days when this chap from BPC rang me up and said "We're doing this part-work, would you like to have a crack at it?" Well, I did two days a fortnight for about two years and that gave me a basis to work on. Part-works created a whole mini-industry and an opportunity for photographers to make a start. Two years ago Marshall Cavendish were putting out something like nine days' work a week which, spread around, meant they were probably using two well-established photographers and two recently established ones, with the chance for three or four new chaps to have a go as well.

Left: Bread by
Norman Parkinson,
1965 (original in
colour). By kind
permission of
Vogue, Condé
Nast.

So it was very good for the industry. It gave people a chance to get enough regular work to run a studio.'

The big part-works, *Cordon Bleu, Super Cook, Good Cookery,* and *Carrier's Kitchen* have created two generations of food photographers and have helped lay down the ground rules for the business side of the editorial work: five shots a day, with step-by-step sequence counting as a single shot, at an agreed rate that all food photographers and editors adhere to. But five shots a day can mean ten to fifteen recipes, so it quickly becomes obvious that a food photographer has to be more than technically competent, he also has to be a good organiser and a good team member, for more than most areas of photography, food photography is a team effort: art editor, home economist and stylist as well as the photographer. And in book production, where fifty to a hundred recipes all have to be linked together by a common theme and style, the ability of this little group to work well together becomes paramount.

Daphne Mattingey was an art editor for Octopus Books for several years, and worked with the very best food photographers, such as Bob Golden, Bryce Atwell, and Christine Hanscomb. She explained the qualities she would look for in a photographer: 'Because of the pace at which you have to work, they must be easy to get on with and enthusiastic to work on the project, because once they are enthusiastic, you get an immediate rapport. They have to be creative, too; they have to

contribute to ideas. There are photographers who are technically brilliant, but who can't put two plates together in an interesting way. It's difficult to pin down, but you can see it in a portfolio. You tend to see the same old thing churned out over and over again and then every so often you see something. It might be only a couple of shots and you think "That's a really good idea. I hadn't thought of it that way before." '

Once the art editor has chosen a photographer for a particular book, the schedule runs something like this: first, the recipes are written and, hopefully but not necessarily, tested in advance to make sure they actually cook as intended. The type is marked up and the pages laid out with holes left for illustrations. Photographer, stylist and art editor then get together to discuss how they are going to fill these holes.

To begin with, what is the theme? Sometimes the style of the cuisine decides that for itself: ethnic cookery usually calls for some degree of ethnic setting. But suppose it were a book of ice-cream recipes: should it have an Italian feeling to it, or a seaside look, or maybe everything should be kept clean and crisp and cool with a minimum of props?

Once that decision has been made, the stylist has something to work on. Twenty-five years ago, stylists simply did not exist, and prop hire companies barely so. It was left to the photographer to cajole department stores or strain friendships to get together the necessary props. Now stylists are well established, much respected and an absolutely vital part of the process. Every photographer has a favourite stylist and will guard her and treat her with the consideration she deserves.

The stylist's budget will be for the entire book, so it is possible, and even preferable, to spend less on the simpler recipes in order to leave enough for really elaborate shots rattling with silver plate and sparkling with crystal decanters. But however the finances are arranged, the right selection of props is essential. As one art director put it: 'If you get bad props, the food will look bad and the shot will look bad.'

No less critical, of course, is the preparation of the food itself — the home economist's responsibility. Again, because of the number of shots that have to be taken, organisation is the key. The day's work can start with the dishes that do not take long to prepare or can be prepared in advance, patés and soups for example, while recipes that need a long cooking time, casseroles and roasts, can be shot later on. If the main dish happens to coincide with lunchtime, so much the better: everyone gets to eat well!

Although the relation between the home economist and the photographer is rarely as close as that between the photographer and the stylist, which at its best can become an almost telepathic coinciding of tastes, mutual trust and respect are still important. The home

21

economist must be able to trust the photographer to organise the schedule so that she can comfortably prepare the food in time, and, a point sometimes overlooked, the photographer must also be trusted to provide her with a good, modern kitchen to prepare it in. For his part, the photographer has to rely on the home economist to get the right ingredients and to choose those that look as if they are in peak condition even though they might actually be out of season, and then to prepare it all immaculately.

And this is a good point at which to dispel one great myth about food photography: there is virtually no faking. The laws relating to advertising are strict and no agency is going to risk the consequences of breaking the Trade Descriptions Act by a fraudulent presentaton of their client's product. And since in editorial work, the prime purpose of the shot is to show the reader what the recipe is supposed to look like, faking it would be self-defeating.

That is not to say that there are not special techniques, though most of these are concerned with enhancing the qualities of the food rather than disguising its deficiencies, and giving it that magic quality that is at the heart of all food photography: appetite appeal, lighting for texture, adding judicious touches of oil or glycerine to catch the highlights and retain the appearance of freshness, cooking meat a little rarer than would suit most palates, getting a controlled touch of melt on an ice-cream to soften off an unappetisingly spikey coldness, baking cakes with a little extra flour and egg white so that they cut cleanly and do not leave a messy splattering of crumbs across the set, these are a few of the techniques that combine the skills of both photographer and home economist in getting the food to look exactly right.

Opposite page top and bottom: Bryce Attwell.

In advertising work, the pace may be less gruelling, but the need for perfection is more so. One shot a day is good going, but that shot has to be absolutely flawless, every nuance right, every detail unimpeachable. Many photographers feel this restricts their creativity, others find this same precision a spur to creativity. Bryce Attwell has done both advertising and editorial work, and he has no doubt about which he finds more creatively rewarding: 'Advertising is always a bit behind as far as style is concerned. You get such a structure there that it is almost inevitable that it is going to follow a set pattern, that it's not going to be adventurous. Most food advertising is convenience food and they think their market is C2 and they think that C2s don't aspire to anything, so with that sort of attitude, you're not going to get anything much happening.'

Bob Golden, who has given up virtually all editorial work in favour of advertising, takes a different view and when he talks of the exhaustive attention to detail in an advertising shot, it is with joy, not exasperation: 'Every square inch of the picture is as important as every other square inch, and so whatever is brought forth to be photographed has to be wonderful, a wonderful manifestation, a wonderful example of what it is supposed to be.'

Len Fulford's view of advertising photography is also encouraging: 'There has been a period in which the quality of photography has been very high but it's been slightly boring, but suddenly one sees beautiful quality photographs around — and interesting photographs, too.'

And, in truth, advertising agencies are coming up with more inventive campaigns. The one for Tesco is a recent example that used a number of different photographers to lift the store's image from that of a place where bored housewives cram wire baskets with pre-packaged stodge to being a haven for a discerning gourmet. Photographically, the campaign was a big step up from the indiscriminate heaping up of goods on a scoop of Perspex that supermarkets have gone in for in the past. Agencies and their clients are becoming more aware of people's changing attitudes to food and are increasingly prepared to trust in a photographer with a style and ideas of his own; when Bob Golden was approached by agencies for new campaigns for Heinz and for McVities, it was precisely because of his individuality and his intensely-held beliefs about photography. And Bryce Attwell's own recent work for Young's Frozen Foods has shown how far the photography of convenience foods has improved on the good old giant close-up of half a fish finger.

Taking different views over the merits of advertising and editorial work is perhaps also a way of disarming the sense of rivalry that inevitably crops up from time to time within such a small specialised world. All food photographers know the work of practically all other food photographers; many know each other personally, and some are close friends. But although the market is big, the number of buyers is small, and friends and acquaintances not infrequently find themselves competing against each other for the same job. A photographer necessarily spends his time looking back over his shoulder and forward over someone else's, which can lead to mediocre, copycat work. On the positive side, though, the more creative photographers are constantly obliged to push the field forward stylistically, which is tough on them, but good for photography.

It also means that art editors, and to a lesser extent art directors, are always on the look-out for new talent. Christine Hanscomb is now well-known for her food photography, but her first venture into the field came only a few years ago when an art editor from Marshall Cavendish asked her to do a book on Italian cookery, specifically because she was not a food photographer and her approach was bound to be different. That particular art editor was taking a bigger chance than most would care to, but although most of the time art editors do like the reassurance of seeing the shot they have in mind already in the photographer's portfolio, they are aware of potential, too.

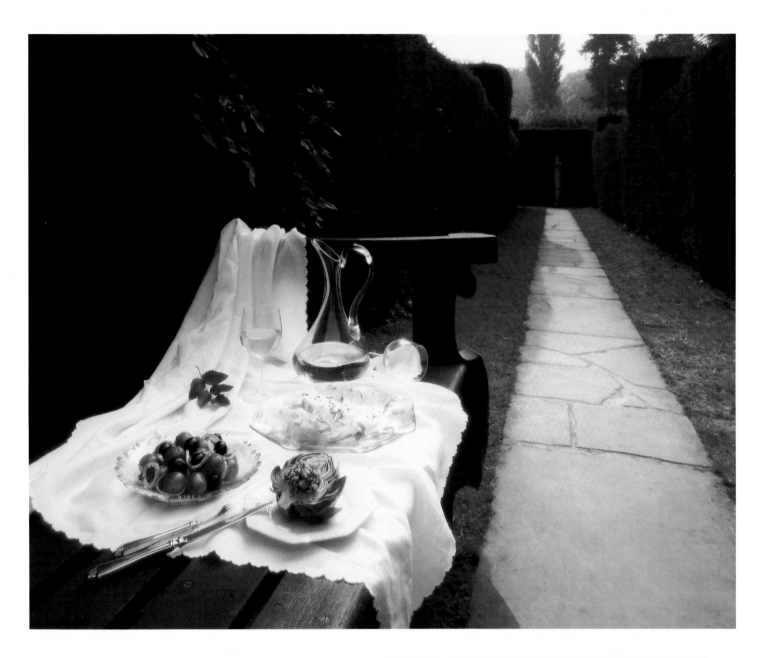

At about the same time as the Marshall Cavendish book came up, Daphne Mattingey also saw Christine Hanscomb's portfolio: 'When I first met her she was very new. She'd done a lot of still-life and she had a wonderful sense of composition, wonderful lighting, and I just knew she could do cooked food shots.' And she too immediately gave her a book to do.

Perhaps because much of her early work was photographing interiors, one of Christine Hanscomb's fortes is location work. This is an area most food photographers prefer to avoid, partly because of a fear of the unknown, that is to say the weather, and partly because it tends to be too expensive for the closely

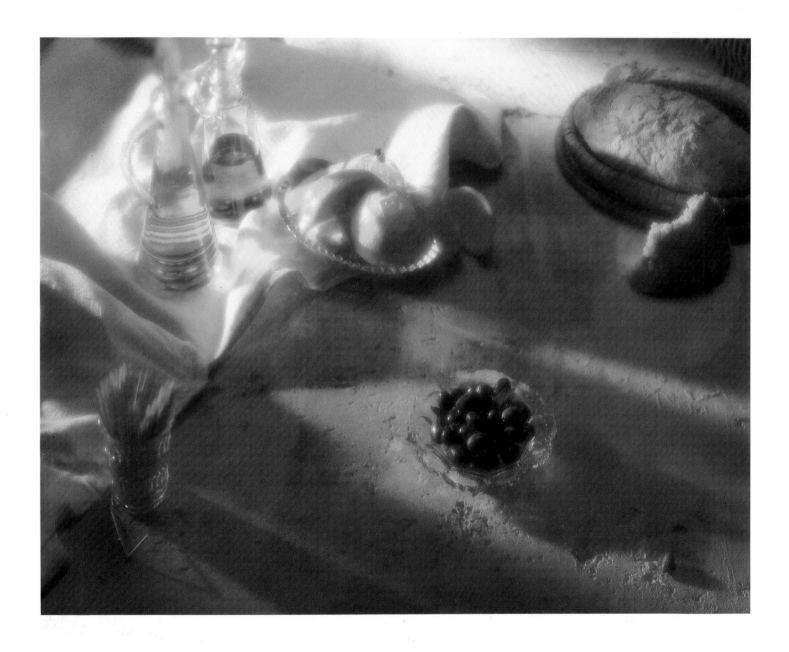

Above: Robert Golden.

regulated budgets of magazine and book publishing. In advertising, money is a secondary consideration, but the shot has often been so precisely pre-conceived that a location that is right in every detail does not exist and there is no alternative but to build a set.

There are occasions, though, when the food and the location are inextricably linked, such as in Robert Freson's highly praised series for the *Sunday Times* on French country cooking where the recipes were specific to individual restaurants. Although practically devoid of props, Freson's sense of lighting and composition kept the food looking delicious, the atmosphere inviting. Another memorable piece of location work was by

Anthony Blake, one of the grand masters of food photography, who did a series on the Great Chefs of France which made full use of their restaurants as a setting for their culinary specialities and which combined a documentary feel for the quality of light and the ambience of each location with the attention to detail of a studio set.

What might be described as the ultimate on food photography, however, is *Wild Food* by Roger Phillips, which won the 1984 André Simon Award for original work in cookery. Shot entirely on location on 35mm and using only natural light, it is the result of two years' work, researching the recipes and writing the text, then

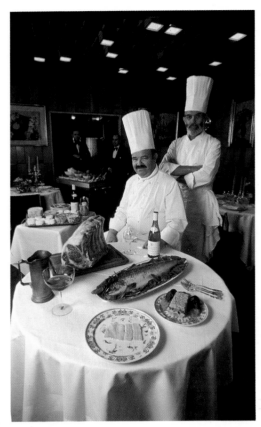

Top left: Robert Golden.

Bottom left: Len Fulford.

Top right: Anthony Blake.

Bottom right: Christine Hanscomb.

Add an egg
– add goodness

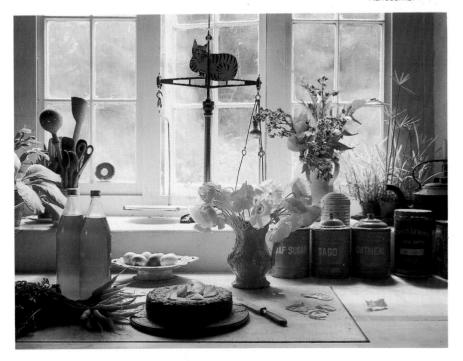

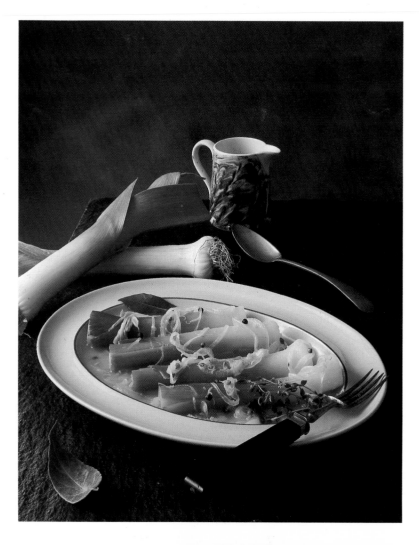

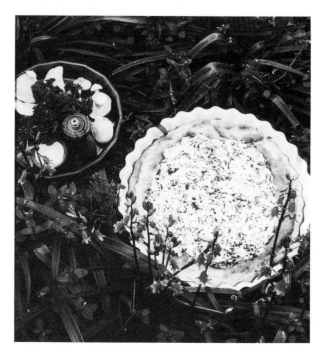

travelling all over Britain and Ireland to find sites where the ingredients do still grow wild, cooking and photographing them on the spot, and finally editing and laying-out the whole book.

Above: Christine Hanscomb.

Below: Martin Brigdale.

Top right: Roger Phillips (original in colour).

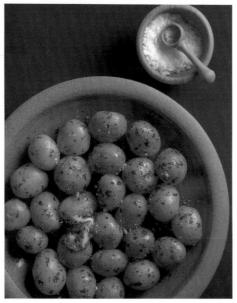

For a photographer to produce his own books like this as a business, as opposed to a one-off piece of fun, is a relatively untried area. It requires a good initial idea, a lot of work, and a very long-term view of profits, for it is only after the book has been selling well for two or three years that the photographer can expect to break even, let alone make money.

However, it does side-step one facet of publishing that rankles with food photographers, that of copyright. Cookery books account for about 750 new titles every year, only 1.5% of the total, but a far bigger percentage than that in sales. Cookery books are acknowledged to be good business for publishers and since they own the copyright on everything a photographer shoots for them, they can, and do, piece together new books from a mosaic of old transparencies, for which they can expect a nice profit and the photographers can expect exactly nothing.

On the other hand, a photographer who is interested in only money is better off doing something else anyway. Food photography does provide a reasonable living, but it is also deeply demanding. Although there is still plenty of work about, the best of it will only go to those who truly care about food, who have the patience and sensitivity to turn it into a thing of beauty and not just body-fuel — who can, in Bob Golden's words, 'reveal the very essence of what something is, as opposed to simply rendering it in straightforward photographic terms.'∎

There are now cameras that talk — and cameras that answer back. **L. Andrew Mannheim** *assesses how far modern electronic systems have taken us towards*

The Intelligent Camera

'THE CAMERA that thinks for you' was a popular slogan in the 1960's when camera designers took first uncertain steps to — then mechanical — automation. Flooded with superlatives and hyperbole, consumers soon became suspicious of anthropomorphic attributions to any kind of machinery. Today's much more sophisticated intelligent computers, video recorders — and even photo equipment — thus tend to have a lower profile than the technological miracles of 20 years ago.

Before the 'intelligent' tag follows the 'thinking' one into oblivion, a brief definition. Leaving aside the philosophy of intelligence, the fine distinction that is beginning to emerge between 'automatic' and 'intelligent' apparatus is that the former reacts to inputs purely quantitatively while the latter in some more or less primitive manner analyses inputs and responds qualitatively. In concrete terms, an automatic flash control can switch off the output of a flash when a sensor cell has registered a given amount of reflected light; an intelligent system might check ambient lighting levels and yield more flash exposure at low levels (flash alone) than at high ones (fill-in flash only). Obviously the two differ only in degree, the intelligent control operating on a slightly higher level. The difference is nevertheless significant as a first step towards machine intelligence. While waiting for the latter to materialise in an intelligible way, we are beginning to see its elements here and there, singly and in combination, even if not yet very coherently.

To get an overview we can try to classify these elements — perhaps a little arbitrarily, as some of them overlap:

a Information inputs
b Control modes
c Communication
d Data analysis and processing

e Interaction — where at the latest we may have to ask how far an intelligent machine depends on an intelligent user

In cameras (and also other photo equipment) all these have grown enormously in recent years. They have also tended to develop to some extent independently of each other — which may make us wonder at the comparative lack of co-ordinating vision but at least allows us to examine the trends on their own.

Inputs: multilevel information

The first step towards automation in cameras involved exposure measurement. Hence the first input was a light intensity or luminance registered by a light-sensitive cell. In the majority of even the most automatic cameras we still have a single luminance value input although the sampling pattern — what precisely the cell measures — may vary. The cell (or perhaps a pair of linked cells) may thus measure the whole of the image on the screen of an SLR camera, with or without concentrating preferentially on a selected portion of it (centre-weighting). In a few cases the cell may read a small part only of the subject; in others again (since the Leica R3) the user may choose either full-frame or spot measurement.

All this is really old hat, for the differences have nothing to do with any kind of intelligence of the instrument but only with selection by the designer and/or user. Such an input offers little scope of being analysed. You get a signal and you can only do one thing at a time with it. You can get multiple input levels by switching meter response levels, measurement locations or angles — but the camera is neither intelligent enough nor automatic enough to do it for the user. The one exception so far is the multipoint light measurement of the Nikon FA; we shall come back to that in looking at signal analysis.

A higher — and more intelligent — level of input is that involved in electronic sharpness measurement, especially where it involves the analysis and comparison of lateral brightness distributions in different parts of an image. We shall return to that, too, but should note at this point that in most cases distance measurement (usually by active infrared or sonar systems) is a simpler signal processing procedure.

Analog and digital input

Two other significant inputs are lens aperture in cameras with interchangeable lenses and film speed, film length and film type. At this point also the approach to input shifts from analog to digital.

Film speed is of course an essential parameter of exposure control and has in the past been a manual setting made by the camera user. The recent introduction of DX coding has made this more foolproof. Once the principle is fully established you can no longer forget

to set film speeds and you are no longer likely to leave a camera set to ISO64 after switching to a high-speed film of ISO400. What made automatic film speed sensing on cartridges possible however was the progressive shift of exposure control systems in cameras from analog to digital information processing. Formerly, adjustment of the film speed setting changed a resistance value in the meter circuit (the higher the speed, the lower the resistance — an analog principle). Different speed settings on more recent cameras involve alternative connections between a selection of half a dozen or so conductors. The setting opens or closes five or so switches in different combinations — a typically digital input equivalent to a modified binary logic system (grey code). At this point the switches can be closed by contacts outside the camera, such as conducting patches on the film cartridge — which is of course what happens with DX coding.

While all the world's major film manufacturers have now announced that they would follow Kodak's lead in DX coding their 35mm film cartridges, at the time of writing only one camera with the complementary sensing equipment had reached the market. Others will no doubt follow soon. None has yet made use of the further possibilities of DX coding, namely input into the camera of film length (number of exposures) and of the film's exposure range or latitude — encoded in a similar way in the conductive patches on the cartridge.

Digital input is also appearing on certain interchangeable lens systems to feed aperture information into the camera. This is needed for certain kinds of aperture signalling in the camera finder, also for program and shutter speed priority automation modes. The input

for this can be analog and on many cameras is still a mechanical linkage that adjusts a mechanical or electric input value on the camera itself. The more elegant way is electric input via contacts between the camera and lens. The electric linkage is not new — Pentacon after all has used it for many years in place of an aperture simulator on Praktica cameras. The 10 or so contacts to control lens apertures and shutter speeds on the Rollei SLX have been known for over 10 years while similar systems have recently proliferated in other rollfilm reflexes. Comparatively new is however the grey code input of maximum aperture from the current Pentax lenses to the Pentax Super A and Program A cameras, as the KA mount short-circuits (or fails to short-circuit) contacts on the camera mount according to whether corresponding locations on the rear of the lens are conducting or not. And if five sensing contacts on the DX code can by their permutations convey some two dozen alternative film speed values, the scope of the KA lens mount system has obviously more than enough reserve capacity.

This issue of lens information input illustrates also the sometimes conflicting requirements of marketing and engineering. The KA system requires a series of camera contacts on the lens mount and the familiar insulating spots on the lens. As a digital input it is comparatively insensitive to 'noise' (in this context slight variation in contact quality through dirt etc). It thus provides highly precise input values for what Asahi engineers insisted were high precision requirements of the camera's aperture control system. The KA mount, a derivative of the fairly widespread K mount, is however subject to patent licensing, which has caused some friction on the

The computer camera's electronic logic (Canon T70).

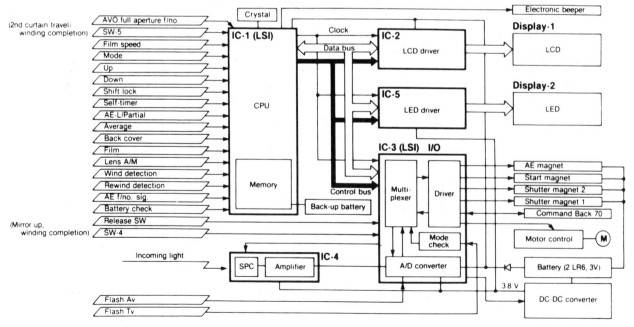

market with independent lens manufacturers. The situation is not made easier by the appearance of yet another K mount derivative: the Ricoh's RK with a single contact and a resistor built into the lens to form an aperture input value. As the resistor may range between 5 and $100K\Omega$ in value, it is of course an analog input. If the contact between camera and lens is less than perfect, the modified resistance value sensed by the camera may (at least in theory) introduce errors. The marketing difficulty is that this development runs counter to any desired standardisation of information transfer between cameras and lenses.

Nor is the situation likely to improve — feeding in information of focal lengths, vignetting allowance, power and sharp/unsharp signals for automatic focusing will further complicate matters. (And digital information transfer needs rather more contacts than analog.)

Going to town with control modes

Camera designers and marketing managers appear to be agreed, however, that enormous mileage can be got out of emphasising a growing number of ways in which a camera can operate automatically. The multi-mode camera that six years ago tried to resolve the controversy over relative merits of aperture-preferred or shutter speed-preferred exposure automation by offering both, is now obsolete if it has not at least three program configurations. Disregarding for the moment the publicity pride in six, twelve or more programs (lumped together indiscriminately with operating modes to boost up the total), multiple programs are a sensible answer to the restrictive nature of programmed exposure automation. This goes back to exposure-automated cameras around 25 years ago that in response to the subject luminance adjusted both aperture and

The microcomputer — essential element of growing camera intelligence.

shutter speed but left the user stuck with just one combination of the two at each level. A compromise combination of for instance 1/60sec at f/5.6 for EV11 is too slow for action (where 1/500sec at f/2 might be preferable), while extreme depth of field could call for 1/15sec at f/11.

To counter camera shake problems, some designers weighted programs in favour of faster shutter speeds. In 1983 the first multi-program camera appeared that gave users a distinct choice of alternative program combinations (Chinon CP-5) while the Ricoh XR-P was the first (by a very short head) to offer three separate auto programs — two weighted ones in addition to the classical compromise sequence. On this camera the programs are selected by a three-position lever that controls the path along which the program branches between 1/8sec at f/1.4 and 1/2000sec at f/22 — EV4 and EV20 respectively. (Below EV4 all programs can only lengthen the exposure time at the maximum aperture; above EV20 they can only reduce the aperture if the lens stops down beyond f/22.)

With the normal compromise programs shutter speeds get shorter and apertures smaller in equal increments so that for instance EV11 the program combination is around 1/90sec at f/4.8 (the time-and-aperture adjustment is continuous). The other two alternatives are a depth-weighted program that stops down the lens much faster and shortens the exposure times more slowly, reaching f/22 already at 1/125sec. At EV11 the combination is about 1/40sec and f/7.5 — good for increased depth of field.

The third program is speed-weighted and — with increasing lighting levels — remains at maximum aperture until the speed reaches 1/125sec; then the lens begins to stop down. At EV11 the combination is here 1/250sec at f/2.8 — about right for making (nearly) the most of action-stopping scope.

Program selection

In the Ricoh XR-P selection of the three principal programs is left to the user, aided by an explanation of the alternatives in the instruction book (and in some markets additionally supported by a recorded cassette). For the T70, Canon assumed that alternative programs are primarily desirable to avoid camera shake with longer-focus lenses. So there the alternative programs are labelled 'wide' and 'tele'. The standard program again increases evenly from 1/8sec at f/1.4 to 1/1000 at f/16; the 'wide' program goes in parallel from 1/2sec at f/1.4 to 1/250 at f/16 (slower shutter speeds throughout) while the 'tele' program stays at f/1.4 until around 1/200sec and then rapidly stops down the lens.

A step up in camera intelligence would be to let the lens select the program by a focal length input. The Nikon FA has a program switch actuated by a cam on current longer-focus lenses (above 135mm) to switch automatically to a program with faster shutter speeds at each exposure level. Mamiya developed something similar for its (now probably discontinued) ZE-X with a selective crossover system that in shutter speed priority mode tries to maintain a certain minimum speed (as long as light conditions allow) to avoid camera shake. This minimum is controlled by electrical values fed through camera contacts and keeps to a slowest shutter speed of 1/30sec with lenses up to 60mm in focal length, 1/60sec with lenses from 61mm to 140mm, 1/200sec for lenses from 141 to 300mm and 1/500sec for still longer focal lengths.

Program precision

Programmed automation also enters into overriding the restricted exposure range of shutter speed priority automation. The familiar problem is that though the camera's meter system may be able to cope with a range of some 18 or more EV steps, the adjustment range of

DX coding on 35mm film cartridges. In the right-hand sketch, the lower row of segments 2 to 6 (segment 1 is always conducting) encodes film speeds from ISO25 to 5000. As shown here, with segments 3 and 5 also conducting, the code is for ISO100. Segments 8 to 12 (again 7 is always blank) cover film length and exposure range.

MACHINE READABLE BAR CODE

CAMERA AUTO SENSING CODE

LATENT IMAGE BAR CODE

RASTER PATTERN

the lens aperture rarely exceeds 7 EV steps. The solution — already employed six years ago — is to make the camera switch at either end of the aperture range to aperture-preferred automation and to override the user-selected shutter speed to a faster setting if the smallest aperture is reached, or to a slower setting at the largest aperture. This is the process that publicity copywriters early on called cybernation; the name has stuck as a semi-technical shorthand for this override function.

The way it is done has shifted however from so called stop-down remetering to true program control. Stop-down remetering meant that in shutter speed priority mode the meter system read the image brightness through the lens while the lens aperture was closing down (as the first step of the exposure cycle). It then switched to control of the electronic shutter speed when the system detected underexposure at the largest (or overexposure at the smallest) aperture. The drawback is that such a system suffers from mechanical tolerances. Due partly to imprecision in the lens aperture mechanism and partly to variations between lenses, these cause a remetering correction even within the normal aperture control range of the lens. So while the camera will still set a correct exposure, it may not stick to the shutter speed selected by the user in shutter priority mode — and/or may not indicate the same exposure setting or combination that the camera is using.

To cope with this, camera makers looked to ways of making auto aperture control more precise. This covered three aspects: *1* linearised iris control, *2* digital (or pseudo-digital) stop-down mechanisms and *3* uniform inertia and other movement parameters.

The linear iris control meant that the stop-down coupling link in the lens had to move through equal distances for each f-stop by which the iris was stopped down. This is not to be confused with the lens aperture ring used to couple with the camera's aperture simulator — this has for a long time been linear in its movement on nearly all lenses. The stop-down coupling movement however tends to cover large intervals per f-stop at large apertures and smaller ones at small apertures. The latter settings thus become increasingly inaccurate. At small apertures this could cause the camera remetering sequence to select — even in shutter priority mode — a considerably slower shutter speed than the photographer intended.

Both Nikon and Asahi in recent years switched from non-linear to linear control which raised problems of compatibility. For in a camera such as the Nikon FA a lens with non-linear mechanism would yield different exposure combinations in some of the auto or program modes, from a lens with linear mechanism. Nikon solved that by installing a signal pin in the camera mount and machining a correspondingly located pit into the rear of the lens mount for linearised lenses. When mounted on the camera such lenses would not affect the signal pin. Older lenses without pit would depress the pin and so switch over the camera's meter system to an alternative program allowing for the different iris stop-down characteristic.

Asahi went futher in devising a high-precision control of the stop-down linkage from the camera to the lens. In the Super A this is controlled by an opto-mechanical pulse generator involving a star wheel and something resembling a mechanical watch escapement. The star wheel interrupts the light path between an LED and a photocell, generating current pulses that are counted as the lens iris closes down at the beginning of the exposure cycle. The stop-down movement is arrested when the number of pulses matches a previously stored value

First digital lens aperture input with contacts on camera mount. Non-conducting plastic patches in rear of Pentax KA mount lens encode maximum aperture by a grey code. The Pentax 645 embodies many of the 35mm 'A' series electronic features.

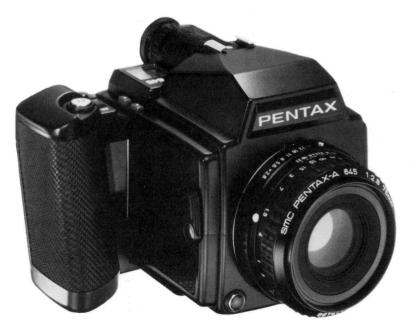

equivalent to a digitally encoded exposure reading (allowing also for preselected shutter speed, film speed etc). The logical extension of this would be an aperture adjustment drive built into the lens and controlled by a similar digital pulse count. The nearest to that achieved so far is the (misnamed) linear motor aperture adjustment of the Rolleiflex 6006 and SLX. There however this control is still analog and not digital.

In the Pentax Super A the star wheel generates some eight pulses for each f-stop interval and the aperture setting should thus in theory be precise to 0.125 f-stop. The practical accuracy depends on the mechanical tolerances in the lens system — the exact spring tension applied to the stop down system, the delay between the instant when the correct pulse count is registered and the iris movement actually stops etc. If these factors vary too much from lens to lens (or in one lens on different occasions) the accuracy of the aperture setting obviously suffers. Asahi claims that it can keep the practical tolerance down to around 0.2 to 0.25 f-stop but only if Asahi has full control over the manufacture and mechanical testing of the lenses. (Asahi quoted this as an argument against licensing the KA mount to independent lens manufacturers — this is valid in engineering terms but proved untenable for marketing.) Ricoh has claimed fairly similar tolerance levels for its version of a precision aperture stop-down mechanism in the XR-P and Ricoh RK-mount lenses.

Supplementary modes

The interaction of cybernation with alternative program modes on the one hand and with ways of flash exposure metering on the other can give rise to numerous further operating modes. Thus Ricoh has in its XR-P a series of so-called shutter-assisted programs that elaborate on the more classical shutter-priority auto mode by making the override response depend on the setting of the camera's program selector. And with flash — nowadays with automatic duration control via a photodiode measuring the light reflected from the film — several cameras (including again Ricoh) also offer more sophisticated control features. Some have the 'intelligent' approach (as defined before) of being able to decide whether for a given shot the flash is to be treated as the sole light source or as fill-in illumination with prevailing ambient light. (The decision is based on measurement of the ambient lighting level: when this is above a certain value the flash exposure is reduced to let the ambient light predominate.) In other programmed flash modes the flash also sets the camera's lens

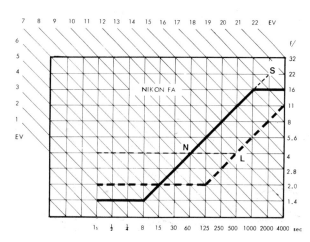

Of the three programs of the Ricoh XR-P, the P program is the conventional compromise, incrementing aperture and shutter speed evenly from 1/8sec at f/1.4 to 1/2000 at f/22. The PD program is depth-weighted (smaller apertures with longer times) and the PA program speed-weighted for action shots (reaching faster shutter speeds sooner).

The normal program (N) of the Canon T70 is virtually the same as P on the XR-P. But here the Wide (W) program is merely shifted by two steps towards slower speeds; the tele (T) alternative is however even more heavily speed-weighted.

The lens-actuated program switching on the Nikon FA shifts an even-increment program (bold) bodily towards faster speeds (broken line) with long-focus lenses. At smaller maximum apertures this program also keeps the lens at maximum aperture longer — which is advantageous for the longer tele lenses which are slower, anyway. Thus an f/4 lens stays at maximum aperture until 1/500sec (point L).

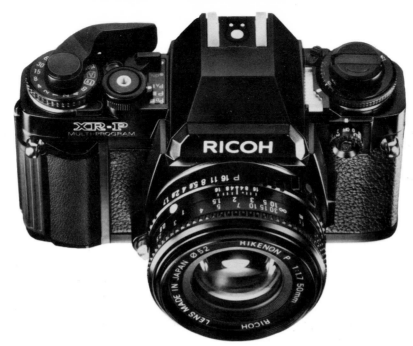

aperture — either according to the power level selected on the flash (Pentax Super A) or by firing an infrared preflash to measure the subject distance for a most suitable range (Canon T70). The flash duration is then finally controlled by the sensor cell on the flash itself. These modes of course presuppose a suitable dedicated flash which also sets the camera's shutter to the appropriate synchronising speed.

More modes — or at least control functions — can sometimes be produced by motor drives and special camera backs. Electric contacts between motor and camera by now smoothly intercouple motor and shutter operations without mismatching faults of earlier times. So designers can concentrate on additional functions such as selecting the length of exposure sequences and of intervals between shots in a sequence. Originally such functions were available through separate control units such as Olympus M.AC control box or the Leica RC remote control unit for the winder and motor drive of the Leica R3 and later R4. Now these functions are increasingly incorporated in the motor drive itself (Chinon, Olympus Motor Drive 2 and others).

Many of these functions depend on triggering pulses being delivered at suitable timed intervals, with a quartz timing circuit and a microprocessor to allow it to operate

in alternative modes. All that nowadays needs to take up no more space than a data back (which already contains the timing system). This is leading to the emergence of control backs such as the Multifunction back for the Minolta X700 (and later models) and the Command Back 70 for the Canon T70. Apart from imprinting time, calendar and numerical data in half a dozen variations, these control backs can be set to:

a Make exposures at specified intervals up to some 24 hours (Canon) or 100 hours (Minolta);
b Make long time exposures (provided the camera battery holds out) at the shutter's B setting up to the same length;
c Preselect the number of exposures to be taken in sequence up to 99 (Canon) or up to 999 999 (Minolta);
d Act as an extra long selftimer with up to 24 hours delay (Canon).

(On the Ricoh XR-P the selftimer of the camera provides additional interval control functions, too.)

Crystals for communications

Not only the data input into the camera has become more complex but also the information output to tell the photographer what is going on. Four years ago liquid

Left: The Ricoh XR-P claims a total of some 16 modes and programs; several of these are controlled by the program selector lever with its PD, P and PA position.

Far left: Mode selector of the Nikon FA.

crystal displays were beginning to challenge light-emitting diodes for user signals in the camera finder (where LEDs had earlier displaced meter needles). During the past year or so camera engineers have begun to discover the scope of the LCD — and its considerably higher information capacity at an incomparably lower power penalty (and hence less battery drain than with LED systems). The major merit of LCD systems is however their ability to combine a wide range of digital figures (and letters) built up from conventional 7-bar blocks with ordinary bits of lettering, numerous symbols etc. The lower power consumption of an LCD also meant that the drive circuits could handle more information at once. For the key to the versatility of an LCD is the number of elements that can be controlled (in effect switched on or off to make them visible or not). Thus one of the first LCD displays of shutter speed — in the Nikon F3 — used 20-odd separately controlled elements to convey its information. The most complex camera LCD so far — the bar graph, shutter speed scale, reading points and other signals of the Olympus OM-4 — runs to well over 90.

The number of switchable LCD elements is not necessarily the ultimate criterion of complexity. One reason why the OM-4 LCD has so many elements is its insistence on an analog-style display where each piece of information is located in a different spot and so needs a separate element. The LCD systems of the Canon T70 and the Pentax 645 have around 50 switchable elements yet provide more information on exposure mode, film speed setting, shutter speed and/or aperture, frame counter, progress of film transport, long-exposure

countdown, exposure override or compensation etc.

This information inflation also obliged camera designers to rethink other aspects of presentation. Cameras that tried to cope with such a multiplicity of signals in the traditional way inside the SLR viewfinder created a confusing clutter resemblng the neon light publicity of a city centre. The solution was to move the whole bag of tricks into a separate information window — an LCD panel on the camera top. Not necessarily by accident, that became reminiscent of the video screen of a home computer. (The fact that LCD alphanumeric characters and pictorial symbols had become familiar to millions of digital watch and pocket calculator owners also helped.)

Another aspect reminiscent of personal computer operation is the appearance of keyboard control. Some years ago the Pentax ME Super introduced the idea of push buttons that you pressed to run shutter speed settings up and down — a technique widely used in adjusting and function selection of digital watches. The latest cameras to follow this up are again the Canon T70 and the Pentax 645 where push buttons (controlling microswitches) select the function to be changed while other switching buttons control the cycle of settings available for each function. For instance on pressing a film speed button, the LCD panel displays an ISO speed. Pushing the 'up' to 'down' buttons then runs the speed up or down within the available range (for instance from ISO12 to ISO1600). Or, on pressing the mode button, the selector button then runs through the cycle of aperture-priority AE, shutter-priority AE, programmed automatic mode, metered manual mode etc, displaying

The Olympus OM-4 carries a set of push buttons next to the pentaprism for selecting spot, highlight and shadow measurement and for setting and cancelling the eight-reading memory.

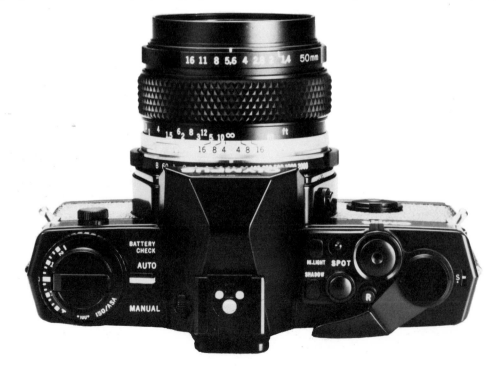

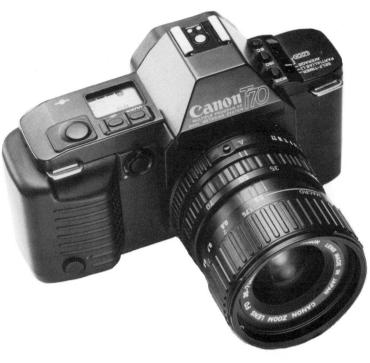

the appropriate mode signals (and preselected exposure settings where appropriate) in the LCD panel.

This keyboard operation has merits and drawbacks. Against it is a certain lack of user friendliness: instead of having a separate control for say shutter speed, film speed, exposure compensation etc adjustments, the photographer has to learn and memorise alternative sequences for operating the same set of buttons for different settings. A further nuisance is the delay in microprocessor-controlled adjustment: instead of turning a shutter dial from say 1sec to 1/1000sec you have to press at least two buttons together and wait while the camera control on its own runs through the adjustment range. True, this is a matter of habit — once the owner of such a camera has got used to this procedure he will be as happy with it as a car driver accustomed to an automatic gear box.

Splitting the information

A camera signalling system akin to a video display unit on

the top of the body lacks one facility of less sophisticated cameras: the instant check of exposure settings while viewing the scene through the finder. Cameras with elaborate LCD panels thus had to provide additional displays — usually by digital LED — in the finder itself. In the Pentax 645 a simple LED shows both aperture and shutter speed plus ready flash and exposure factor warnings. In the T70 the finder LED signals aperture in auto mode (shutter speed in certain cases) and certain other multicolour mode signals. (The essential exposure information remains split between the finder and the LCD panels). The Pentax Super A (which started split LCD information in the finder and the camera top) shows aperture, speed and mode in the finder and shutter speed on top. No doubt other cameras in the offing with multiple displays will come up with suitable further combinations and permutations — the possibilities are confusingly extensive.

The other way of splitting information is to present it to the ear as well as the eye. Thus beeps and other signals can warn of under- or over-exposure limits, flash readiness, confirm correct flash exposure, double up as battery check, selftimer and other rundown timing signals. The logical, though not necessarily sensible, development of this is the speaking camera with a built-in voice synthesiser to generate reminder messages ('switch to flash' etc).

The speaking camera can probably be regarded as a passing gimmick; hearing warnings or messages is not the most efficient way of communication. Speech is a sequential process where the complete message is built up in the hearer's memory where it immediately starts to fade, whereas the visible signal remains fully in view as long as it is being presented. Hence a spoken message is more easily missed, quite apart from problems with the user's language. (Minolta's talking AF-SV camera was marketed in three alternative language verions to cope with potential Japanese, English, German and French owners. Fuji had no such problems with its Japanese-only talking instant-picture camera, as Fuji is not marketing instant-picture systems outside Japan).

Information and control functions are not confined to camera bodies. Minolta's Multifunction back for current X series models incorporates additional timing functions for long exposures, long sequence intervals and preselected motor sequences.

Acoustic signals are helpful in extending information receptivity when they provide confirmation of expected situations. Thus a flash ready or auto check beep is less confusing than a steady or flashing LED among a variety of other visual signals. Warning beeps for wrong camera settings are more likely to worry the user who has to remember what the signal indicates; a beep is not as self-explanatory as 'over' or an arrowhead LED in the finder.

If this description of information presentation seems unorganised, so is conveying of information in general. The latest generation of cameras bristles with signals, lights and data displays, much as many cameras 50 years ago bristled with not very systematically arranged controls and gadgets. The latter now tend to be organised by ergonomic principles. There is as yet a conspicuous lack of what might be called mental ergonomy in information handling. (Perhaps not entirely surprising, as computer programmers have similar problems.)

Advances in analysis

Analysing ability was an attribute that we associated with emerging machine intelligence. This is beginning to appear in several forms. Two that have grown significantly beyond plain two-way options are multipoint exposure sampling and automatic sharpness measurement.

The unique example (so far) of the first kind is the automatic multi-point (AMP) metering system of the Nikon FA. Here a set of photocell sensors and associated optics separately register the luminance of the centre and of four outside quadrants of the finder image. (There is a limited amount of overlap and some special weighting among the readings.) A microprocessor with hard-wired program then evaluates these five-channel readings, establishing maximum and minimum luminances, brightness range (contrast),

difference between the centre and other areas and so on. From these the program derives a number of exposure values based on a centre reading, highlight reading, shadow reading and midtone reading. At the same time the program evaluates the scene as a whole (based on the five-channel outputs) according to general luminance level, brightness range and a few other special conditions of an 'if . . . then, . . . ' kind. From this evaluation, covering altogether about 20 alternative subject conditions, the camera selects one of the four exposure values previously established (centre, highlight, shadow or midtone) as the eventual exposure.

The purpose of this elaborate evaluation is to increase the reliability of automatic exposure measurement and to compensate for the majority of subject conditions that lead to wrong exposures with straightforward light readings.

While in terms of decision level as defined before this could count as an intelligent camera function, the intelligence is strictly that of the program engineers. Prior to designing the system these programmers analysed subjects and the kind of exposure readings they would yield. The analysis involved establishing how many shots were correctly exposed, what wrong exposures were due to (subject failure etc), what correction such faults needed and how subject conditions could be defined in photometric terms — which after all is the only thing the camera's photocell could measure. In fact, the decisions are all built into the system and may not be the exposure decision a photographer might want to make every time. For example AMP metering of a sunset scene would expose for some foreground and

The bar graph display (below the viewfinder area) of the Olympus OM-4 employs over 90 separately controlled liquid crystal elements for an elaborate simulated analog information readout. Right: in addition to shutter speed values and the bar graph elements themselves, this includes spot reading markers (top), signals for shadow (upper centre) and highlight readings, memory mode (centre), exposure compensation (lower centre), manual zero matching (bottom) and overexposure, underexposure, flash, etc symbols.

shadow detail and overexpose the sunset itself, even if you might prefer to render the glowing ball of the sun against a completely silhouetted foreground. (With the Nikon FA this can be overriden only by switching to a semiautomatic or manual mode.)

Sharpness metering in SLR cameras — for electronically assisted or automatic focusing — also makes use of multilevel analysis. The two main methods both sample the image in two (or three) planes and compare contrast or alternatively brightness distribution in the image in front of and behind the sharpest plane.

Where contrast is the criterion, this is highest when the image is sharpest. Thus a contrast comparison in several planes shows in which plane the image is sharpest and hence in which direction focus might be adjusted to obtain optimum sharpness in the film plane (or in practice in an equivalent image plane). Brightness distribution analysis on the other hand can compare image locations in different planes and so check whether two part images (like rangefinder image sections) are accurately superimposed or not.

The precise methods of sharpness measurement (and their practical limitations) have been described at length; relevant to the question of camera intelligence is the fact that the measuring system utilises a large number of separate sensor readings, compares them and evaluates the result — a distinct intelligence generation beyond a simple response to a single photocell output. (It is also part of this second generation evaluation to check whether contrast or brightness distribution differs sufficiently in the various planes to give a reliable maximum sharpness signal.)

Modes in moderation

Possibly the most curious aspect of the current spate of developments in camera technology is their coherence. Camera designers have assumed that the larger the number of desirable features in a camera, the more desirable the camera becomes as a whole. In fact such cameras may only become more confusing to use and this realisation is perhaps the next stage that camera makers will have to experience. For multiplying modes makes good publicity copy. By judicious totting up Ricoh claims some 16 modes for its XR-P (including seven permutations with flash). For the T70 Canon claims 'only' eight modes (but could easily boost this up by another five by counting full-area and selective metering as separate modes). Eight years ago Leitz could by similar permutations of spot and full-area metering claim eight modes for the Leica R3 which got condensed to five rather more useful ones in the R4.

However camera producers currently reduce the number of modes only to create less expensive alternatives to their top models — for instance the Leica R4s reduced to three modes or the Pentax Program A (reduced from six modes of the Super A to four modes).

A sensibly planned camera intelligence should offer something more — namely operating modes matched to user needs. Designing intelligent cameras would need a study of intelligent photographers (in terms of their requirement — not of what psychologists or educators refer to as intelligence).

Except at the simplest level this has proved peculiarly difficult — compared with say the programmable domestic washing machine which even a technically totally ignorant housewife (or househusband) could easily cope with. True, picture takers' ambitions cover a rather wide range than distinguishing between three or four kinds of household fabrics. But the point is that these ambitions do not seem to have been systematically studied (at least not by camera designers).

Interaction levels

The intelligent camera should be able to make the kind of

Far left: Push-buttons for selection and an LCD screen display for conveying information have replaced setting dials and scales on the Pentax 645.

Left: Another way of passing on information. Almost the largest part of the voice synthesiser system in Minolta's AF-Sv talking camera is the ½in speaker, seen here next to the synthesiser IC.

decisions that the intelligent photographer wants to make. We can regard this on perhaps four levels:

1 Decision-free photography This is the only systematically investigated level and the result of such investigations led to Kodak's concept of the Disc camera. This is not just the disc format on its own but the analysis of snapshooter subjects in terms of lighting level and distance, to establish camera parameters that would cover the majority of such occasions and yield reasonably sharp and correctly exposed colour prints. The fact that Kodak may have misjudged picture quality expectations does not alter the criteria of decision-free photography arrived at. But this investigation appears to have taken place after the study of disc configuration possibilities, since first research disclosures of the disc idea appeared in 1978 and initial research presumably goes back further still.

2 Minimum-decision cameras This is the point-and-shoot camera that in fact makes quite a lot of decisions for the photographer, with focusing automation (simple active distance measurement), straightforward exposure program, possibly automatic flash when ambient lighting levels drop, motorised film transport and rewind etc. This is a considerably more automated camera than the disc model and — as sales figures of the past year or two have shown — is currently one of the most popular camera types on the market.

3 Limited interaction The single-lens reflex takes moderately ambitious photographers beyond the limitations of the compact point-and-shoot camera, covering closeups, alternative focal lengths and a possibility of matching exposure conditions to the subject and not only to prevailing lighting levels. This is where the market is at present most confused with its proliferation of operating modes and signals. The needs of the current automation-conscious SLR photographer could be met by a camera with three programmed exposure modes (as in the Ricoh XR-P but no other alternatives), with built-in flash, an active autofocus (distance measuring) system and a permanently built-in zoom lens with extended near focusing range. Sooner or later a camera manufacturer will present such a model and grab a significant market share of point-and-shoot as well as SLR camera buyers. Such a camera can have intelligent refinements (multipoint metering etc)

provided operation does not involve more than fairly simple subject-matched mode selection.

4 Open-ended interaction This is the domain of the future intelligent camera and this is where we know least of intelligent user needs. As today's multi-automatic cameras virtually incorporate a micro-computer as well as something akin to a video display unit, we could stipulate that the next generation of intelligent camera should also offer a more advanced level of interaction similar to the scope of a small personal computer. That would imply that what Canon calls the 'T70 television screen display' might signal options and questions ('Action?') and expect an appropriate user input to help the camera decide how to handle a shot situation.

This question-and-answer pattern, analogous to menu handling on a VDU, is of course too cumbersome for much of fast-shooting practical photography. (It might make sense for handling the rather more complex multiple controls of a studio or view camera.) Programming engineers will have to think up something more appropriate to the amateur and possibly even professional photographer. One of the future options could even be speech input, once the necessary recognition and processing capacity can be accommodated in a small enough chip. This is feasible technically — NEC has already a Japanese voice word processor that recognises speech and turns it into written characters. There are still numerous practical problems — calibrating the recognition circuits to specific user voice patterns, teaching the user to speak at a sufficient level of distinctness, storing an adequate number of command responses etc. A camera that could

Far right: Some of the display possibilities of the Canon T70 LCD panel. From top to bottom, left: Empty camera; loading (bars at bottom) and film speed; loaded for first exposure (frame counter); normal program (with shutter speed); wide program. Right: Shutter speed priority auto with selected speed; manual and bulb (counter and bottom bars count seconds); stopped-down AE; end of film; rewind signalling.

Right: The Pentax 645 splits its information between the LCD panel on the camera top (left; with indication of mode, aperture/ film speed/shutter speed, exposure compensation and frame counter) and the LED inside the finder (right; shutter speed and aperture, also exposure factor warning and flash ready signal).

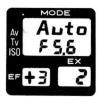

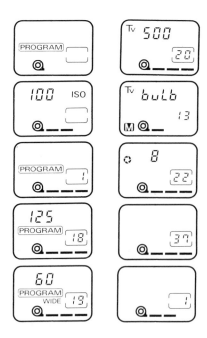

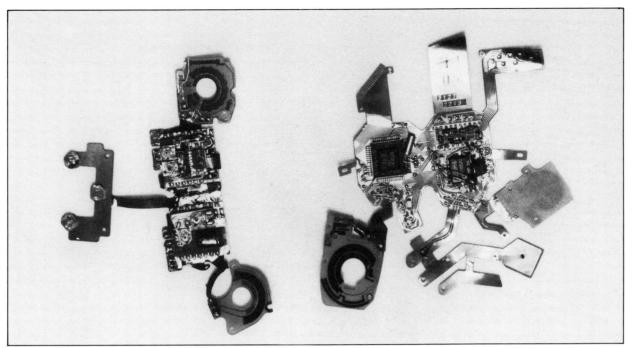

Three stages of growing electronic circuit integration. Top left: Equivalent of an integrated circuit (Ricoh XR-2 camera in 1977). Top right: Flexible circuit with IC on chip (Ricoh XR-S in 1981). Bottom: Multiple integral ICs in the Ricoh XR-P of 1984. The three circuits are shown at the same scale.

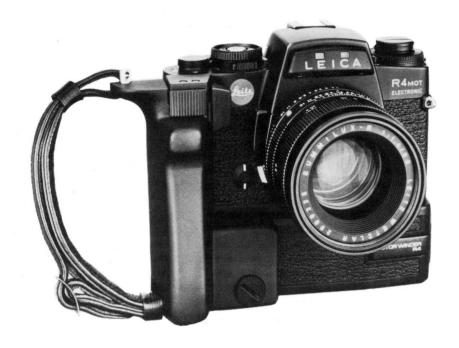

set an exposure in response to a spoken 'two-hundred-and-fifty at f-eight' would typify a new level of intelligence.

Electronic image prospects

Quite a few of the current questions and problems of sophisticated camera control spring from the hybrid nature of modern photography: we rely on electronic systems to provide the intelligence that adjusts the camera to the needs of a photochemical process. Electronic image recording for general photography is in the offing, despite present controversies over information content, image quality and marketability of such electronic systems. While the first systems announced (Mavica etc) are simply photographic cameras with an electromagnetic recording system (tape or magnetic disc instead of film), recent research disclosures show that electronic recording engineers are already thinking of more advanced future generations of such systems.

Image recording via solid-state arrays such as charge-coupled devices (CCD) can operate digitally and are

therefore open to considerable image processing scope. It is thus feasible for an electronic camera to scan an image, evaluate its shortcomings in terms of detail, definition, brightness level etc and correct it accordingly on a next scan. Photographically, this is equivalent to an instant-picture camera that all on its own looks at the exposure it has made, assesses the picture quality and takes another shot with suitable corrected settings.

Such image analysis can cover numerous aspects. Thus successive scans (which in TV mode take around 1/50sec each) can detect direction and rate of image movement so as to control something like a shutter speed for a sharp action shot. The same image (or two or three successive scans) can be analysed for optical sharpness and control an autofocus system. And in a colour record the camera could analyse colour balance and correct the rendering to match preset standards. (Video cameras can do that already.)

There is thus every indication that the next generation (or the one after) of intelligent cameras will be an electronic image recording system . . . ■

For its intelligent meter evaluation the Nikon FA defines subjects by general luminance level (from brightest — 1 — to darkest — 5) and by contrast (lowest at level 6 and highest at 10). For the different brightness/contrast combinations the program then selects one of four exposure settings derived from the five sensor outputs (a = centre-weighted reading, b = highlight, c = midpoint, d = shadow reading). Areas A, B, C and D represent additional (and more complex IF/THEN choices; e.g. in area D (extreme contrast, medium to low brightness) the program selects the midpoint reading if the image centre is brighter than the average of the rest by more than 1 EV, while if the difference is less or the centre is darker then the exposure is based on the shadow reading. The various conditions and selections are based on a statistical computer evaluation of several thousand typical subjects and pictures.

PICTURE
SECTION

J O H N K I P P I N

MARIUS ALEXANDER From 1974 until 1980 Marius Alexander spent much of his time on long journeys through Nepal, India and the tribal areas of Northern Pakistan, first with a sketch pad and increasingly with a camera. Back in his home town of Edinburgh he took a City and Guilds certificate and a Higher Diploma in photography. He is at present working on assignments for various German magazines.

TOM ANG A freelance photographer working on book illustrations, travel and advertising, Tom Ang is also technical editor of *Camera and Creative Photography* and writes for a number of photographic journals including the *BJP*. These pictures are from *Walking the Scottish Highlands* (Tom Ang and Michael Pollard) published by André Deutsch.

EVE ARNOLD American born Eve Arnold is a long-standing member of the Magnum Photos agency in New York and Paris. She is one of the world's best known and most respected photojournalists in the truest sense. Her books include *The Unretouched Woman, In China* and recently, *In America*. Now resident in London, Ms Arnold is a regular contributor to the Sunday Times colour magazine among others.

RICHARD AVEDON American born Richard Avedon lives and works in New York. A recipient of numerous photographic awards, he remains one of the world's most highly respected fashion and portrait photographers. This photograph was one of a series commissioned by Art Director Paul Arden at Saatchi and Saatchi, London, for Alexon.

ROBIN BARTON Robin Lindsay Barton. Age 25. UK citizen. Freelance music photographer, London.

HOWARD BAUM Born in France, Howard Baum lived in South Africa for nine years and Germany for five. He has recently completed a three year photography course at Bournemouth and is currently assisting Ashvin Gatha.

MICHAEL F BEDDINGTON The work of Michael Beddington has been exhibited and published in England, France and America. His main influences have been the visual arts — in particular the impressionist painters and the way in which they saw and used light-music, and through Taoism to Zen. Beddington uses the zone system to give the degree of control that his work requies.

ROBYN BEECHE Australian born Robyn Beeche has lived and worked in England for over ten years, initially as an assistant to Harry Peccinotti before setting up on her own as a fashion, beauty, advertising and travel photographer. Her work in the field of beauty at the moment has been concentrating on shadow, illusion and three-dimensional effects.

MICHAEL BIRT A portrait photographer for the past eight years, Michael Birt has been commissioned by many magazines including *Tatler, Ritz, New Society, Over 21* and *Honey*. September

'84 saw his first major exhibition at the Open Eye Gallery, Liverpool.

JOSEPH BUEMI A New Yorker born in 1923, Joseph Buemi studied at the Institute of Photography in 1951 and has been taking pictures ever since, believing that pictures reveal themselves to the sensitive eye.

MIKE CALDWELL Working in photography for five years since leaving school, Mike Caldwell is presently a freelance assistant while undertaking his own commissions particularly in travel.

BOB CARLOS CLARKE A graduate of the London College of Printing and the Royal College of Art, Bob Carlos Clarke is one of this country's best known photographers in the field of Fashion and Advertising. Commercial clients range from Singapore Airlines to Kawasaki, Pirelli and Lee Jeans. 1985 will see the publication of his third book: *The Evil and the Innocent* by Quartet books. He is at present directing his first commercial for TV and hopes to move his personal work into film in the future. Picture information: Fashion shot for 'Lowe Leather' — Art Director Paul Eastwood — Geers Gross, Model Sue Gibson. (Airbrush chlorobromide print including three negatives). 'Apollyon': Two negative chlorobromide print 'Sister Morphine': Three negative split tone chlorobromide. Apollyon and Sister Morphine are included in Carlos Clarke's forthcoming book *The Evil and the Innocent*.

PETER CATTRELL A Glaswegian by birth, Peter Cattrell studied fine art at St Andrew's University and photography at the London College of Printing. In the past two years he has had a number of exhibitions including the group show 'New Contemporaries' at the ICA in 1983. He is an assistant to Fay Godwin and freelances, mostly in portraiture.

ANIL CHANRAI Born in West Africa and educated in England, Anil Chanrai worked for a while in India for WWF and magazines before settling and working in West Berlin.

JOHN CLARIDGE A well known advertising and travel photographer, John Claridge's image of Venice for P&O is typical of his soft colour and focus work in this sort of setting. And yet some embarrassed amusement was caused by this particular shot, when another commercial photographer coincidentally took almost the identical picture for another company which was marketed at almost the same time of year.

KERRY COPPIN Since 1978 Kerry Coppin has been a full-time faculty member at Columbia College, Chicago. Having grown up in the Bronx, NYC, he began photography at the High School of Art and Design. A series of qualifications from the Fashion Institute of Technology, the Rochester Institute of Technology and Rhode Island School of Design allowed Coppin to study with Aaron Siskind, Harry Callahan and Ray Metzker.

GERRY CRANHAM A specialist sports photographer for the past 27 years, Gerry Cranham

is best known for his work connected with horses. This photograph comes from a book recently published by Heinemann entitled *The World of Flat Racing*. Gerry Cranham is a member of the RPS.

RICHARD CROFT For the past year Richard Croft has been working in London as a freelance portrait photographer. The year before that was spent making portraits of the inhabitants of a South Coast town. The collection of twenty prints from which this comes is entitled 'Home Entertainment'.

ANDREW CROWLEY A black-and-white printer employed by Adrian Ensor, Andrew Crowley was a runner-up in the Ilford Young Printer of the Year Award 1983. For the past four years he has been teaching himself to take photographs and uses a Leica. This picture is one of a series on London's Brick Lane market.

LARRY DALE GORDON It was in the early 50's during his US military service that Larry Dale Gordon developed his addiction for travel. Realising that his chosen profession of architect would limit his chances of seeing more of the world he escaped to Europe with his cameras, picking up work as he moved around. Eventually finding his way back to America he has become established as an editorial, advertising and glamour photographer who still travels the world on location.

NANCY DURRELL McKENNA Born in Canada, Nancy Durrell McKenna is now resident in London. Much travelled, her work has appeared in a variety of magazines ranging from *The Economist* to *Good Housekeeping* and publications prepared by a number of charity organisations including Oxfam and Christian Aid. This photograph is from a recent book on black South Africa entitled *Sawubona!*

DIANA EAST An inhabitant of the Forest of Dean, Diana East travels abroad taking photographs as a freelance. One of her most recent trips was to Cape Verde. This photograph is one of a series taken on a trip to Portugal.

BARNEY EDWARDS A well-known London based photographer Barney Edwards is known for 'specialising in not specialising' and yet retains a highly recognisable style in the field of fashion, advertising and editorial photography. This portfolio shot is typical of his preference for pastel colours and use of painted backdrops and soft lighting.

ORDE ELIASON Born in South Africa in 1956, Orde Eliason is a freelance photographer based in London specialising in photoreportage.

GAVIN EVANS An 'underworked and overdrawn' ex Harrow College of Higher Education student, Gavin Evans in partnership with friends in Manchester is hoping to break into the music business as a photographer/graphic designer. Still only 19, his interest in photography began at the age of 12.

JILL FURMANOVSKY Originally a student of textiles, Jill Furmanovsky moved into graphic design and photography while at the Central School

of Art. Her professional career took off whilst still at college, working for weekly pop magazines. She is now a well-established music business photographer working in colour and black and white. The picture of Marielle and Katia Labeque was taken at her north London studio.

MICHAEL GREEN A photographer and artist living in Suffolk, Michael Green was educated in Fine Art at Dulwich College, London. He has worked as a freelance on films such as 'The French Lieutenant's Woman' and 'Ploughmans Lunch'. In 1983 he received a photography grant from The Eastern Arts Association and exhibited at Sheffield Polytechnic and the Cambridge Darkroom.

IRENE HALL An ex-student at Bournemouth and Poole College of Art, Irene Hall works as a dance photographer, looking for images that express the feeling and movement of the dance.

DAVID HEIDEN A physician as well as a photographer, David Heiden lives in San Francisco, California. The work shown here was taken while doing medical relief work in Africa at Bo'o Refugee Camp, Somalia.

ED HORWICH A graduate in Creative Photography (Derby 1982) Ed Horwich has had a number of exhibitions of his work at galleries round the country including Open Eye, Liverpool, City Art Gallery, Derby and The Photographers' Gallery, London.

MARK JOHNSON Born in Sydney, Australian Mark Johnson graduated from Sydney University in 1970 and completed postgraduate studies in London in 1973. His work has been widely published and exhibited in Australia and is in a number of national collections.

LEN JOHNSTON A resident of Australia, Len Johnston has been involved in photography for about ten years and has recently had two exhibitions of his work in Melbourne. This picture was taken while on a visit to Assisi in Italy.

DAFYDD JONES A 'society' photographer for Tatler magazine, Dafydd Jones also freelances for a variety of other magazines, newspapers and publishing companies.

BOB KAUDERS Since 1980 Bob Kauders has been photographing changes in Gypsy communities in Lincolnshire while teaching photography part-time. Having graduated in 1973 from PCL, Kauders worked on a landscape project funded by the Arts Council and a PCL scholarship. He was appointed Fellow in Photography with Lincolnshire and Humberside Arts from 1976-78. He has exhibited widely and an exhibition called 'A Time There Was' is now on tour.

MICHAEL KENNA Having studied at Banbury School of Art and LCP Michael Kenna moved to San Francisco in the late 70s and has been resident there ever since. His work has been widely exhibited and published in America and Britain.

JOHN KIPPIN John Kippin is 33 years old and lives in Newcastle upon Tyne. He has exhibited his photographic and video work widely throughout Britain and Europe. He has lectured at a number of colleges in Britain and was photography organiser at Newcastle Media Workshops from 1979-84. He is currently working on a one year Northern Arts/Forestry Commission residency in Northumberland and is a Basement Group member.

NICK KNIGHT 'Sufferance leads to purity'. Born in London in 1958, the son of a psychologist, Nick Knight has been a professional photographer since the summer of 1982. His recent personal work has been a series of photographs dedicated to the pursuit of physical excellence. He is a regular contributor to The Face and other youth culture magazines.

ROBERT KOWALCZYK A resident of Kyoto, Japan, Robert Kowalczyk has to date published two books — Morning Calm: a photographic journey through the Korean countryside and Namaste: photographs from the Nepalese Valleys of Kathmandu and Pokhara through Dawn Press of Nara, Japan. These photographs are from a soon to be published book on Japan.

CHRIS LOCKE After studying photography and film making at West Surrey College of Art and Design and Trent Polytechnic until 1972, Chris Locke currently lectures in photography at Great Yarmouth College of Art and Design, Norfolk, the area where he photographs.

RAY MASSEY Over the past 10 years Ray Massey has gradually been moving into still life and special effects. Since 1971 he has been a freelance mainly in reportage and editorial photography. A student at Somerset and Medway Colleges of Art and Design, Massey went on to assist Penny Tweedie, Dennis Jackson and David Montgomery.

NEILL MENNEER A graduate of Guildford Photographic College and Nottingham University (English Literature and Art History), Neill Menneer won The Observer photographic competition in 1980. Since then he has been working in London as a freelance. Clients include many of the colour supplements and book and part-work publishers.

PETER DAVID MORGAN A freelance photographer, Peter Morgan is a part-time teacher at Harrow College of Art and has had his work (mostly montage and mixed media) published in various magazines from New Scientist to Classical Music. His work also sells as mounted images, notably recently to British Petroleum. Morgan is currently working in conjunction with Ally Hines.

ANGUS McBEAN Now in his eighties, Angus McBean is best known for his work in theatre photography creating surrealist settings for portraits of well-known actors and actresses. Recently he has been commissioned by Vogue and L'Officiel to produce fashion photographs in his own style.

IAIN McKELL With a degree in Graphic Design/Photography from Exeter College of Art, Iain

McKell moved to London and started on a career in Fashion, Advertising and Editorial photography. His many clients now include The Face, Blitz, Lei, The Observer, Vogue and numerous others. One of his most successful advertising commissions was for Canadian Club through Foote, Cone and Belding, and various record covers and promotional photographs for top artists in the rock music business. Shown here too is some of his personal work taken on visits to Sicily and Gambia last year.

MIKE OWEN A freelance for three years, Mike Owen works in the music business, fashion and portraiture.

STEVE OXENBURY Steven Oxenbury is a young photographer who has recently completed three years of study at Bournemouth and Poole College of Art.

CAROLINE PENN After leaving University with a degree in geography and then teaching English in the Sudan for a year, Caroline Penn returned to England and took a one year photography course in Southport. Since 1983, she has been a freelance photojournalist with Xenon Photo Agency.

GIANNI PEZZANI Working in Milan as a still life photographer for Vogue and Grand Bazar among others, Gianni Pezzani began his research into polychromic toning in 1978. His personal work has been exhibited and published widely in Italy, France and in China.

MARK POWER Born in Herefordshire in 1959, Mark Power qualified with a first class honours degree at Brighton Polytechnic in Graphic Design/Illustration in 1981. Since then Power has taught himself to take photographs. During the twenty months after graduating, Power's travels to Australia and back led him through Hong Kong, China, New Zealand, Malaysia, Bali, Java, Sumatra, Burma, India, Nepal and Bangladesh. The pictures shown here were taken in Burma and Thailand.

ADAM SHIPP A recently qualified student of Richmond College of Art, these photographs were part of a portfolio presented by Adam Shipp as Richmond's sole entry to the 1984 Polaroid Student's Competition. Adam Shipp was the worthy winner of a special individual student prize for his entry.

P G SIMPSON Peter Simpson trained as a Graphic Designer/Photographer and now works as an Industrial/Commercial photographer. His personal work has moved away from landscape, his main preoccupation to date. This example of current work was taken at Newstead Abbey.

GEOFF STERN As recently as 1980 Geoff Stern picked up a camera and began taking pictures of his fellow skateboarders. Four years on and after a brief flirtation with film school, Geoff is directing his first professional film Underground set on the London Underground featuring bodypoppers and breakdancers. During filming he documents progress on stills film. In the past year he has had an exhibition at the London Transport Museum of his

Underground shots and was a prizewinner in the recent GLC Photography competition.

ANDY SUMMERS Born in Blackpool in 1942, Andy Summers grew up in Bournemouth, Dorset and is better known as the guitarist in 'The Police' rock group. Self-taught, Andy took many photographs whilst on tour in the West Indies and the United States; these were published by Sedgwick and Jackson in a book called *Throb* last year.

KAREN SZEKESSY For over twenty-five years Karin Szekessy has worked as a photographer, fifteen of them as a freelance for various international magazines, both commercial and artistic. She has had many exhibitions all over the world, working in portraiture, nudes, still-life and architecture.

JOHN R J TAYLOR Currently a full-time lecturer in photography at West Glamorgan Institute of Higher Education, John R J Taylor continues to work on personal photographic projects and preparations for a forthcoming exhibition.

STANISLAV TUMA Originally a film maker, Stanislav Tuma became interested in stills photography whilst teaching at Prague Film Academy. In 1975 Tuma became a freelance photographer in portraiture, theatre and architecture. Although he now lives in Stockholm and teaches in Amsterdam, he knows that Mala Strana the old part of Prague is for him the most fascinating and dearest subject for his kind of photography to which he returns often.

YVONNE VAAR Although Toronto, Canada is Yvonne Vaar's home town, she spends several months in Europe every year. She is a painter and cinematographer, but has lately devoted most of her time to still photography. Her work has been published and exhibited in many countries around the world.

JAKE WALLIS Born just after World War II and after disastrous schooling, Jake Wallis spent happy years in turn as a farmworker and occasional lumberjack. At 23 it became clear that his life was due for a restructure and he chose photography as a means to 'get on'. He ended up printing 40 000 negatives for Angus McBean and in 1970 won the portrait section of the Ilford Print competition. Jake then started in advertising and has progressed to major campaigns throughout the world, with automobile advertising becoming a large proportion of his workload.

GARY WATERS A student of Hornsey, Birmingham and the Royal College of Art, London, Gary has taught since 1976 and is presently head of the Photography Department at Bradford College of Art. His work has been included in many mixed and one-man shows in the UK and Yugoslavia.

GRAIG WILLIAMS This photograph is one of a series on the subject of 'Burning Coal in Domestic Fireplaces', part of a commission set for five photographers by the Solid Fuel Advisory Council. 'Real Fire' has become a touring exhibition. Craig Williams completed this commission whilst still a student at Derby Lonsdale College of Higher Education from which he has recently graduated.

ALISON WILSON Born in 1960, Alison Wilson is a graduate of Exeter College of Art and Manchester Polytechnic where she graduated in 1982 with an MA in photography. Alison has since taught in both Exeter and Manchester whilst pursuing a freelance career in advertising and has recently received a 'Residency' award from South-East Wales Arts to photograph the dockland areas in and around Cardiff.

TREVOR WOOD Originaly training at Art school as a painter, Trevor Wood switched half way through to the newly established photographic course. For six years afterwards he pursued a career as a set designer with the BBC, his photography remaining a hobby until gaining a photographic prize influenced him to try making a career of it. After four years of struggle, Trevor Wood gradually built up a thriving business in travel photography. Ten years later he is now moving back into still-life in his own purpose-built daylight studio.

PAUL YULE Born in 1956, Paul Yule has been working extensively as freelance for magazines, newspapers and book publishers since 1978. His photographs of the people and native culture of Cusco, Peru entitled 'The New Incas' has been published as a limited edition album by the New Pyramid Press, London.

ELIZABETH ZESCHIN Resident in New York, Elizabeth Zeschin freelances between New York and London. She has an MA in Theatre Arts from Illinois and moved into photography through the Art Institute of Chicago and advertising assistantships.

D A V I D H E I D E N

ANDY SUMMERS

ANDY SUMMERS

NICK KNIGHT

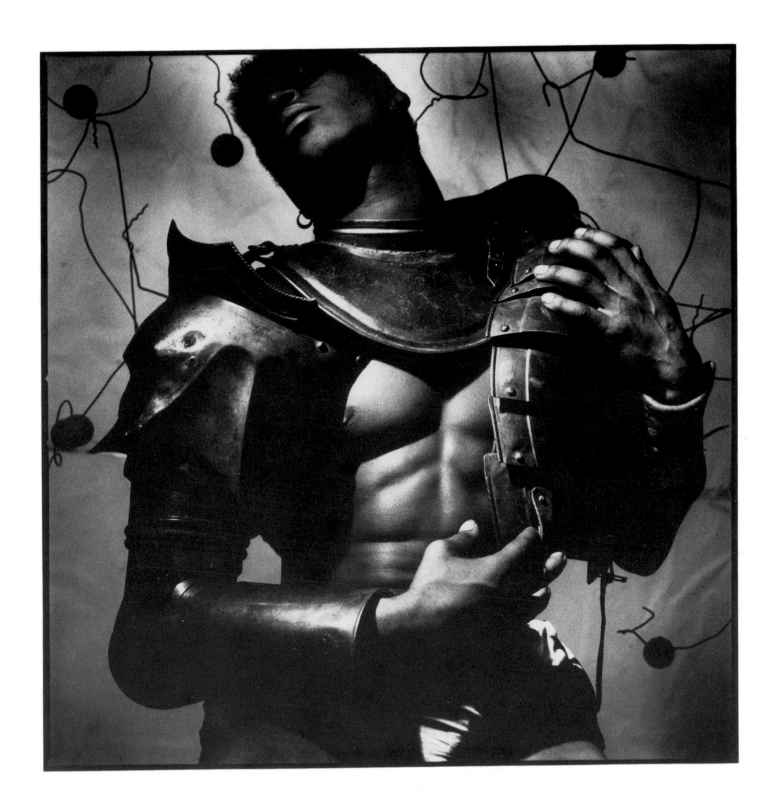

NICK KNIGHT

JAKE WALLIS

JAKE WALLIS

JAKE WALLIS

PETER CATTERELL

R A Y M A S S E Y

ROBYN BEECHE

ALISON WILSON

CINDY PALMANO

K E R R Y C O P P I N

ROBERT KOWALCZYK

ROBERT KOWALCZYK

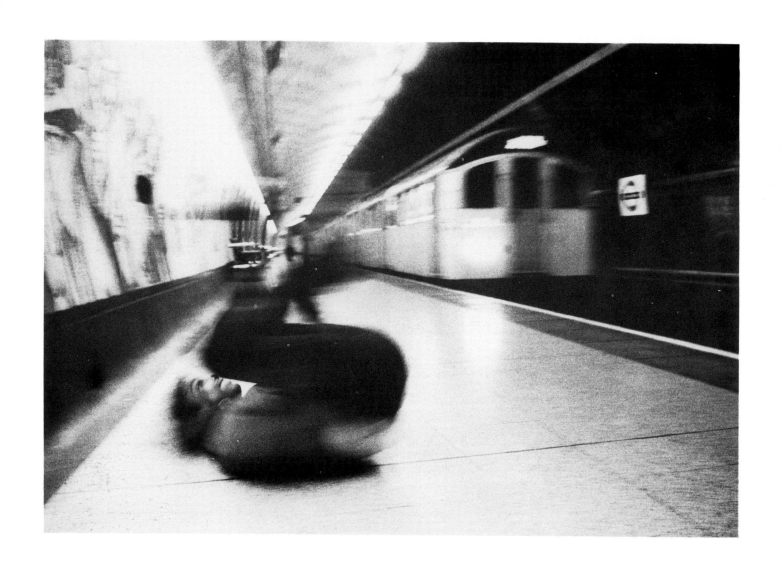

G E O F F S T E R N

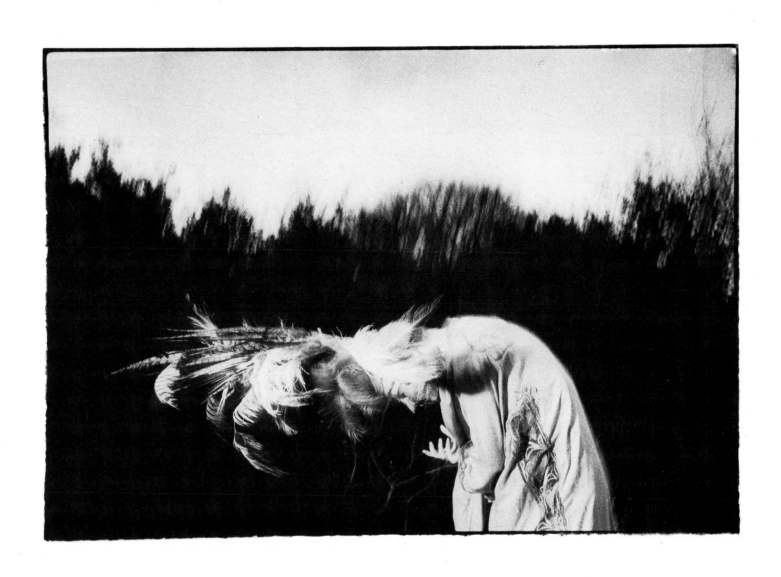

IAIN McKELL

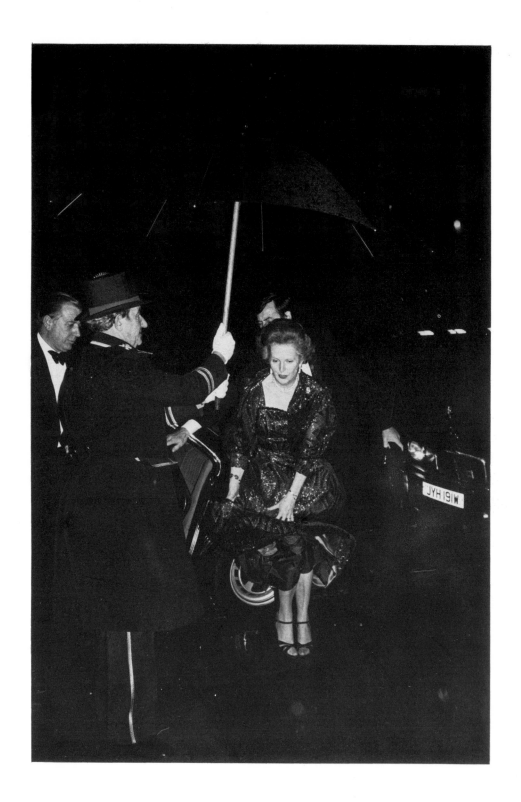

D A F Y D D J O N E S

DAFYDD JONES

KERRY COPPIN

KERRY COPPIN

M I C H A E L B I R T

MICHAEL BIRT

G EVANS

G EVANS

J O H N R J T A Y L O R

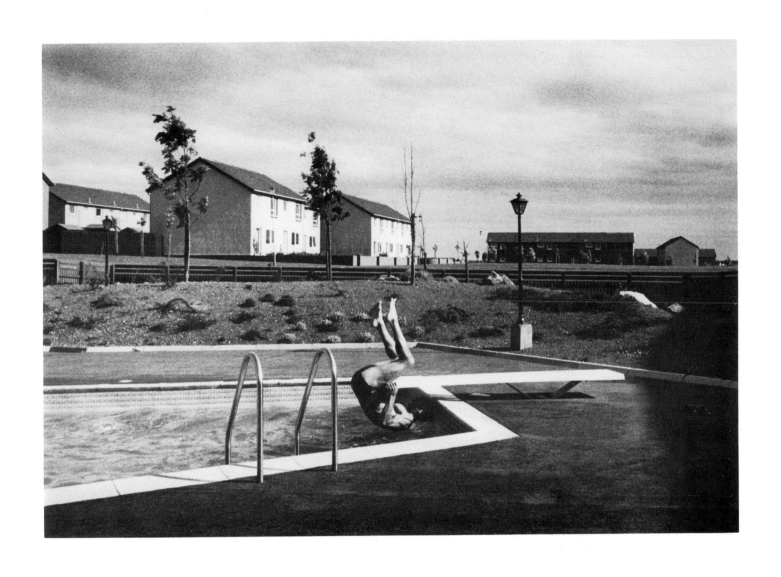

J O H N R J T A Y L O R

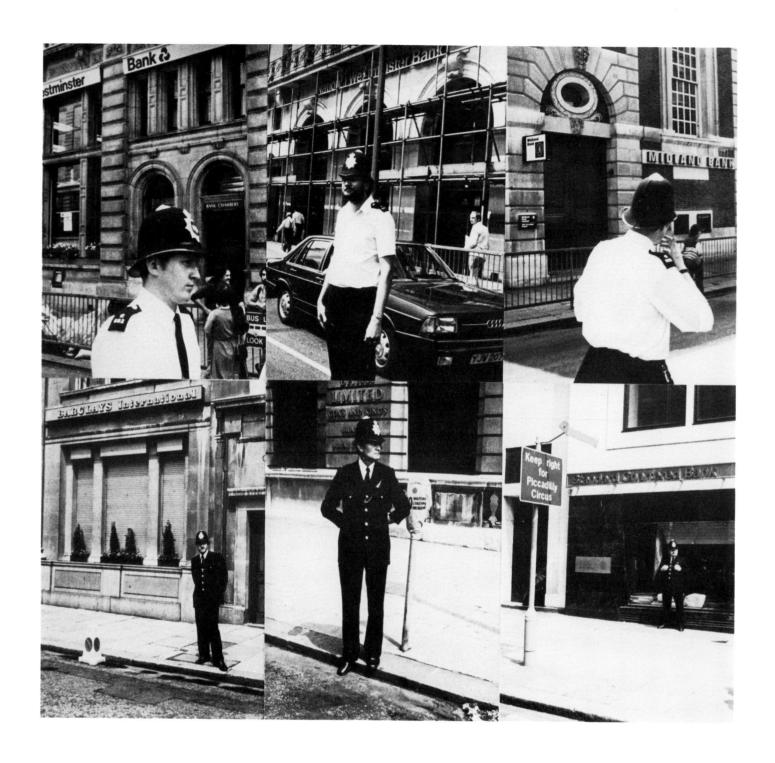

MICHAEL GREEN

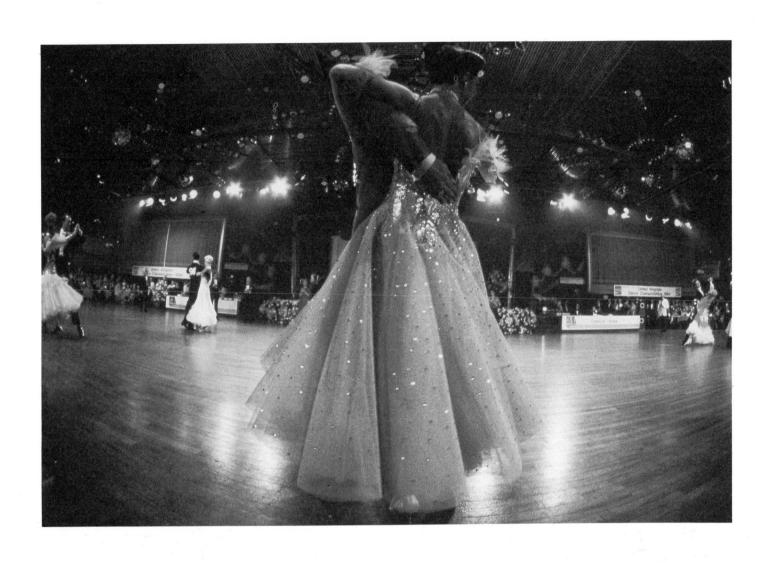

C A R O L I N E P E N N

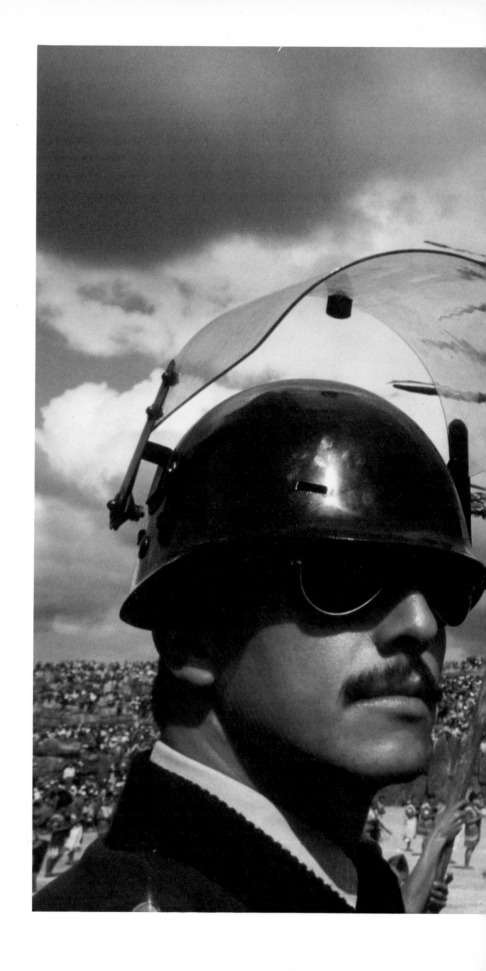

PAUL YULE

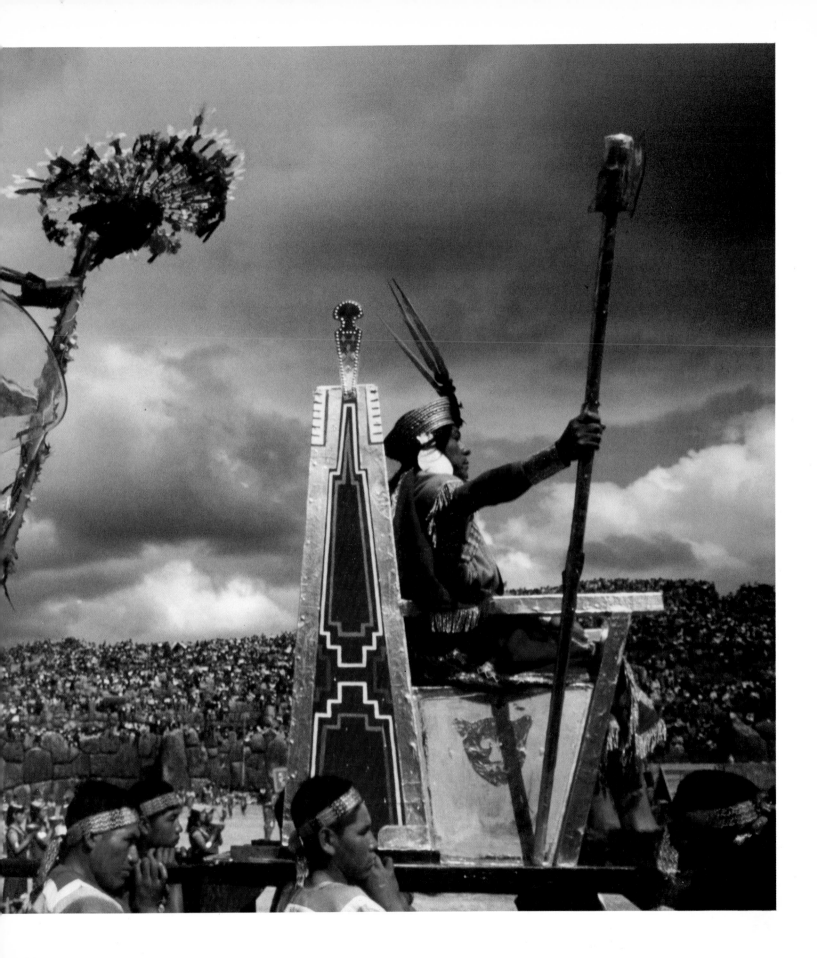

M A R I U S A L E X A N D E R

ANIL CHANRAI

T O M A N G

TOM ANG

ANDREW CROWLEY

MICHAEL KENNA

STANISLAV TUMA

S T A N I S L A V T U M A

JOSEPH BUEMI

M A R K J O H N S O N

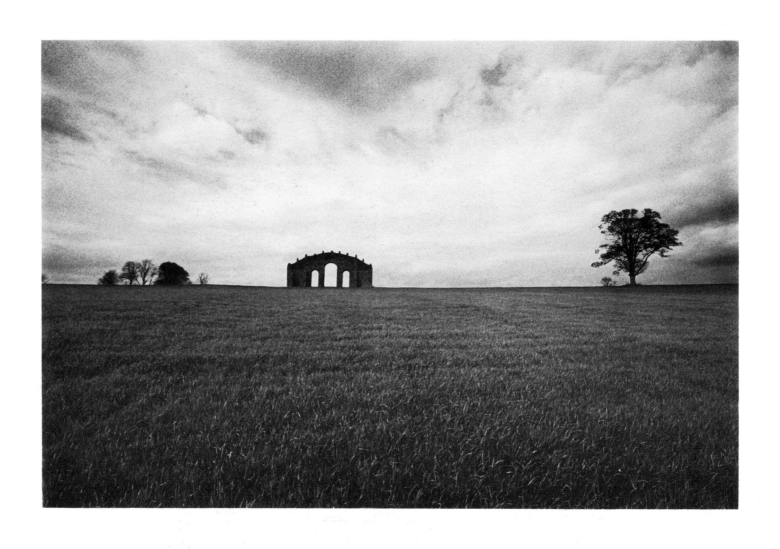

M I C H A E L K E N N A

LEN JOHNSTON

M A R I U S A L E X A N D E R

YVONNE VAAR

B O B K A U D E R S

BOB KAUDERS

BOB KAUDERS

O R D E E L I A S O N

GERRY CRANHAM

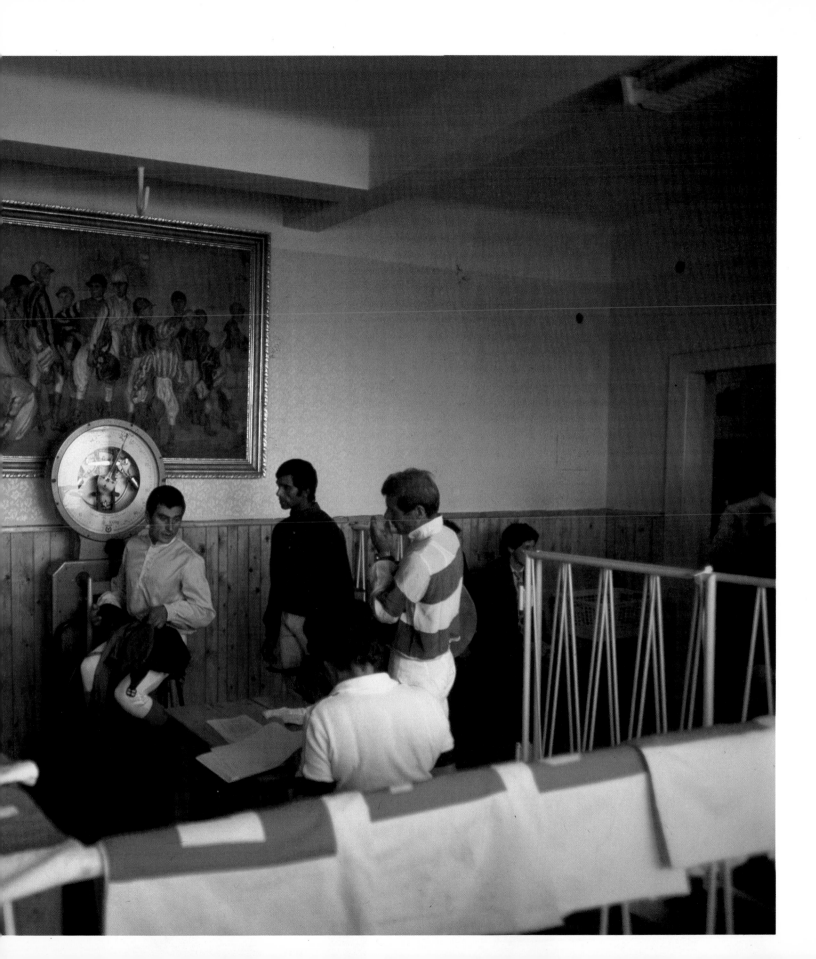

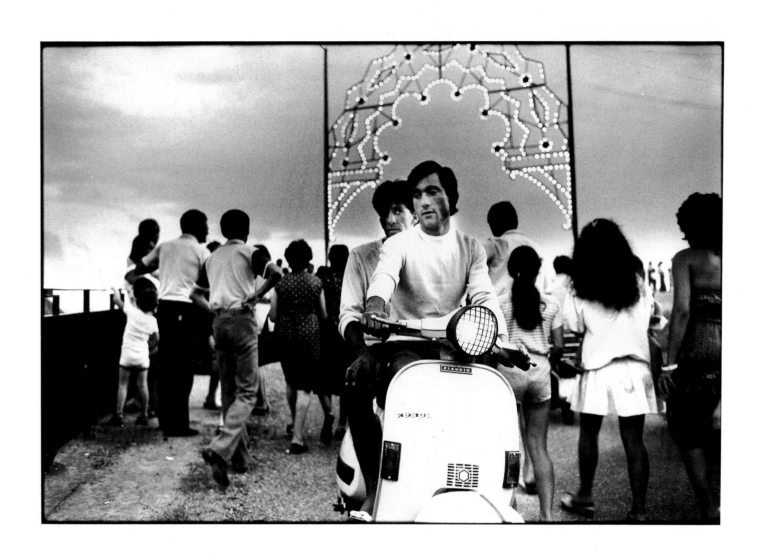

IAIN McKELL

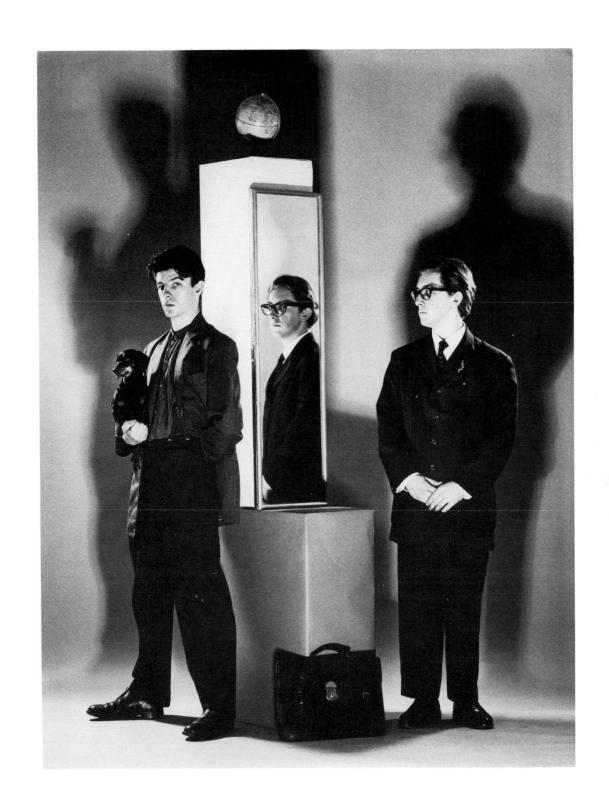

MIKE OWEN

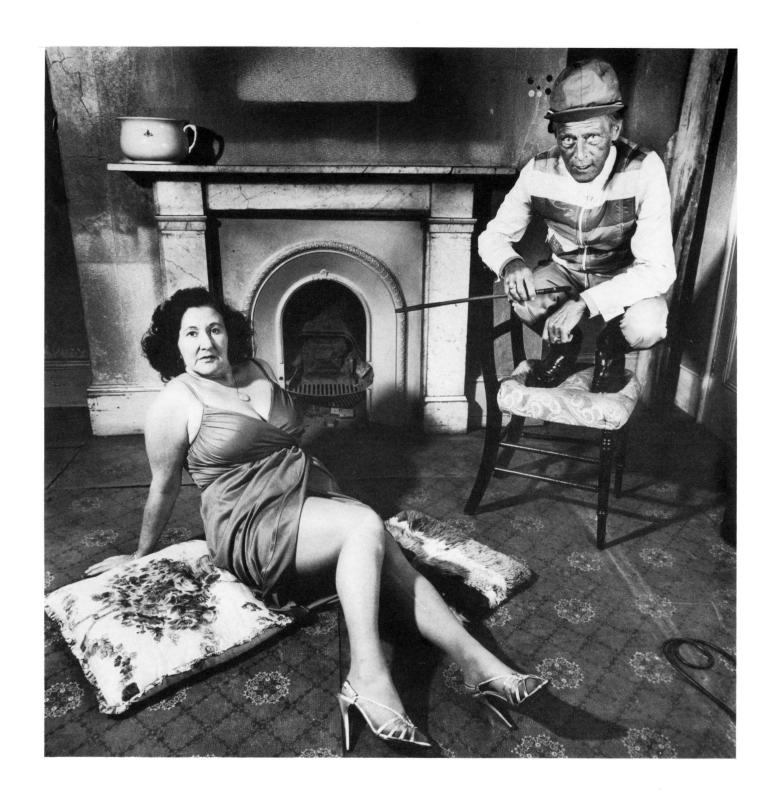

RICHARD CROFT

KARIN SZEKESSY

MARIUS ALEXANDER

MIKE OWEN

ROBIN BARTON

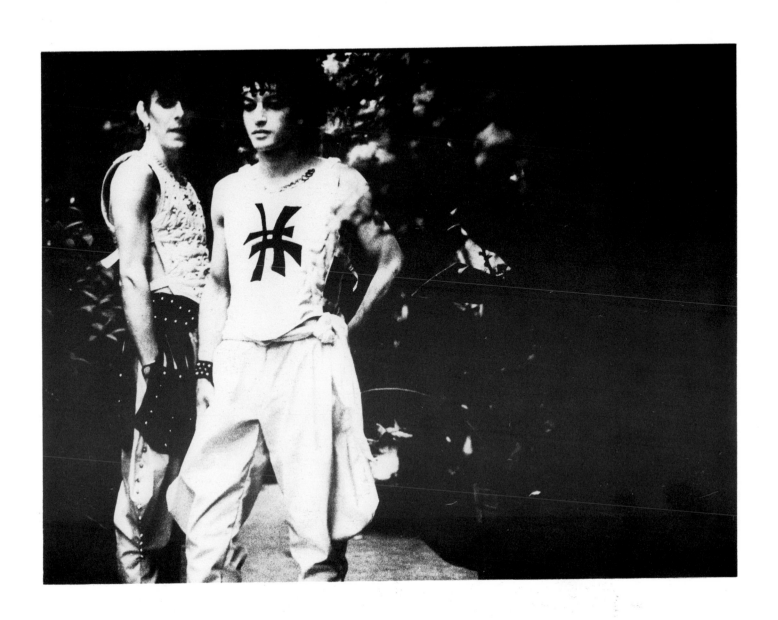

R O B I N B A R T O N

IRENE HALL

ANGUS McBEAN

E L I Z A B E T H Z E S C H I N

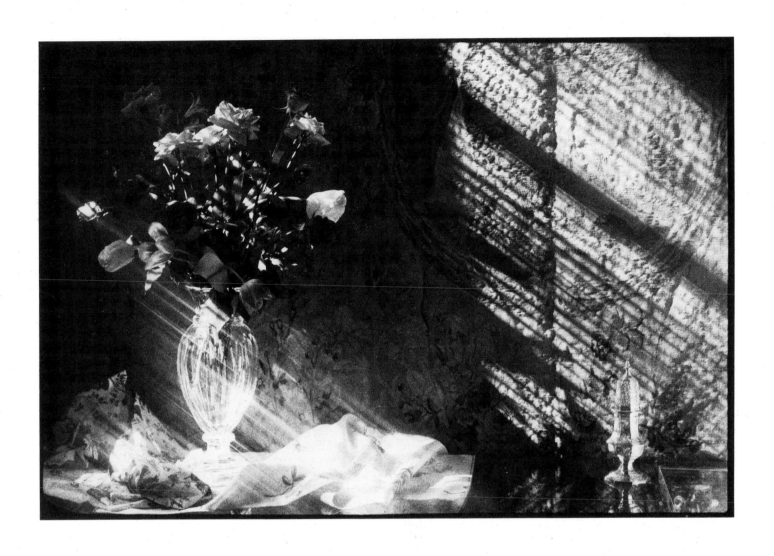

ELIZABETH ZESCHIN

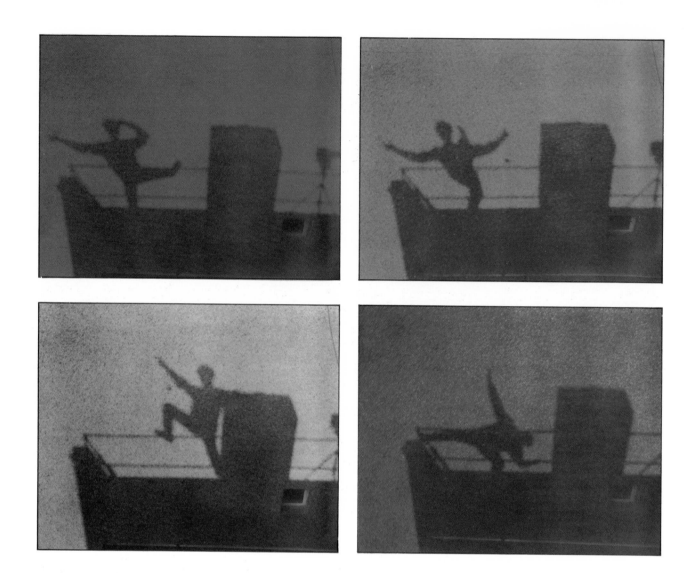

A D A M S H I P P

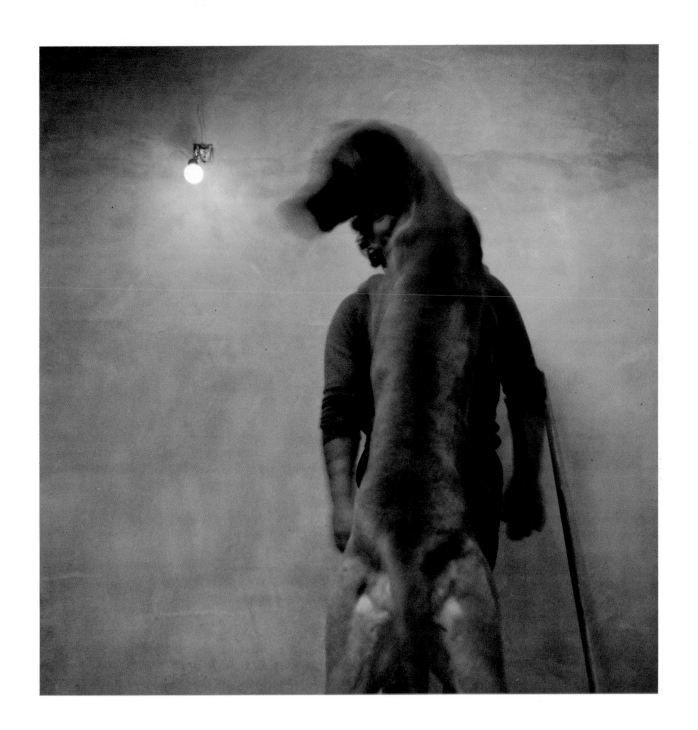

STEVE OXENBURY

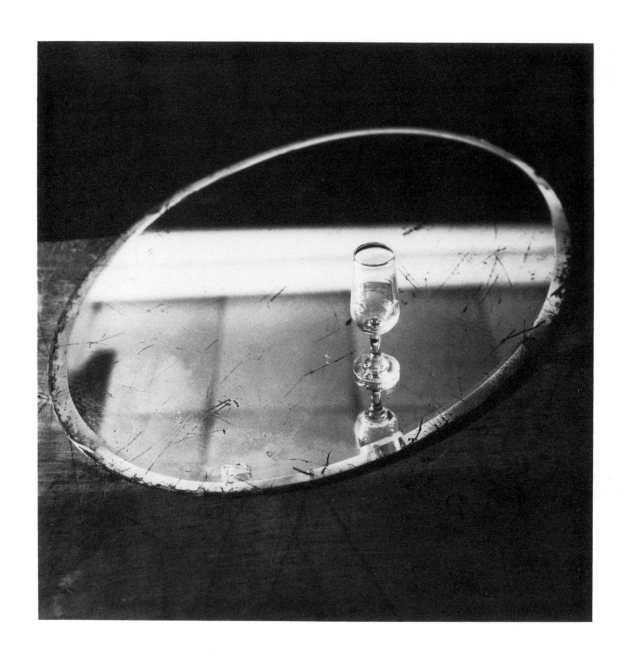

GARY WATERS

G A R Y W A T E R S

E D H O R W I C H

RICHARD AVEDON

J O H N C L A R I D G E

CENTRIFUGAL FOURS.

CENTRAL

JAKE WALLIS

EVE ARNOLD

M A R K P O W E R

MARK POWER

B A R N E Y E D W A R D S

LARRY DALE GORDON

MIKE BEDDINGTON

MIKE BEDDINGTON

CRAIG
WILLIAMS

M A R K P O W E R

JILL FURMANOVSKY

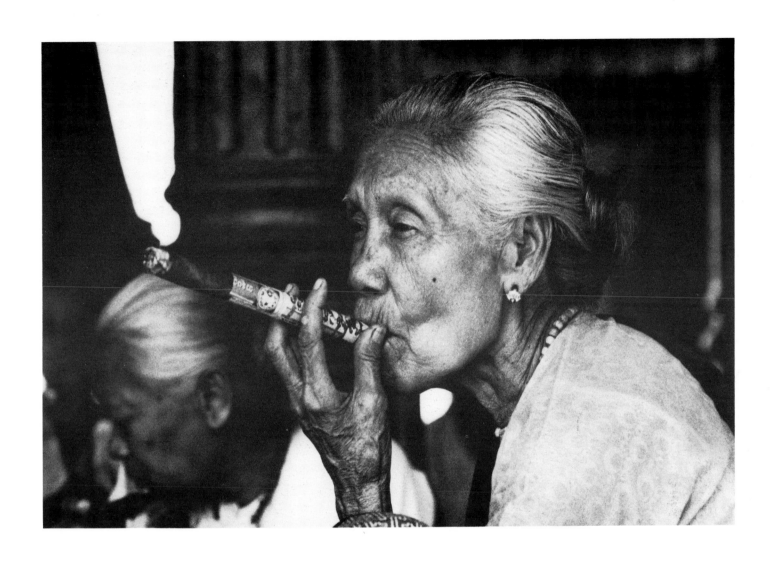

MARK POWER

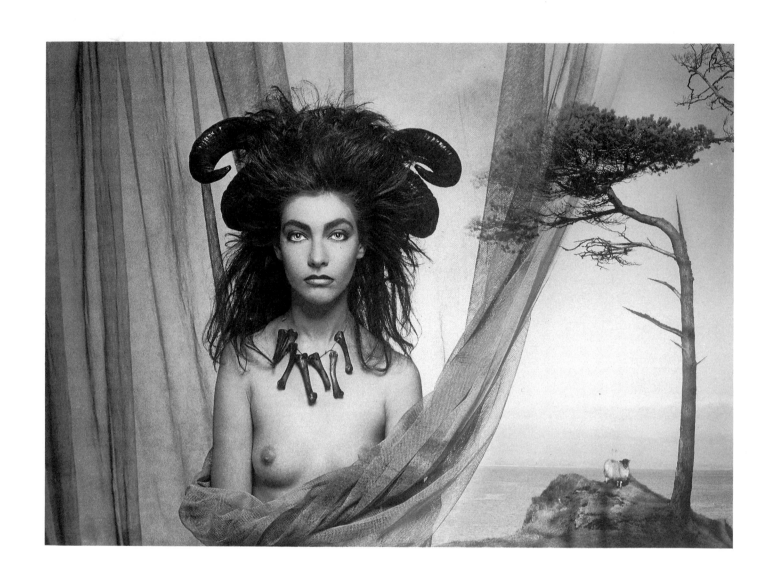

B O B C A R L O S C L A R K E

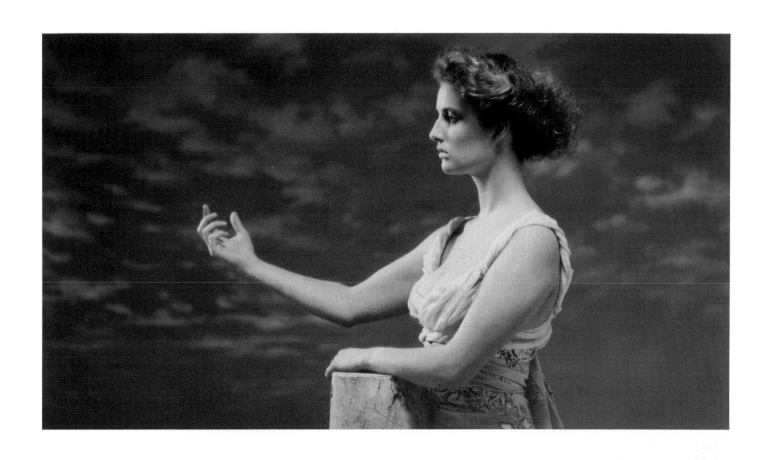

BOB CARLOS CLARKE

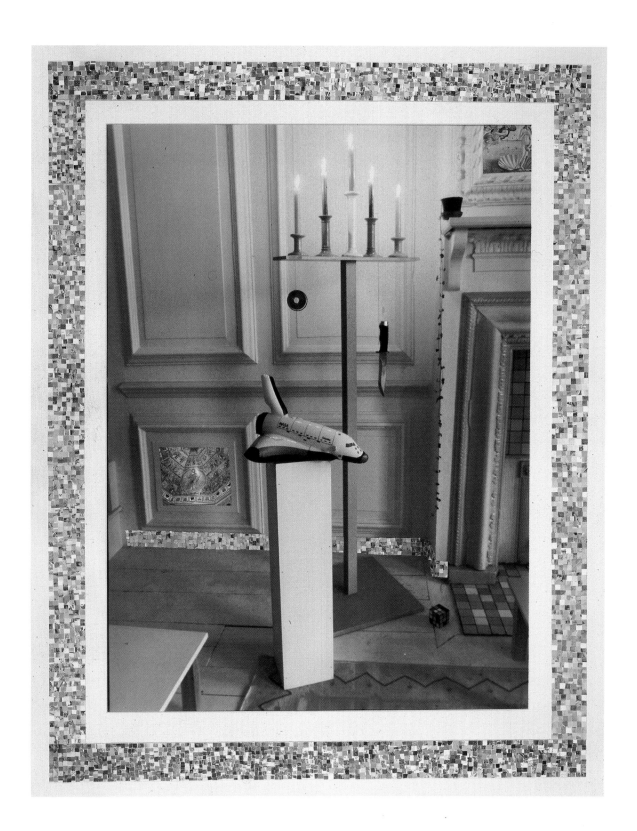

PETER MORGAN

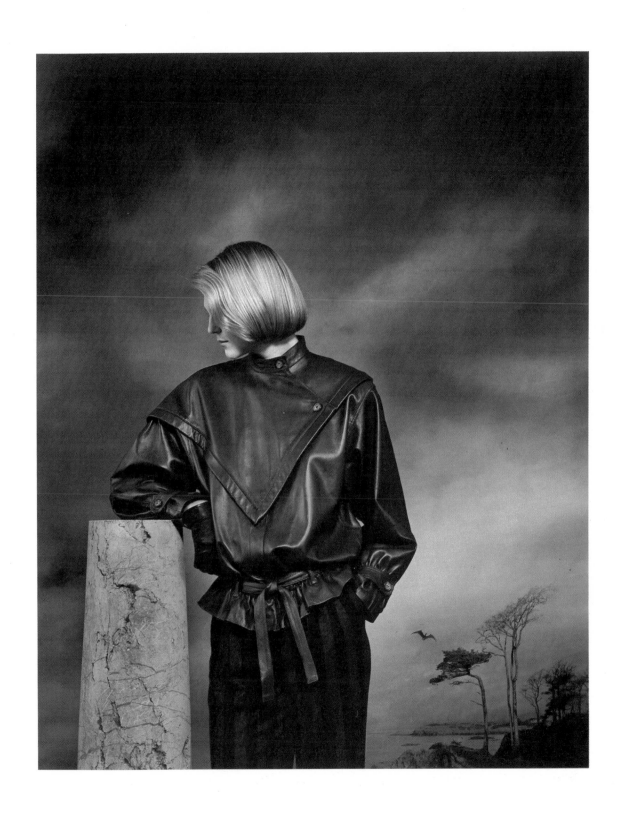

BOB CARLOS CLARKE

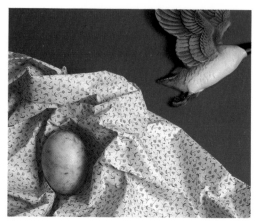

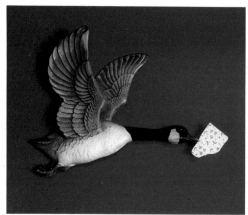

N E I L L M E N N E E R

CHRIS LOCKE

PAUL YULE

PAUL YULE

PAUL YULE

PAUL YULE

Viewed from the perspective of economies of scale large volume production is inevitable. You may rest assured however, that we know where the line between uniformity and drabness will lie.

B R E N D A N M c N E I L L

N A N C Y D U R R E L L M c K E N N A

P G SIMPSON

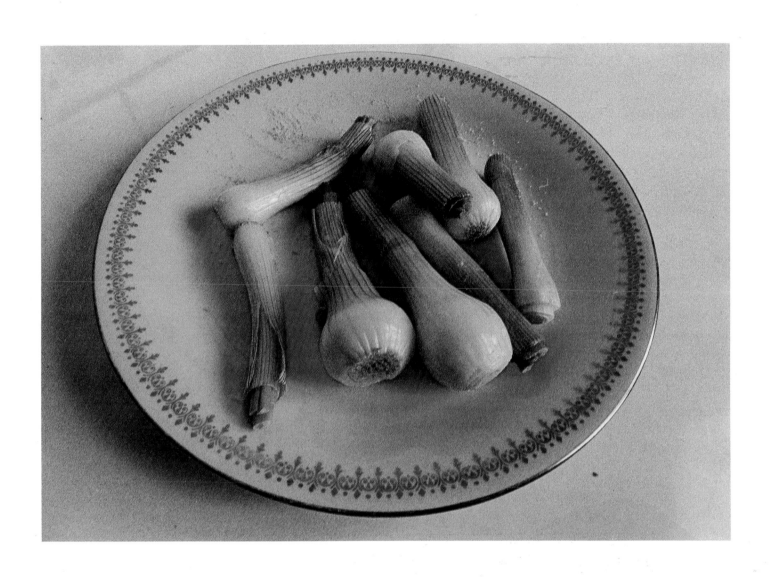

GIANNI PEZZANI

TREVOR WOOD

TREVOR WOOD

RAY MASSEY

MIKE CALDWELL

D I A N A E A S T

YVONNE VAAR

HOWARD BAUM

JOHN KIPPIN

SUMMARY
OF PROGRESS

Education

The Leverhulme programme of study into the future of higher education was organised by the Society of Research into Higher Education with grants from the Leverhulme Trust and from the Gulbenkian Foundation. 'Trial by seminar' is the best shorthand description of how the Leverhulme programme of study set about its work. The first seminar was held in April 1981 and the last in September 1982. In addition follow-up conferences were organised by the SHRE to discuss the recommendations made in the seminars. The final report *Excellence in Diversity* was published during the year. Leverhulme represents for the 1980s what the megaplanning of Robbins did for the 1960s. As such it represents a pattern of future development for higher education into the next century. Its effect on the lens based media of photography, film and television with their inherent diversity will be considerable. The following extracts from the final report reflect the tentative quality of contemporary policy analysis.

'There will be substantial excess capacity by the early 1990s unless universities, polytechnics and colleges can adapt to new tasks and to the needs of new types of student. They must be capable of responding to academic developments and to fresh demands from society. They must be in the forefront of technology, both initiating and evaluating it. However little additional capacity will be created. New developments must come from adaptation, not expansion.

'Much of the work of colleges, universities and polytechnics is intrinsically valuable but this does not preclude the need for some public accountability. Response to changing demand need not be passive acceptance of external circumstances. Education is properly concerned with influencing public attitudes. Nevertheless, the case for public expenditure on higher education must be based on benefits for the nation. One of the main aims of this report is to suggest changes which would make more visible the contributions of higher education to the economy and to society.

'Expenditure has to be restrained in an activity that must remain largely within the public sector and compete for resources with other social and education services. The strategy outlined in this report would encourage the development of a network of vigorous, efficient and cost-effective institutions, each excellent in its own range of activities, each imbued with a strong sense of academic purpose and responsive to the needs of a wider society. The main theme is an endorsement of diversity. This requires strong institutions and multiple criteria for policy formulation and resource allocation.'

'Our strategy has eight main aims:

— To provide opportunities for all who are able to benefit from some form of higher education and to encourage access from a broader social spectrum than at present;
— To reduce undue specialisation in secondary education and the initial years of higher education;
— To create a framework within which the quality of teaching and research can be maintained, at a time when underlying demographic trends will make competition for resources difficult;
— To stimulate research and other academic activities not directly linked to student numbers;
— To encourage institutions to prepare realistic development plans;
— To increase the capacity of universities, polytechnics and colleges to respond positively to changing academic, social and economic and industrial needs;
— To promote efficiency in the use of resources;
— To create a framework for policy and management studies that will help leaders of academic institutions meet the challenge of adaptation without growth.'

'British students tend to be young and to be concentrated in full-time courses despite some welcome expansion of part-time and non-degree courses outside the universities. A central concern for the future is whether this pattern remains the best way of providing for a larger and more varied student population.

'Robbins drew attention to marked differences in participation rates between different social groups and these remain. To this has been added since the time of Robbins the problem of apparently low participation by some ethnic minorities. The overall proportion of students who are women rose for several years but declined between the mid-1970s and the early 1980s. Considerable disparities persist in participation rates between different regions of the country. Such discrepancies should not be accepted as an inescapable feature of higher education.'

'The specialised honours degree has intrinsic merits. It is centred on the idea of an academic discipline: a coherent body of knowledge or range of subject matter that "holds together" and provides recognised methods of analysis. However, there are also advantages in properly integrated degree schemes in which students are able to experience the methods of thought of several disciplinary perspectives. There is no reason why everything in an undergraduate curriculum should be taught in great depth. Breadth and the ability to integrate different ideas have intellectual as well as practical value. In the probable employment conditions of the 1980s and 1990s, very specialised first degrees are likely to be even less appropriate than they were in the 1960s.

'In recent months there has been increased public discussion of proposals for a pattern of courses linked by a basic initial course of two years of full-time study (or part-time equivalent) rather than the three or four-year full-time honours degree which forms the lynchpin of the present system.

'Three possible versions of two-year initial courses of study have been proposed: more intensive first degrees of the existing type, a new type of non-degree qualification in some institutions and a new type of initial degree in all institutions.

'However, a two-year pass degree would require radical rethinking of both undergraduate curricula and the pattern of postgraduate courses. After obtaining a pass degree some students would finish their higher education, at least for a time. Others would proceed to a one-year honours course enabling them to go on to a higher degree. Another route could lead to one, two and three-year courses relating to specific occupations.'

The demand for higher education

The CNAA is among the growing number of organisations suggesting that the DES has underestimated the likely demand for higher education in the 1980s. They have listed seven areas of demand they consider to have been ignored or underestimated. They cast doubt on the premise for the entire exercise, pointing out that over the past fifteen years there has been no relationship between the number of eighteen-year-olds and the total student population. They conclude that those entering higher education do not form a homogeneous group but a variety of groups in terms of age, qualifications, level of course and mode of study. The estimates contested concern; part-time students, whose numbers the CNAA expects to continue growing, rather than remaining constant at the figure of 300 000 projected by the DES; young entrants who enter higher education at nineteen or twenty, rather than straight from school or college; mature entrants who are not 'suitably qualified', whose numbers might be expected to grow if unemployment remains high; those who join courses with a single 'A' level, who are not included in the DES projections; students on short courses; a small group, which might grow significantly in future, who are admitted directly onto the second or third year of the course because of special qualifications; and, entrants from further education, especially those with two 'A' levels. The CNAA notes that other developments are even more uncertain, listing credit transfer and credit accumulation as possible catalysts, and the expectation that circumstances in the 1990s will lead to greater appreciation of the value of higher education on the part of government, industry and the professions because of the need for a more educated workforce.

The DES Statistical Bulletin 5/84, published in April 1984, shows that overall enrolments to non-advanced further education remained fairly static at around one and a half million between 1972 and 1982, in spite of major increases in full-time and part-time attendances. One of the major reasons for this is that although students on full-time and sandwich courses increased by 81%, enrolments on part-time day courses involving release from employment decreased by 34% between that period, while evening enrolments fell by 16%.

A breakdown of this period to the last four years between 1978 and 1982 indicates that this is likely to be the continuing pattern. During that period full-time and sandwich enrolments grew by 23% as did part-time. But at the same time part-time day release enrolments fell by over a third. In total the number of students released by employers fell by some 140 000 or 31% during that period, with the decrease being slightly less for females and for those aged nineteen and over, than for males and those aged sixteen to eighteen. During this four-year period, there has also been a marked increased of 35% in the number of students taking full-time examinable vocational courses as compared to only 10% increase in the numbers taking GCE examinations.

The BIPP policy statement

The British Institute of Professional Photography has recently published its long awaited *Statement of Education Policy*.

This document is a statement of newly agreed policies with regard to education. The Institute wishes to extend and develop its link with colleges and courses, and with students with a view to actively assisting those intending to make their careers in photography. It seeks to help and guide colleges in the formulation of courses, to provide professional liaison during a student's course, and to provide assistance to graduates and diplomats on completion of their courses at the time they are seeking to establish their careers.

The past fifteen years have seen many changes in the pattern of post-school education, with new national schemes of validation and with major developments in the planning and structuring of courses. At one time the Institute played a significant role as a validating body, but this role had declined as CNAA, BTEC and SCOTEC validation increased. The Institute is aware of the need to advise, and has within its membership a wealth of professional experience and expertise which can and should complement education and training provided in colleges.

The Institute sees its future involvement taking place at several levels, and in a variety of ways, including:

1 Advising Government, the national validating bodies and individual colleges of the educational and training requirements of professional photography and careers available. The Institute is making available a series of profiles indicating in the most general terms the capabilities likely to be shown by successful entrants to Qualified Membership of the Institute.

2 Providing direct liaison between colleges and qualified successful practising professional photographers. The Institute will maintain lists of Professional Liaison Visitors, who are Associates and Fellows who are willing to assist colleges and students. Professional Liaison Visitors will assist in the provision of work experience for students.

3 Actively assisting entrants to the profession before, during and after college, particularly those gaining experience prior to achieving full corporate status.

The guidelines for approval of college courses are flexible and the demands are intended to be suitable for all courses irrespective of level or mode of learning. They are:

1 That the intention of the course is to prepare students for entry to, and subsequent career in, a definable part or parts of the photography industry.

2 That a major part of the course is directly concerned with developing the ability and knowledge required in the practice of photography, including the acquisition and development of sound practical skills.

3 That full-time courses are of the order of not less than 2000 hours which will include directed private study and work experience. The part-time course will be comparable with appropriate weighting being given to relevant work experience.

4 That the course contains elements of study, experience and/or work related to the practice of photography but directed at developing skills, knowledge and awareness of the importance of: *a* interpersonal skills and relationships in business; *b* the fundamentals of business practice with particular reference to the small business; and *c* the place of photography as a communication tool and its dependence on, inter-action with or relevance to, the other communication media.

5 That other elements of the course have some direct relevance to the development of knowledge and understanding of photography and the social and commercial context in which it operates.

6 That the providing department or section maintains an active contact with the photography industry and that the professional teaching staff keep up-to-date with local and national industry trends and developments.

7 That the facilities, equipment and staffing are adequate to the course needs, bearing in mind other demands upon them and that the experience and qualification of the latter are appropriate to the course requirements.

The relationship of examinations to Institute qualifications has always proved to be a contentious issue. The Institute has now produced the following guidelines which protect the Institute's maintenance of ▶

standards at various points of entry. Degree and Professional Qualifying Examination courses will lead to corporate membership of the Institute at Associateship level, after two years' relevant professional experience with a submission of work, subject to Institute approval of the course. BTEC and three-year SCOTEC Higher Diploma courses will lead to corporate membership of the Institute at Licentiate level, after two years' relevant professional experience. After a further two years' post-qualification relevant experience and submission of work, they would normally be eligible for regrading to Associateship level, subject to Institute approval of the course. The City and Guilds 744/745 Advanced and BTEC Higher Certificate gained by part-time study will give eligibility for entry at Licentiate level. After a further two years' post qualification relevant experience and submission of work, they would normally be eligible for regrading to Associateship level. BTEC and SCOTEC Ordinary Diploma and City and Guilds 744/745 courses will lead to corporate membership of the Institute level after two years' relevant professional experience, where they have been *specifically* approved by the Institute. The Military Route will be maintained in that Service Courses which are currently approved and future submissions in respect of other such courses will be considered and approved individually.

The Annual Report of the Direct Admissions Scheme of the Society of Industrial Artists and Designers while concerning itself with the broader spectrum of design does include photography within its scope. Some of the concerns mentioned here are echoed in the BIPP *Statement of Education Policy*, if not directly then by implication. Assessors are pleased that courses have received the accolade of DATEC recognition, but some have mentioned a concern that the larger student intake on some courses will obviously increase staff/student ratios and restrict the use of studio space and equipment. There is some worry that the contractions of three-year courses to two years may leave insufficient time to prepare students to meet the demands of professional life.

Assessors do however, appreciate the perennial difficulty of teaching the theory of professional practice to students, when its relevance can only be understood once they have left college and are faced with their first job. It was suggested therefore that the linking of design projects to a particular course of professional practice lectures might help to overcome this problem. In the graphic design reports the main concerns were: that on some courses students did not understand the role of photography as a prime source of image making in graphic design; that many were confused with copyright law and, finally, that not only was much typographic detailing poor, but students are still not being given a sufficient understanding of electronic composition and computer generated typography.

The most recent *BJ Directory of Photographic Education* was published after this summary went to press. Its contents include the range of courses 'O' and 'A' level in Photography and Film to Undergraduate and Graduate courses in Photography, Film and Television. It also records courses having a minor photographic, film or television content. This survey shows an increase in courses using 'lens media' despite the not inconsiderable cuts in further and higher education. The answer may be, although there is no statistical evidence to support such an assumption, that while the total number of courses has increased, thus reflecting a society with increased visual awareness, the actual percentage of photography in such courses has decreased thus reflecting the adverse economic climate.

The present role of part-time courses

An important survey on the frequently forgotten area of *Part-Time Courses in Photographic Education* was published in the *Journal* in late April 1984. This survey by Peter Rolls was an up-date of a survey made the previous summer. The previous survey identified 30 colleges as the UK centres for part-time education, with plans for a total of 52 courses. In the present economic climate a gap between intention and execution is not surprising and the provision for 1983-84 was 28 colleges with 46 courses. The changes in part-time provision from the 1981 to the 1983 intakes can be summarised grouping courses into four levels: Assistants (City and Guilds 750) none in 1981 and 5 in 1983; Basic (City and Guilds 744 and 745; TEC/SCOTEC Diploma and Certificate; BIPP Basic Medical) 38 to 31; Higher (City and Guilds Advanced 744 and 745; TEC/SCOTEC Higher Certificate) 12 to 8; Degree (CNAA BA) remaining steady at 2. These figures show an increase at Assistants level with the introduction of the City and Guilds 750 schemes, against a marked loss at both the Basic and the Higher levels. These changes are not compensatory; there has been a significant shift in the balance of provision. Rolls suggest that 'few people now regard the evening class as an ideal form of study, but it retains its place for two reasons: *a* students cannot always get day release concessions (this includes some who work in a different field, while seeking entry to photography through a professional course); *b* some courses are over subscribed in the daytime.' Evening classes are available in three areas and the number of students put at 137 or some 13% of the part-time student population. The earlier survey estimated some 350 students reached final assessment in 1983 with the number of part-time students at all levels in the region of 970-1020. Current figures show 353 students in their final year with a total of 1076 part-time students.

The survey looks at the regional provision of part-time courses. This shows a thin presence in most regions, but there appears to be a marked under-provision in the South West (4M people: 1 college) and the North (3M people: no college). By comparison, London has an embarrassment of opportunity with seven colleges and a student population of over 500 which represents nearly half the UK total. The scarcity of courses at the higher level are especially apparent outside London. In terms of trends, the earlier study pointed to a decline of 15% in part-time provision in 1982 following on from several years of relative stability. 1983 showed little change in total, but the balance of higher level courses is now markedly reduced. Lack of historical data makes it difficult to chart any national trends in the student population but, in terms of numbers recruited, many colleges would count 1983 as a comparatively good year. The estimated total intake of 570 is probably higher than in 1982, although this is seen by some as a 'bulge' which may not be sustained.

Photography for teachers

The Royal Photographic Society's 'Certificate of Further Professional Studies; Photography in Schools' has now been in operation for over five years. It fulfils the function not only of making teachers aware of the potential of photography as an educational tool but also gives them the necessary skills to take advantage of it. The aim of the Certificate is to provide evidence of sustained study in the practice and use of photography in schools following successful completion of a suitable course involving a minimum contact time of forty hours. Limited to qualified teachers only, the courses aim to help teachers to become proficient not in the teaching of photography but in the use of it in the teaching of other school subjects. Courses include the setting up and equipping of a school photographic section; the development and practice of photographic skills and techniques; the study of photographic equipment; the role photography plays in society; and the ways in which photography can be used as a means of creative expression. The RPS itself does not run courses leading up to the Certificate but, when a

College or Teachers' Centre proposes a course, a panel of qualified educationalists acting on behalf of the Society closely examines the structure of the course, the relevant qualifications of the course director and teaching staff, and the facilities available and the method of assessment to be used.

In the Foreword to *The BJ Directory of Photographic Education* Edward Martin strikes a cautionary note well known within the profession which also demands comprehension by all those with an interest in 'these ever-tempting careers'.

'Last year, a very high proportion of applicants to full-time courses in photography, film and television failed to reach enrolment, and a small proportion of those who did enrol soon discovered they were on the wrong course. Even for those who completed courses, the scramble for suitable employment left much young talent behind, with little hope of creative fulfilment beyond income from the DHSS or the indistinct hope of a grant from their Regional Arts Association.'

Michael Hallett

Video

The year has been rather a momentous one for video, with a variety of developments that have changed the scene to a greater or lesser extent, bringing clarity in some cases, and confusion in others.

The launch of 8mm Video was a prime example of the latter: a fourth, completely new, format, aimed at the home movie market which has been declining for some time — whether due to the high cost of film and the hassle of projecting it, or the more fundamental reason that even a half-decent movie requires skill and effort to make, no one can yet say for sure. But the fact that Kodak are leading the way doesn't have the same significance in video that it does in photography; the companies that *do* matter — like JVC, Matsushita and Sony — are waiting for some real sign of a market renaissance before they will commit themselves to the format that they initiated. Which is why Hitachi and Matsushita are quite willing to provide the camcorders for photographic companies and others to put their badges on.

In the meantime they hope to coax interest with their own camcorders designed around the Beta and VHS formats. This year Video Movie, taking a VHS-Compact cassette, joined Betamovie on the world market. Both of these have smaller head drums and restricted tape paths to achieve miniaturisation but, by ingenuity of design, maintain complete compatibility with the respective format specifications — though Betamovie's use of time compression for the video signal does prevent in-camera playback.

The miniaturising process has also been applied to Beta and VHS portables taking full-size cassettes, with the very latest examples being almost as small and just as light as the present VHS-C portables. So whether these will continue to be used with separate cameras, and the new models be smaller still (perhaps adopting the Video Movie solution), remains to be seen. The pocketable video recorder may not be far away.

Moving upmarket, Hitachi have developed an ENG camcorder taking the quarter-inch Compact Video Cassette that Technicolor flirted with briefly in the domestic/industrial markets, though employing much more sophisticated recording techniques and a faster tape speed. The Hitachi is similar to, but, as yet, not entirely compatible with, the Bosch Quartercam

format, and both are aimed at the high-band U-matic level of broadcast and top industrial/commercial usage — the same market as the Betacam and VHS-based M-format camcorders. Betacam has been leading the field in terms of sales, though VHS-M has proved more popular with manufacturers; and both of these should be able to stay the course.

The smaller tubes
Inside cameras there's been a downward drift in pick-up tube sizes, with the 17mm gaining favour over the 25mm in ENG/EFP cameras, and the 17mm size in amateur cameras being gradually superseded by the 13mm, with various design improvements and inherently greater efficiency largely compensating for the image quality loss. Matsushita have also introduced an 8mm tube for amateur use, while single tube cameras are inevitably gaining popularity over three-tube designs in the sub-broadcast field.

Cameras using solid-state pick-up devices have shown promise, but still can't match up to the general ability of tubed cameras, though both sub-broadcast and amateur models continue to appear. And CCD telecine machines are challenging flying spot scanners in the broadcast field.

Other amateur camera developments include through-the-lens auto-focusing, continuous automatic colour control, and colour electronic viewfinders — the last shared by French broadcast cameras.

Stereo hi-fi
On the recording side, the year has seen the launch of both Beta and VHS stereo hi-fi machines that have improved the sound quality out of all recognition — like a 20kHz bandwidth and more than 70dB dynamic range. These are achieved by feeding the audio through additional heads on the drum scanner rotating at 1500rmp (PAL/SECAM). It has so impressed hi-fi freaks that many are being used for audio recording alone.

But present models will need an adapter to receive the stereo TV broadcasts in a year or two, for which the BBC has been conducting test transmissions, employing digital stereo sound on an extra carrier that mono sets will ignore.

There may also be video hi-fi machines in the V2000 format according to Philips. But it may not be worth developing, because both Philips and Grundig have largely switched to the VHS format, at first buying in ready-made machines from Matsushita, then the mechanical components to be assembled in their own factories, and finally going it alone. Grundig has also dropped the V2000 Video Mini Cassette that would have competed with VHS-C. Amongst Beta companies, Toshiba have joined Sanyo in producing VHS machines alongside Beta ones — leaving Sony rather isolated. Toshiba get the VHS head drum assemblies from JVC, and Sanyo get theirs from Hitachi — and sell the results under the Fisher name.

Toshiba assemble their VHS machines in the UK, while Sanyo assemble Beta machines here. Sharp have begun a new factory in Wales to produce HVS machines; while Ferguson and Mitsubishi are using existing sites — also for VHS.

Some new industrial VHS machines were also introduced, including a video hi-fi model from Panasonic (Matsushita), and a portable from JVC.

Olympus opened a VHS editing facility and video gallery at their photographic gallery in Princes Street, London W1. Although primarily aimed at the amateur, the inclusion of a low- and U-matic VCR has also brought in off-line work from commercial users.

Tape
Olympus were also the first photographic company to buy in video cassettes and sell them under their own name, thus starting a trend. 3M, ▶

who supply Olympus, caught the UK public's imagination with their 'Lifetime Guarantee' for Scotch Beta and VHS tapes, which they've now extended to cover their professional Beta and VHS tapes. In the USA it was BASF that got in first with the same offer. But the most significant development has been the achievements of metal evaporated tape, which is necessary to achieve tolerable definition from 8mm Video with its comparatively low writing speed of 3.1m/s (PAL/SECAM).

If 'normal' metal coated tape is used then special sendust heads are necessary. As for conventional video cassettes, prices have been forced down as new brands of lower quality have come on to the market. But that will change if the EEC's plan for a blank tape levy comes into force — and they've successfully pushed up the prices of virtually everything else, including half-inch VCR's. According to the Tape Manufacturers' Group retail prices could double over the next year; with the proceeds going to the International Federation of Phonogram and Videogram Producers to compensate for the pirating of video and audio programme software. Video piracy in the UK has actually declined, though, thanks to the new law imposing greater penalties and the efforts of various organisations representing the affected parties.

The proposed levy would make two-speed machines virtually *de rigueur,* to bring the running cost back to a pre-levy value. The V2000 format has joined VHS in offering such machines, abandoning the auto-reverse idea of playing both sides of the cassette in sequence, so that a 2 x 480 cassette can now last for 2 x 8 hours. By the time that you read this there will very probably be two-speed Beta machines as well, giving just over seven hours on an L-830 cassette. Naturally, programme software will continue to be produced at the standard speed for each format.

Cable and DBS

Many people's viewing will be the poorer though, now that the so-called 'video nasties' have been outlawed by 'Bright's Bill'. The culmination of an emotive campaign exploiting children and fuelled by certain newspapers and sundry vociferous pressure groups.

The video disc also continues to be something of a controversial matter, with the pessimists remaining in the majority. Even with two formats on the domestic market — LaserVision and CED — both hard and software continue to be slow moving. On the industrial/commercial side there's cautious optimism. So Thorn-EMI have introduced JVC's VHD player and software, in competition with Philips' industrial player. But small companies will still find tape more convenient and, more importantly, cheaper.

As for that other disc system, the Mavica, the agreement on standards has yet to bring forth the goods as I write. But photokina in autumn 1984 would be an obvious showcase for a European launch, with both the photographic and video press there in force, so perhaps it will have been in the shops in time for Christmas 1984.

The granting of pay cable TV licences also came in for some media attention; and here too growth is expected to be slow. Certainly the American example doesn't give great cause for optimism, with the majority of companies either losing money or barely breaking even, and the very few — like Home Box Office — remaining the exceptions. There is also a question mark hanging over the provision of programming: where is it coming from and what will its quality be like — technically and aesthetically? The videogram producers have already squandered most of the English language films that are more or less likely to attract viewers — and the number of VCR owners is now considerable; so there will have to be a fairly rapid gearing up of alternative — and comparatively inexpensive — production if subscribers are to be attracted in sufficient numbers for profits to be made.

Some think that the direct broadcast satellite is the only viable alternative to conventional broadcast TV. But the need for a converter and an expensive — and large — dish aerial on the roof should dampen initial enthusiasm.

In the meantime, the Cable and Broadcasting Bill has set the scene for a new era of television. Though whether there will be more *real* choice for the viewers is another matter.

To end, domestic VCR sales have declined slightly this year, and this trend is predicted to continue until the replacement market gets under way in two or three years time. On the industrial/commercial side however, the market continues to grow, with more and more companies and institutions producing video or making use of the machines in various roles. A change partly brought about by the availability of heavy duty VHS machines. And partly to the flexibility of video.

Reginald Miles

Holography

1984 saw a big expansion in the embossed-hologram business. Following Mastercard's introduction of a credit card containing a hologram intended to make forgery difficult or impossible, NatWest in the UK also introduced one; Jeff Blyth promptly wrote a paper showing how easily such a hologram could be forged, with an example to back it up!

Holography continued to make headway in the field of advertising. Two holograms made their appearance alongside the escalators at Leicester Square Underground, and another appeared on the concourse at Piccadilly Circus. Holograms were commissioned for display by May and Baker, Distillers, WB Pharmaceuticals and a number of other firms including the Midland Bank. The *National Geographic Magazine* featured an article by Allen Boraiko on lasers and one on holography by John Caulfield; the issue (March 1984) carried an embossed hologram on the cover, an image of a bald eagle — of superb quality. Eleven million copies were produced, the longest run ever for a hologram. The same image appeared in *holosphere*, in an advertisement for the American Banknote Co, who were responsible for the hologram.

The 'Light Dimensions' exhibition, which closed at its initial Bath venue in October 1983, was reopened soon afterwards at the Science Museum, London, where for some seven months it attracted an average of more than 1100 visitors a day. Many of the exhibits were updated, and the opportunity was taken to improve the lighting, most noticeably in the case of the American white-light transmission holograms by Rudie Berkhout, Sam Moree and others. There was no room to show the excellent AV presentation on the principles of holography, but the opportunity was taken to improve the informative material in the entrance.

Just before Christmas 1983 the Royal Photographic Society's Holography Group came into existence under the chairmanship of John Webster, who during the year was awarded the RPS's Hood Medal for services to holography and photography. As with the other RPS groups its meetings are open to non-members, who at present form the majority of the audience, though the introduction of holography as a subject for the Society's distinctions may well influence its recruitment among the holographic fraternity. At the time of writing there have been four

meetings, all very well attended. Two were addressed by prominent American holographers: Fred Unterseher, author of *Holography Handbook,* gave a talk on dichromated-gelatin holograms, and Peter Miller, a lecturer in fine arts from California, explained the details of the making of multicolour reflection holograms, a number of which have been on display at the Light Dimensions exhibition.

If 1983 had been a good year for holography, 1984 was even better, certainly for the professional holographers who make critical holograms for sale in galleries. Permanent exhibitions have opened in Blackpool, Edinburgh and Bath, as well as St Helier in the Channel Islands, and shops in resorts such as Harrogate and Brighton display and sell holograms. The Light Fantastic Gallery in Covent Garden now has its own research laboratory facilities, and regularly commissions work for its own walls and for sale to the public, as well as for advertising and commercial purposes. A number of small companies such as See-3 Holograms of Clapham have begun to specialise in the production of high-quality master holograms for runs of silver-halide or embossed prints. At one point early in the year so much holography was being done that Agfa-Gevaert ran out of 8 x 10in plates and film! Incidentally, it has been something of a relief to learn that the company has commissioned a new plant for coating holographic plates and film: the frustrating emulsion faults we have all experienced should soon be a thing of the past.

An exhibition of lasers and their ancillary equipment was held in Brighton in the spring of 1984, and showed how far the technology has advanced recently. Although the latest tunable pulsed excimer lasers are likely to be beyond the pocket of the average holographic laboratory, prices of argon and helium-cadmium lasers are coming down steadily, while their reliability goes up. Krypton lasers, with a choice of some half-dozen visible wavelengths, are now becoming a realistic proposition for large commercial holographic laboratories, and Advanced Holographics has recently acquired one. Early in January their 'Stations of the Cross' went on permanent display in Coventry Cathedral crypt. This is a set of eleven 30 x 40cm holograms of scultpures by Malcolm Woodward: the eerie quality of the hovering golden images gives an unearthly beauty to these powerful creations.

Another exhibit at the Brighton exhibition was an example of Ealing's new range of holographic cameras. These are intended for use in non-destructive testing, and are particularly suited to holographic inter-ferometry. They use 35mm or 70mm in a special magazine, with integral high-speed single-solution processing.

New Holographic Design has marketed a new version of its holographic viewer which can replay laser transmission holograms up to 10 x 10in in size, using a white-light source with a holographic optical element behind the screen to pre-correct chromatic aberration. The product is aimed at teachers, architects, engineers and other non-holographers who have a need for three-dimensional imagery in their work; not the least advantage of this method of presentation is that, unlike models, holograms can be filed in envelopes.

The teaching of holographic skills is still lagging in the UK; at the time of writing only Richmond Holographic Studios is operating, and is (as might be expected) fully booked for some time ahead. However, an agreement has been reached with Goldsmith's College for Michael Wenyon and Susan Gamble to resume their courses in holographic techniques. The Royal College of Art is now taking a keen interest in holography as a creative medium and is building a facility which will be supported financially by short courses open to the public, several of which should have been held by the time this appears in print. In addition, the RPS Holography Group is to maintain a holography facility at its Bath headquarters which can be third to members and others, and will also be available for teaching purposes.

Research into computer-generated holography (CGH) has com-manded a good deal of attention this year. In particular, Lee Lacey in the USA has announced a new technique which synthesises computer-graphics views recorded on microfilm into a three-dimensional hologram. John Caulfield reports on three new hologram writers, one of which (Honeywell) has electron-beam operation with resolution better than a micrometre; CGHs promise to be particularly useful in testing lenses and in optical pattern recognition, as well as for making holographic optical elements not constrained by wavelength and angle of incidence. In the UK, work is continuing at the Royal Sussex County Hospital on three-dimensional images produced from series of computerised-tomography 'slices', each recorded by holographic means in its appropriate plane. Stephen Benton of Polaroid has been working on optical configurations for producing white-light transmission holograms without any intermediate master. In the new system he modifies the geometry of a focused-image hologram to incorporate the principle of Fourier-transform holography, producing a final image that is free from distortion and replays with white light.

Another piece of research has come from Nick Phillips and his team from Loughborough University. The subject is not holography but Lippman photography. A Lippman colour photograph has certain features in common with a reflection hologram, in particular that the colours of its image are produced by interference: the exposing light passes through the emulsion and is reflected back to form a pattern which, when illuminated with white light, causes constructive interference for the correct wavelengths to produce the original colours. An investigation of the properties of a Lippman photograph could well throw light on reflection holography. With the aid of some elegant mathematics, the paper shows that two mechanisms are present for producing the interference patterns: the 'blur' mechanism, which allows for about six wavelengths of useful fringes provided the optical image at any point contains a fairly narrow band of wavelengths; and the 'modal' mechanism, whereby the emulsion behaves like a Fabry-Perot resonant cavity, allowing fringes to form only for discrete wavelengths which are integral submultiples of the emulsion thickness. The team carried out a number of experiments using holographic emulsions (which are just-sufficiently fine-grained for the purpose). The paper examined the implications of the Lippmann theory for the possibility of creating reflection holograms using incoherent light, but concluded on a pessimistic note about this.

Applied Holographics, after many rumours, at last came into the open this year, launching their much-vaunted holographic camera capable of producing up to 10 000 20 x 25cm holograms per day at the touch of a button. The light source is a 0.6-joule pulsed laser, and the material is rollfilm, the emulsion and processing chemistry having been developed for the purpose by Ilford. Although the system can be used for making originals and master holograms, the single-beam (Denisyuk) con-figuration limits the scope for creative lighting, and it seems likely that its main use will be for long runs of high-quality transfer reflection holograms using masters made on an open table; the Denisyuk arrangement is ideal for this purpose. In the system the image colour is controlled by the exposure, being bluer for longer and redder for shorter exposures. Applied Holographics also produces a range of holographic equipment such as mirror holders and plateholders which complement the equipment available from the Newport Co catalogue (obtainable in the UK from Metax). Holographers can now obtain virtually any piece of equipment for making holograms from 4 x 5in up to 1m square from one or other of these suppliers, though they will still need well-lined pockets. The company is also running a full programme of research. ▶

Altogether, 1984 was a year of consolidation rather than innovation. To quote Nick Phillips: 'A few new rules have emerged.' Cottage-industry holographers have done well from sales at the galleries, and especially from the Light Dimensons exhibition; more important, they have polished up their techniques, so that today's pictorial holography is far brighter and cleaner than it was a couple of years ago. But it is in the expansion of holography into the field of commerce and advertising that the year has been notable.

Graham Saxby

Micrographics

The increasing integration of photographic microform and digital electronic systems, commented on in previous years and widely viewed as being the key to the survival and continued success of the commercial micrographics industry, was graphically illustrated in 1984 at the Annual Conference and Exposition of the US Association of Information and Image Management, formerly known as the US National Micrographics Association. The two growth areas this year have been in the development of a range of sophisticated 35mm engineering micrographic products and in the development of a new generation of general office computer-assisted microform retrieval systems which make use of digital scanning techniques to enable users to handle images electronically and integrate image, text and data processing in one general office system.

In the engineering drawing office environment, Computer Aided Design and Computer Aided Manufacturing systems are having an impact every bit as big as data processing, word processing and office automation systems in the general office environment. An industry spokesman recently predicted that in five years' time companies' CAD databases would, in terms of volume of data stored, have outgrown their existing financial databases by an average of 50%. This wholesale conversion from manual drawing preparation to CAD will create an enormous market for 35mm graphic COM systems capable of outputting drawings created on a CAD system onto 35mm rollfilm or aperture cards for cheap, secure, permanent storage. Just as today over 65% of all mainframe computer users make use of Computer Output Microfilm to archive and disseminate data and as a cheap, fast alternative to paper output so, in the near future, industry experts expect a similar proportion of CAD users to begin outputting their drawings on microform rather than costly large-scale paper plotters. This has, of course, been happening for a number of years, but 1984 saw a dramatic increase in the number of 35mm microform systems launched on the market with 3M, Imtec and a number of West German companies leading the way with a new generation of 35mm COM recorders, 35mm aperture card camera-processors, high-speed computer-controlled aperture card duplicators, computer assisted card retrieval systems, and a range of sophisticated plain paper aperture card reader-printers and enlarger-printers. We comment on specific products later in this review.

In the Computer Assisted Retrieval field, a number of companies during the year launched a new range of electronic microimage transmission systems which enable users to locate one set of their microform files centrally and retrieve, digitise and transmit copies of any particular image housed in that file, under full computer control. These new generation systems known either as videomicrographic systems or electronic document storage and retrieval systems have been designed to overcome one of the basic limitations of conventional microform based CAR systems — namely that they did not cater for simultaneous multi-user access. In other words, with conventional roll film based CAR systems such as the Kodak KAR 4000 or 3M Micrapoint systems, if a number of users in remote locations require access to the same file then copies of the microform file have to be duplicated and disseminated to all the users. This is because the microform images are stored offline and once the users have searched the computer index to find the required document location, they have to manually extract the relevant roll of film from their storage unit and insert it into their own retrieval unit. To overcome this limitation, the new generation of systems are based around one centralised set of microform. The format used can be microfiche, 16mm roll film, aperture cards or jackets, depending on application — there are units designed to accept all these formats. The microform file is loaded into one or a number of automated storage, retrieval and scanning modules which vary in their storage capacity and the type of microform they can accept but which all, essentially, carry out the same function. The storage units are linked to a control computer and also, via a local area network system, to a range of high resolution user terminals and printers for soft and hardcopy display. In operation, the microforms are indexed as they are entered into the system, so that the system controller knows exactly where any particular image is located in the system and can automatically recall it when requested. The indexing systems used are very similar to those in conventional CAR systems and vary in sophistication, depending on the needs of the user. In operation, depending on the size of the system, any one of up to fifty or a hundred users will access the computer indexing system and carry out an online search for a particular document or documents on a particular subject. As in any online system, the response will be a listing of documents retrieved plus, in this case, details of their location within the system. If the user wishes to view one or all of these documents he presses a specific key and the computer system then sends a signal to the relevant storage module and, in the case of a microfiche based system, such as those supplied by Access, Integrated Automaton and TERA Corporation, the relevant fiche will be retrieved automatically, positioned so that the relevant frame is directly below or in front of a Charge Coupled Device scanner. The frame will then be scanned and digitised and the digital representation of the image transmitted via the network to the terminal where the original request was made, where it will be displayed on the user's high resolution terminal or printed out on a plotter or laser printer.

In the most advanced systems, the same terminal used to access the computer index and to display the retrieved image can also function as a general-purpose computer terminal and be linked into the company's mainframe system, enabling the user to carry out word processing, data processing and image processing on the same terminal. At present these systems are extremely expensive, often costing in excess of a million dollars and they are customised to meet individual users' requirements but there are over a hundred systems installed in the US now and the major microform companies, led by Kodak, have announced their intention to offer such systems commercially within the next year. Kodak have given several presentations of their system, which they call the Kodak Image Management System (KIMS) which, predictably, is based around standard blipped 16mm roll film housed in their Ektamate cartridges. Their Autoload retrieval/scanner unit can hold up to 200 of these cartridges giving the system an online storage capability of approx 1 million pages and each autoload unit is supplied with four film transport units and four CCD scanners so in large multi-user systems, films can be scanned while others are being retrieved or placed back in the store using

robotic techniques.

The development of such videomicrographic systems, based around conventional microform offer users of conventional micrographic systems a path to the future and provide one more example of how micrographics is becoming inextricably linked with advances in electronic systems. Moving down the scale, however, the past year has also seen a number of significant improvements made to the design of conventional microform products and we must now briefly cover these under the standard product headings.

Computer output microfilm

As discussed above, one of the main developments has been the launch of a number of new and improved 35mm graphic COM recorders for use in CAD systems. Imtec announced a new version of their microfilm laser plotter (MLP) with an integral aperture card processor module so that CAD drawings can be plotted onto 35mm film and output within 2min on ready-to-use processed aperture cards — providing a far more convenient output option than 35mm roll film which needed to be cut and processed externally prior to use. Also new, Tameran, a US company, launched their TGR-1000 graphic COM recorder which can record images from host computer or CAD systems directly onto 16mm or 35mm roll film or microfiche. According to Tameran, any electrically-generated graphic or alphanumeric image that can be plotted on paper can be plotted on film with their TRG-1000 COM recorder. They can supply an on-line version of the recorder or an offline unit which accepts data on magnetic tape or floppy disks.

Turning to conventional alphanumeric COM systems, two trends were observable during the year. On the one hand, both DatagraphiX and NCR showed completely automatic high volume fiche production, processing, duplication and collation systems designed to speed up throughput and avoid the need for continuous operator supervision of high volume COM production. With these systems, fiche duplicators are linked directly to COM recorders with their own integral processing units so that once a fiche is produced and processed it is passed automatically into the duplicator where it is duplicated and copies of the fiche can be collated. DatagraphiX call their system the Interlink and have developed a number of sophisticated facilities into the system so that fiche can be stacked prior to duplication and bar codes can be recorded on the fiche by the COM recorder and read by the microprocessor-controlled duplicator so that it knows how many copies of that particular fiche are required. At the other end of the scale, both NCR and DatagraphiX have also launched a range of lower cost nonintelligent COM recorders which can be controlled externally by personal computers. It is hoped that these units will appeal to bureau users who wish to set up their own inhouse systems.

Cameras

The year saw the launch of a third updatable microfiche system by Canon to compete with the AB Dick System 200 and Bell & Howell Microx units. The new Canofile 900 makes use of Canon Silnova film, a type of coated dry silver film which enables individual frames to be heated up and imaged while the remainder of the fiche is unaffected. The unit is not yet in full production but it has created a great deal of interest due to its relatively low cost of approx £8000.

The other main developments during the year have again been in the 35mm field. Imtec showed an aperture card processor module for their popular A0 camera system and both 3M and Extek in the US took on agencies for the SMA Schaut range of A0 size 35mm cameras. The most interesting new cameras, however, came from Tameran who showed an automated large format rotary camera capable of accepting documents up to 45in wide and of any length and recording them onto 35mm film. The camera features a sophisticated lighting system comprising 45 1in-wide lighting zones which can each be automatically controlled to achieve maximum exposure and resolution. Tameran claim that, as a result of this breakthrough, poor quality drawings can be enhanced at the filming stage.

Computer-assisted retrieval systems

Minolta and Agfa-Gevaert launched 16mm roll film based systems designed to compete with the existing systems from Bell & Howell, 3M and Kodak but the most significant new system to be launched this year is based around a cassette microfiche retrieval unit produced by MAP in West Germany and sold by Information Design in the US and Eurocom Data in the UK. The unit can retrieve one frame from 30 fiche in under 4sec and display it on a range of screen sizes from A4 to A2. The unit is microprocessor controlled and can be operated by its own movable keyboard or via, an RS232C/V24 interface, by a range of personal computers. Eurocom are developing a range of CAR systems based around the DEC Rainbow 100 and in the US, Datacorp have shown CAR systems based around the IBM PC-XT. Two other companies, Consolidated Micrographics and Saul have introduced similar cassette fiche retrieval units as well this year and many predict that we will see a significant market for fiche and jacket based CAR systems in the next two years.

Readers and reader-printers

The year saw very few readers launched on the market. The boom area continues to be portable units where Finlay, Microphax, Bell & Howell and DatagraphiX report large orders. Among desktop units the trend is towards lightweight plastic moulded, modular units and the user of quiet, convection cooled fanless readers.

With reader-printers, plain paper processes continue to attract attention with the range of plain paper units increasing rapidly. The year saw the launch of A2 and A1 size plain paper enlarger-printers while, at the other end, Canon launched a fiche plain paper reader-printer for little more than the price of a conventional electrostatic unit. The A1 units come from Xerox and Shacoh and are aimed at the engineering market once again. Also aimed at the aperture card market are two A2 plain paper machines from Minolta and Regma while, moving down the scale, Canon launched their NP580 universal A3 size plain paper reader-printer at the end of 1983 and then followed it up with their PC Printer 70, a fiche reader-printer based around their personal copier which is selling for as little as $2600 in the USA and should provide Agfa-Gevaert with some stiff competition in coming months.

Tony Hendley

Graphic Reproduction

Photographic innovations

The process camera and enlarger continues to be the principal medium linking-in the graphic reproduction processes, the art department and the printroom, and some twenty-five manufacturers compete in this still lucrative market, which indicates that the scanner, whilst limiting traditional film methods, has certainly not superseded them. An ▶

important factor contributing to this state of affairs has been the remarkable development in platemaking materials, plus advance in computer and electronic equipment resulting in sophisticated computer-controlled models. The new technology of 'robotics' and information technology stemming from the advent of microelectronics has revolutionised camera operating procedure, effectively taking trial and error out of camera work with the trend towards automatic, push button units. Equipment incorporates digital monitoring facilities for focusing, sizing and exposing and light integrators automatically adjust exposures for voltage and lighting variations. Electronic re-sizing is available and slide turrets offer a choice of lenses, including wide-angle types, which can be selected automatically. The use of memory channels for repeat exposure programming is widespread and the majority of cameras offer wide magnification ranges. Hand wheels for focusing to size are being superseded by electronics so that no time is spent winding back and forth and it takes only seconds to slide lens holder and copy board to size and position. Vacuum control foot switches, easily accessible copy boards incorporating positioning grids to assure accuracy and halogen lamps to provide uniform illumination necessary for precise platemaking, are standard features. Accessories have also improved with on-line densitometers assessing copy rapidly; film punches are standard equipment. The modern camera is robustly made and offers manual, semi-automatic or fully automatic operation and is compact to occupy less floor space with a decrease in height and width.

The conventional darkroom is becoming obsolete due to new film technology for both orthodox and scanner techniques. With Du Pont's new laser scanner film CSL-4 scanning operations can be carried out totally under high illumination yellow light. Special sodium vapour safelights provide improved working conditions for the scanner operator. The high maximum density obtainable facilitates colour correction by chemical etching without the appearance of scan lines and the high resolution of the film permits reproduction using an 80 lines per cm screen ruling or finer (200 lines per inch).

Kodak's new line of photo-reproduction films with related products enables users to produce halftones and line work to equal the high quality of lith processing. This Kodak Ultratec product represents a breakthrough in Rapid Access Systems technology. Users can achieve increased productivity and higher quality results as well as considerable savings due to faster throughput, less inventory, fewer remakes and the fact that no control strips are required. Films are available for halftone, line, duplicating and contacting work, together with a contacting paper, contact screens, developer and fixer solutions for both machine and tray-processing operations. The developer is a single solution ready for use, thus eliminating variables in chemistry mixing and saving time on installation. The chemicals are guaranteed to be extremely stable, thus consistent high quality results can be obtained without the need for costly monitoring equipment and time-consuming monitoring procedures. The highest quality results, which were previously only possible using premium grade lith film in lith chemistry, can be achieved using these Kodak Ultratec products for projection monochrome halftone work.

Pre-press and colour scanners

Future developments in the printing and publishing industries will be controlled by electronics and computers. Computers are increasing in power as they reduce in size and cost, and have been responsible for the development and application of electronic systems for business information, text and page composition, colour separation, laser imaging, image assembly, colour proofing, platemaking, press and bindery controls and control of colour and quality. The ability of computers to

handle all these assignments is made possible by software and by the microcomputer. In 1981 there were in the region of 4000 electronic colour scanners worldwide; at the present time it is over 8000 with the major concentrations being in Japan and Europe. The volume of colour separation work which is being carried out using scanners is estimated at between 70-90%. Worldwide suppliers number about ten, with the majority being supplied by three organisations. Over 50% of the equipment in use has electronic (laser) dot generation. Colour scanners, which are gradually being replaced by large sophisticated colour page make-up systems, are being updated with the introduction of the new modular scanners. Crossfield, for instance, with the 640 series, which consists of one input scanner and three output units. One has electronic screening, another uses a contact screen for imaging and the third one has a large format and electronic screening. Hell introduced the CP304 and DC350 scanners to overcome the limitation of the DC300's unconventional screen angle. The new Chromagraph 399 replaces the 299, and a new modular scanner follows. They have pioneered laser dot generators and some 1200 Chromagraph 299 colour scanners with laser exposing systems. Dainippon of Japan have two recent scanners (SG.708 and SG.808) with electronic (laser) dot generation at conventional screen angles.

Flatbed scanners in their present form are something of an innovation as all commercial electronic colour scanners have previously used drum scanners as input. Flatbed scanners have the advantage of speed of output, but were limited in size (11 × 14in) and resolution. The new Autokon 8500 has a larger format and finer screen capability, and Optronics and Sci-tex are active in this field. The latter have produced a flatbed image processing system (Raystar) developed by Helsinki Technical University which has a 17 × 24in format size, and 130-line screen capability for single colour images. A new flatbed scanner for colour reproduction is marketed in the US by Eikonix Corp (Bedford). It is a high-speed, high-resolution image digitising system using self-scan array technology. The scanner resembles a heavy duty enlarger with the flatbed scanner in the top of a desk that contains the control electronics.

The function of electronic colour pre-press systems is to produce a press plate or the completed film for the press plate directly from the copy in one system of integrated and interactive components without intermediate manual operations or films. In the Hell Chromacom system this involves an electronic colour separation scanner or interface with a scanner; a digitising tablet with a cursor or tracer pen; computer storage; one or more high resolution video display stations for local and area colour correction and page composition manipulation; and an output device to record the image of the completed pages or plate imposition on a film or plate. Other systems are marketed by Crosfield, Sci-Tex, Dianippon Screen and Coulter Systems Corp. With Crosfield the Studio 800 consists of a family of three pre-press systems of various levels of sophistication, whilst their Studio 820 series is an off-line system that uses monochrome planning films like the Magnascan 570. The Studio 840 series eliminates the planning films and uses a colour monitor off-line with 1024 × 1024 pixel high resolution colour correction. The most sophisticated system (Studio 860) has off-line colour retouching; interface with Triple 1 Text Editing and Composition System (TECS); with high resolution for text input; fibre optics scanning of transparency input; plus high resolution electronic dot generation output for both line and halftone images.

Electronic printing

The principle of 'non-impact' printing has been assisted by the application of laser technology and has helped in speed and presentation. Xerography relies on the electrostatic principle that two objects of unlike electrical or

magnetic charge will attract each other while those of like charge repel each other. Thus a uniform charge is applied to the surface of a photo-conductive drum, which is then selectively discharged to reproduce the pattern of the original. This electrostatic image is 'developed' into a visual image on paper by a suitable powder (toner) which is then fused to the paper. The laser printer is a development of the xerographic principle specifically for use with computer input data. The main difference is that the image on the drum is laser-generated from electrical pulses instead of being a projected image of an original document. Here print-out speeds of tens of thousands of character lines per minute, (10-20 000 depending on the number of lines per inch) can be achieved. The key to the system lies in the ability to sweep the highly concentrated laser light rapidly across the photo-conductive layer whilst at the same time turning it rapidly on and off to expose discrete spots. The spot density can range from 150-160 per inch. The laser beam is modulated by an acoustic-optical deflector controlled by the computer input which effectively acts as a switch turning the beam on and off to produce the desired dot sequence. The capability of this dot switching system is of the order of several million times a second and at the same time the beam is swept horizontally across the page by a rotating mirror which can produce sweep rates of up to 10 000 sweeps per second. By careful synchronisation of both elements, alphanumeric or graphic patterns are built up on the drum from successive rows of exposed dots.

Added to high-speed capability, laser printers also reproduce copy to a very high standard in facsimile and possess greater versatility than impact printers. Character sizes and character forms can be readily intermixed and the print-out can be scaled down, if required, to fit the size of the document. Duplicate copies can be fed into the computer programme without problems of poor legibility of multi-part sets. Unlike a conventional photocopier, the print-out is on a continuous web of paper which can either be printed or plain. When plain paper is used, some machines incorporate a forms overlay facility which allows printing of logos and other fixed information at the same time as the variable input. The end product is in a single colour. The laser-developed image is made smudge-proof by fusion in the toner into the surface of the paper by the application of heat and pressure, which is the same principle as the conventional photocopier. Because of the higher speeds involved, high fusion temperature is required — a roller temperature of 204°C at a pressure of 40psi. This is achieved using a pre-heated platen to increase the paper temperature, which is followed by high speed fusing. Letterpress or lithography is used, in the main, for continuous form printing and ink systems must withstand the conditions of the fuser station. Experience has shown that fully oxidative inks containing drying oils and no low boiling solvents are preferred. Upon drying, a chemical change occurs in the ink film which very much increases its molecular weight and makes it insoluble and non-thermoplastic. UV-curing inks, which have the advantage of increasing the drying speed, have been successfully tested and, to overcome the problem of print storage whilst the ink hardens, may be used generally in the future.

Ultimately electronic publishing, electronic mail and offices will take over. At present printers and publishers have to combine traditional techniques with an acceptance of electronic technology systems particularly, in the initial stages, in the areas such as finance, banking, instant news, directories and research and scientific data processing. In the field of book publishing — fiction and technical, dictionaries, teaching modules, news and magazines and the advertising media — old and new methods can co-exist in conjunction with each other.

The largest print organisation in the UK, the British Printing Corporation (BPC), has changed its title to the British Printing & Communications Corporation (BPCC). Datasolve, which provides electronic publishing services, has revealed that the news sector in this field has a 34% annual growth rate in the US where ownership of personal computers is growing by five million per year. The scientific and technical world is particularly interested in electronic media on account of its accessibility, storage advantages, speed and archiving potential. The cost of scientific and technical journals is outrunning inflation, and the time lag from submission of manuscript to appearing in print runs to several months. Electronic production provides an easy answer for text transfer, but the problems of satisfactory illustration reproduction have yet to be solved. Information can be distributed in various ways in that the printer can now choose the printed form, floppy discs and video, and it is realised that video tape magazines as exemplified in the US, have a future for specialised fields. In Japan, Sony have their new robotic library in which users check-in via a computer card. Shelves contain video and audio tapes, not books, and requested material is obtained from a screen-displayed catalogue index and delivered by small robots on a railway system to a vacant viewing booth with video recorder.

Instant print, photocopiers and offset printing
Many large firms, as recently as 1980, replaced offset machines with fast photocopiers. This trend has slowed down considerably. The small-offset market has rallied in a remarkable way to the challenge of sophisticated photocopiers, with the introduction of cleaner, simpler and more compact machines. The improved print quality supplied by offset litho is a feature required by many users of print; thus it is found that many companies use photocopiers for simple line reproduction and employ offset inplant equipment for the more sophisticated jobs involving halftone and multi-tone work. The fact that the cost per copy from a photocopier is considerably higher than from a press is another plus in offset's favour. Although a degree of rivalry between the two processes exists they are working amicably side by side in many in-plant firms, offering a broad reprographic service using photocopiers for small, urgent copies and small-offset machines for lengthy, quality runs. In many areas the electronic systems embodied in photocopiers are not yet challenging printing as an alternative form of commercial communication, and the printing press is still the hub around which everything else revolves. Press activity and development continue apace and many innovations first formulated in the late 1970s are now appearing in commercial models to the benefit of the printer. Small-offset single-colour machines are being equipped with numbering, imprinting, perforating and slitting heads, plus quick release plate bars and clamps. In some instances automatic blanket washers are fitted as a standard or optional extra. Improved dampening systems have also resulted in accurate ink/water balances producing satisfactory prints with the first dozen sheets. Clear dots, good solids and sharp halftones favour offset machine duplicating rather than a copier. Microelectronic technology has made possible in offset work the complete automation of make-ready jobs, plate priming and loading, plus printing, ejection of the plate or master and blanket wash-up. This provides a cleaner working environment, frees staff to carry out other duties and also eliminates the need for highly trained operators.

The instant print industry is a progressive and viable area which started to proliferate a decade ago and was ignored by the general commercial printer. Some 70% of output comes under a 24-hour service scheme and there are some 1000-plus instant print shops in the UK. It is estimated that the instant print market will grow by over 150% this year, while the overall print market is expected to grow by approximately 10% in the same period.

Eric Chambers ▶

Colour

Although the flow of new colour materials has slowed down somewhat, in the twelve months ended in mid-1984 there have still been enough new products marketed to make testing and comparisons a fairly continuous process. In contrast to the previous year there appear to have been more new reversal products than negative, although some extremely interesting new negative colour films have been introduced. All the major sensitised materials manufacturers in Japan and Western Europe now make their reversal films to process in the E-6 process solutions and their negative films to process in the C-41 process solutions, with the last company to fall into line being Agfa-Gevaert. For the most part colour products made in Eastern Europe and Russia still adhere to their own formulations and schedules — some details of these can be found in the listings of colour materials on p178 and the pages which follow.

Colour negative films

Agfa-Gevaert launched a complete range of new colour negative films in the spring of 1984, Agfacolor XR100, XR200 and XR400 films, all of which were said to feature substantial improvements in the criteria which decide photographic quality — colour rendering, sharpness, graininess and speed. The name codes of the new films incorporate the ISO speed rating, as is now common with all manufacturers, and the improvements in image quality at these speed ratings are said to have been made possible by the use of new crystal technology, a new type of layer design and improved emulsions. The new films are claimed to incorporate structured twin crystals, either flat or compact in form, to produce high speed with low graininess; the flat crystals would appear to be similar to the crystals of tabular habit which are incorporated in Kodak 'T-grain' emulsions such as Kodacolor VR1000. A large number of other detail improvements have been made in the new Agfa-Gevaert colour negative films, all of which are intended for processing in C-41 solutions, which combine to make these products now comparable with the best from other manufacturers.

To complement the two colour negative films introduced in the spring of 1983, Fujicolor HR100 and HR400, Fuji brought out the ISO200 material, Fujicolor HR200, which had earlier been available only in disc format, in 35mm size towards the end of the year. But in the early months of 1984 Fuji announced that a colour negative film with a speed of ISO1600 would be available world-wide by late spring. This new colour negative film is of unprecedented speed and its development was said to have been accomplished by the advancement of the HR emulsion technique used in the slower HR films, the higher film speed having been accomplished, it was claimed, by the development of an entirely new type of coupler which, during colour development, protects the latent image from being destroyed by the oxidising property of the colour developer. This action of the new coupler permits the realisation of the maximum speed from a given emulsion; the new coupler is referred to as a 'development amplifier' by Fuji.

Fujicolor HR1600 was said, at the time of its introduction, to provide exceptionally fine grain, unexcelled image sharpness and faithful texture rendition, particularly in very low light situations.

In common with other manufacturers Ilford also replaced their ISO100 colour negative films, Ilfocolor 100, with an improved product, Ilfocolor HR100 and introduced also an ISO200 film in 35mm and disc formats. The emulsion of Ilfocolor HR100 film is said to have been developed to provide a greater level of acceptable 'first-time' prints for amateur photographers. Extended exposure latitude and improvements in emulsion stability, both before and after exposure, are said to combine to produce a film which is exceptionally robust. As well as retaining the natural colour reproduction which was claimed for the existing ISO100 products Ilfocolor HR100 claimed also to have added improvements in terms of both colour brightness and colour saturation.

The new Ilfocolor HR200 emulsion is said by Ilford to achieve a level of image quality and speed relationship which would have been impossible without improvements in sensitising technology; improvements which have brought about substantial increases in image sharpness. This new product also reflects the HR100 claims and produces clean bright colours with excellent colour saturation. Ilfocolor HR200 is said to be capable of image quality in excess of that achieved with conventional ISO100 materials, but giving twice the camera speed; this film has fine grain and sharpness characteristics which are an essential requirement for the smaller disc negative format.

In addition to changing the general brand name for their colour films, from Sakura to Konica, Konishiroku also introduced three new high resolution colour negative films, Konica Color SR100, SR200 and SR400 at the end of 1983. Konica Color SR100 is claimed to be an ultra-fine-grain colour negative film offering brilliant colour reproduction and wide exposures, two lengths of 120 size, 6 and 12 exposures and no less than image stability are said to be outstanding. Konica Color SR100 is unusual in that it is available in the widest range of formats and packings, three lengths of 35mm film, 12, 24 and 36 exposures, two lengths of 110 format, 12 and 24 exposures, two lengths of 126 format, 12 and 24 exposures, two legnths of 120 size, 6 and 12 exposures and no less than six combinations of width and length in bulk packings; not all of these are available in all markets, however.

Konica Color SR200 is claimed to feature a new type emulsion which makes it possible to offer the advantages of excellent image quality (ultra-fine grain, sharpness and brilliant colour) in a very fast film. SR200 film is said to utilise major advances in emulsion technology — including Konishiroku's cubic crystal technology, the use of timing precursors and dye compensator layers to attain image quality equivalent to or surpassing that of conventional ISO100 colour negative films. Konica Color SR100 film is available only in 35mm and disc film formats.

Although listed in the promotional material Konica Color SR400 film had not been made available in the United Kingdom until mid-1984; at that time an ISO400 colour negative film identified simply as ISO400 was supplied in the new packaging under the new Konica Color brand name. It seems most likely that this is the same material as was introduced at photokina 1982 as Sakuracolor 400 and that the new high resolution SR400 film will be introduced at a later date.

The only new professional colour negative film to be introduced in the twelve months to mid-1984 was Kodak Vericolor III Type S. According to the manufacturer the new product offers several improvements over Vericolor II, including significantly improved dark storage dye stability for longer lasting negatives, increased sharpness, higher film speed and improved colour reproduction. For the processing laboratory the new film offers reduced process sensitivity, bleaching without leuco cyan dye formation and a reduction in developer replenisher rate of 30%, representing approximatly 20% of total chemical costs.

On test the claims for improved colour reproduction, when compared to Vericolor II, together with better sharpness, were found to be justified and Vericolor III film has obviously benefited from the new developments in emulsion technology which were first incorporated in the two new

Kodak negative films for the amateur, Kodacolor VR100 and VR200.

Colour reversal films

At the same time as Agfa-Gevaert introduced the new range of colour negative films the existing range of slide films was supplemented by two new products under the brand name Agfachrome, CT64 and CT200. As with the negative films these brand names indicate the ISO speed of the films. Colour reproduction, sharpness and graininess have, it is claimed, been distinctly improved and many of the new developments incorporated in the negative films have also been used in the improvement of the reversal films — structured twin crystals, colour emulsions divided into high- and low-speed layers and the use of controlled inter-image effects, for example. However, the new Agfa-Gevaert reversal films also incorporate a number of changes in colour technology which are not shared by other products, a red filter layer between green and red sensitive emulsions to give better colour separation, improved yellow couplers with a colour intensifying action and the incorporation of a control layer which, by the control of inter-image effects prevents excessive dye formation so that colours are reproduced in a more natural and balanced way. This is said to be particularly noticeable in the red and green tones.

The Agfachrome CT64 film, which replaces the long-established Agfacolor CT18, is slightly faster than its predecessor and, of course, is intended for processing in E-6 solutions. Agfachrome CT200 represents an improvement over the material introduced two years ago under the same name which was, in fact the first colour reversal film to be manufactured by Agfa-Gevaert at Leverkusen intended to be processed in E-6 process. Like its slower counterpart Agfachrome CT200 includes all of the new developments in manufacturing technology.

All of the new Fuji colour reversal products which were announced at photokina 1982 and which were described in the *British Journal Annual* for 1984 were introduced in the United Kingdom at the end of that year; these products included both amateur and professional versions of the ISO100 and ISO50 films — the latter proving to be a product of exceptional quality — a tungsten balance film of ISO64 speed and a duplicating film.

Early in 1984 two more Fujichrome Professional reversal films were introduced by the company, Fujichrome 400 Professional D and Fujichrome 1600 Professional D. The first of these, which became available in the United Kingdom in May 1984, was claimed to deliver outstanding colour balance, fine grain and brilliant sharpness. This film is intended for standard E-6 processing and can be pushed in the conventional way, by extending the first development time, to ISO800 or 1600.

Fujichrome 1600 Professional D film is, it is claimed, the world's fastest professional film and allows exposures at ISO1600 and 3200 with Fuji's newly developed ultra-high-speed push-processing system PZ; this new processing method is said to give excellent results with this high-speed film in image sharpness, colour rendition, grain quality and rich colour graduation. At the time of its introduction Fujichrome 1600 Professional D film was scheduled to become available on the market in June but no details of the availability of the special processing were given.

Early in 1984 Eastman Kodak released small quantities of a new Ektachrome material specifically intended for push processing under the name Ektachrome P800/1600 Professional film. According to Kodak, because this film is manufactured specifically for push processing, it provides significantly better results at ISO800 and 1600 than are possible from pushing Ektachrome 400 film. Maximum density with P800/1600 is higher, it is claimed, reducing the 'smoky' shadow areas that may be seen when other films are pushed.

Ektachrome P800/1600 film requires normal E-6 processing solutions but the first development time is extended according to the increase in film speed required. These times range from eight to fourteen minutes.

A second new Ektachrome film was announced by Eastman Kodak at the end of February 1984 to replace, in due course, Ektachrome 64 in all amateur sizes except 110 and 126. Ektachrome 64 Professional film will continue to be manufactured. The new film, Ektachrome 100 Daylight film will be available in 20- and 36-exposure cassettes of 35mm film and a professional version will also be available in 120 roll and sheet film formats. At the time of its announcement the new film was stated to be available in the United States in May. Ektachrome 100 was claimed to offer more neutral shadows than Ektachrome 64, together with improved reproduction of some coloured fabrics and flowers. These improvements, like similar ones claimed for the new Agfachrome films, undoubtedly result from changes to the red sensitisation, with reduced sensitivity to far red and infrared.

Colour print materials

Having for some years supplied a colour paper intended for the Ektaprint 2 process which was manufactured for the company in Japan, Agfa-Gevaert finally introduced a compatible paper of this type of its own manufacture at the end of 1983. Under the same Agfacolor Type 7 Professional the new paper was claimed to be equally suitable for big format enlargements and professional printers and, due to its uniformity and stability, for amateur finishing. The characteristics claimed for the new paper are outstanding colour reproduction, high colour saturation and good colour separation together with greatly improved reciprocity properties. On test all of these properties could be confirmed and as the first colour paper manufactured by Agfa-Gevaert for processing in the widely used Kodak solutions it is undoubtedly a very competitive product, Agfacolor Type 7 Professional paper is available in all standard formats and with glossy, semi-matt and fine grain lustre surfaces.

Early in 1984, to coincide with the Third International Symposium on Photofinishing Technology, held in Las Vegas from 2 to 5 April 1984, Konishiroku announced Konica Color Paper Type SR, a high-speed colour paper designed to give outstanding results with Konica Color SR films and their equivalents from other manufacturers. An important new feature of Type SR paper is greatly enhanced dye image stability which is said to be achieved through the use of exclusive Konica Color SR couplers in the emulsion. Prints made on Type SR paper will, it is said, retain rich, true colours for decades longer. On the basis of tests carried out by the manufacturer yellow, magenta and cyan formed dye images are predicted to retain at least 70% of original density for 100 years or longer, under normal conditions of preservation in a photo album.

In addition to these excellent characteristics, so far as the stability of the processed image is concerned, Konica Color PC Type SR paper offers good latent image stability and reciprocity characteristics; it is said to be equally suitable for use with the latest computerised high-speed automatic printers or for the custom printing of enlargements. This is an interesting development, doubtless as the result of continuing concern about the stability of colour images, and one which will almost certainly be followed by other manufacturers.

Although a new range of Ektachrome papers was announced at photokina 1982 none of these new materials has appeared on the market in the meantime. However, in a paper presented at the Las Vegas Photofinishing Symposium in April 1984 it was confidently asserted by the authors, Guehennec of Kodak-Pathé and Weber of Eastman Kodak, that

the papers would become available worldwide in that month. The new range actually consists of two papers and a film together with a new process for the three materials.

Ektachrome 22 reversal colour print paper is a resin coated material designed to give high quality colour prints from colour transparencies. Compared to Ektachrome 14 paper, which it replaces, the new paper is claimed to have improved reciprocity characteristics, increased printing speed between ⅓ and 1 stop depending on printer type, more neutral stain, improved yellow and magenta dye stability, a better matt N surface and less or no curl in low humidity conditions.

Ektachrome 21 paper is designed to replace Ektachrome 19 paper in amateur and professional copy-print type applications and, like Ektachrome Overhead Film, is similar in its characteristics to the existing product. All these three new Ektachrome print materials must be processed in the new R-3 process which gives the processing laboratory improved process stability and lower processing costs. The new process needs a lower replenishment rate and permits a 95% minimum efficiency of silver recovery. In the case of Ektachrome Overhead film the new process yields increased shoulder contrast and a higher D_{max}. Although these improvements may seem to be no more than minor details they will doubtless be welcomed by photofinishing laboratories since they make an already good product even better. Indeed this can be said of all the new materials introduced in 1983/84 — the quality of colour materials has now reached unprecedented levels in all respects.

George Ashton

BLACK & WHITE
FILMS

N SPITE of the fact that today the majority of photographs are made on colour film there are still a number of markets where black-and-white film is an essential sensitised material — the newspaper industry is perhaps the best example. It is thus still worthwhile for the major manufacturers of sensitised products to produce general purpose black-and-white films for pictorial purposes as well as a range of more specialised products such as x-ray film and the films used for the production of gravure and litho printing plates.

The list which follows is comprehensive in so far as manufacturers is concerned — it includes all those in Europe, Japan and the United States — but covers only those medium contrast films intended for general purpose pictorial photography which are generally available. It does not, therefore, include films for more specialised purposes, such as aerial photography or motion picture photography; nor does it include general purpose films which are available only to special order.

In a number of cases manufacturers actually produce a much wider range of black-and-white films than the listing would seem to suggest; the Eastman Kodak Company and its factories throughout the world, in particular, still list a very large number of monochrome films which are available only with modest or large minimum order requirements for general or specialised use — details of these can best be obtained directly from the companies concerned.

All the films listed are made by the manufacturer named and no 'own-brand' or 'private label' films are included, although a number of manufacturers continue to produce material for sale in this way.

Film	Manufacturer or Distributor	ISO Speed	110	126	135	Bulk 35mm	127	120	220	Bulk 70mm	Sheet	Remarks
Agfa Isopan	Agfa-Gevaert AG Leverkusen, Germany	125	●	●				●				
Agfaortho 25	Agfa-Gevaert	25			●						●	
Agfapan 25	Agfa-Gevaert	25			●		●	●			●	
Agfapan 100	Agfa-Gevaert	100			●		●	●			●	
Agfapan 200	Agfa-Gevaert										●	
Agfapan 400 Professional	Agfa-Gevaert	400			●		●	●			●	
Agfapan Vario-XL	Agfa-Gevaert	125-1600			●							Chromogenic monochrome
Agfa Dia Direct	Agfa-Gevaert	32			●							Direct reversal
Efke R and KB 14	Fotokemika, Zagreb, Yugoslavia	20			●		●	●				Adox licence
Efke R and KB 17	Fotokemika	40			●		●	●				Adox licence
Efke R and KB 21	Fotokemika	100			●		●	●				Adox licence
Fortepan 100	Forte, 2601 Vac, Vam u2, POB 100 Hungary	100			●		●	●				
Fortepan 200	Forte	200			●		●	●				
Fortepan 400	Forte	400			●		●	●				
Neopan SS	Fuji Photo Film Co Ltd, Tokyo, Japan	100			●							
Neopan 400	Fuji	400			●							
Pan F	Ilford Ltd, Mobberley, England	50			●		●	●				
FP 4	Ilford	125			●		●	●	●		●	
HP 5	Ilford	400			●		●	●	●		●	
XP 1-400	Ilford	50-1600			●		●	●				Chromogenic monochrome
Technical Pan 2415	Kodak Ltd, Hemel Hempstead, Herts HP1 1JU	25-50			●		●				●	

▶

Film	Manufacturer or Distributor	ISO Speed	Sizes									Remarks
			110	126	135	Bulk 35mm	127	120	220	Bulk 70mm	Sheet	
Panatomic-X	Kodak Ltd	32			•	•		•				
High Speed Infrared	Kodak Ltd	50-125			•							with filter
Verichrome Pan	Kodak Ltd	125	•	•			•	•				
Plus-X Pan	Kodak Ltd	125			•	•		•	•	•	•	
Tri-X Pan	Kodak Ltd	400			•	•		•	•	•	•	
Recording 2475	Kodak Ltd	1000			•							
Royal-X Pan	Kodak Ltd	1250						•				
Sakurapan SS	Konishiroku Photo Industry Co Ltd, Tokyo	100			•			•				
Sakurapan SSS Professional	Konishiroku	200									•	
Sakurapan 400	Konishiroku	400			•							
Sakura Infrared 750	Konishiroku	—			•			•				
Labaphot SW 100	Labaphot Louis Langebartels GmbH, Berlin	100			•							
Black & White	3M Italia SpA, 20090 Milan, Italy	125			•	•		•			•	
Negrapan 21	Negra Industrial SA, Barcelona	100	•	•	•	•	•	•				
Tura 22	Tura GmbH, Duren 1, Germany	125	•	•	•							
Tura P150 Professional	Tura GmbH	125			•	•		•				
Tura P400 Professional	Tura GmbH	400			•	•		•				
Valca F-22	Valca SA, Bilbao, Spain	125		•	•	•	•	•				
Valca H-27	Valca, SA	400			•	•		•			•	
Orwo NP 15	VEB Filmfabrik Wolfen, 4440 Wolfen 1, DDR	25			•	•	•	•	•	•		
NP 22	VEB Filmfabrik Wolfen, 4440 Wolfen 1, DDR	125			•	•	•	•	•		•	
NP 27	VEB Filmfabrik Wolfen	400			•	•	•	•	•		•	
NP 30	VEB Filmfabrik Wolfen	800						•				

BLACK & WHITE
PROCESSING

General Instructions

Making up solutions

Glass, plastic, new enamel or stainless steel vessels should be used. The chemicals should be taken in order and each completely dissolved before adding the next, using about three-quarters of the final volume of water. Cold or tepid (35-40°C) water should be used, *not* hot water (exceptions are given below). Distilled or deionised water should preferably be used in making up the solutions, particularly the first and colour developers, but this is not essential, and tap water may be used. If the water supply is too hard, it is helpful to add, particularly to water destined for black-and-white and colour developers, *before* dissolving any other chemicals, 2g/l of a sequestering agent: Calgon, sodium hexametaphosphate, or sodium tripolyphosphate.

Anhydrous carbonate should be dissolved separately in about three times its own bulk of hot water. Hot water must also be used to make up a hardener-bleach, which may throw down a white precipitate when cold, but this does not affect its working; stop baths are best made up cold. Time can be saved by using 20% solutions of thiocyanate and bromide instead of solid reagent. Phenidone should be dissolved after the hydroquinone and alkalis.

All solutions should be allowed to stand for about 30min and filtered before use.

Practical metric measures (g=grams; m=millilitres (=cm³ for practical purposes); °C=°Celsius) are used throughout.

Chemical names and synonyms

As far as possible the current preferred names have been used for chemicals. These are the names under which they will generally appear in manufacturers' catalogues. However, earlier editions of the *Annual* and *Almanac*, and formulae from other sources, may make use of alternative names. The most important of these are listed here:

Acid EDTA (see EDTA)
Borax (=disodium tetraborate)
Calgon ([trade name]=sodium hexametaphosphate)
Caustic soda (=sodium hydroxide)
Chlorquinol (=chloroquinol *or* chlor-hydroquinone)
Chrome alum (=chromic potassium sulphate)
Diethylene glycol (=digol)
2,5-Dimethoxytetrahydrofuran (=tetrahydro-2, 5-dimethoxyfuran)
Disodium phosphate (=disodium hydrogen or orthophosphate)
EDTA (=ethylenedinitrilotetra acetic, often called ethylenediamino-tetra acetic acid *or* ethylene bisiminodiacetic acid). The acid has been referred to variously at times as Acid EDTA, EDTA, EDTAA, Ethadimil, Acide tetracémique, Havidote and tetramic acid. Trade names include Irgalon and Sequestrene or Sequestrol (Geigy), Versene (Dow), Questex, Tetrine, Kalex, Trilon B, Komplexon, Complexone, Nervanaid (ABM Industrial Products Limited). Salts of this acid used photographically are EDTA NaFe (=EDTA ferric monosodium salt) and EDTA Na₄ (=EDTA tetrasodium salt). The name edetic acid for the acid, the salts being edetates, has recently made its appearance in the British Pharmacopoeia Codex and the US Pharmacopoeia.
Ethylene diamine (=1,2-diaminoethane)
Formaldehyde (=formalin)
Glycin (=para-hydroxyphenylglycerine *or* para-hydroxyphenyl amino-acetic acid)

IBT ([trade name] = benziotriazole)
Kodalk ([trade name]=sodium metaborate)
Monopotassium phosphate (=potassium dihydrogen orthophosphate)
Monopotassium phosphate (=sodium dihydrogen orthophosphate)
Potash or potassium alum (=aluminium potassium sulphate)
Pyrocatechin (=catechol *or* 1, 2-dihydroxybenzene)
Sequestrene NaFe ([trade name]—see EDTA)
Sodium bisulphate (= sodium hydrogen sulphate)
Sodium bisulphite (= metabisulphite)
Sodium hydrosulphite (= sodium dithionite)

Hydrated salts

Many of the salts used in these formulae may be obtained alternatively in anhydrous or hydrated forms, in some cases in several states of hydration. Some of the principal of these are as follows:

Disodium hydrogen orthophosphate—available with $2H_2O$, $7H_2O$ (relatively rare) or $12H_2O$. The relative quantities required are 1.00, 1.50, 2.00.

Ethylenediamine—in its hydrated form contains 80% of the pure substance: relative quantities to be employed are therefore 1.00 and 1.25.

Magnesium sulphate—has $1H_2O$ in its hydrated form or $7H_2O$ ('Epsom salts'). The relative quantities required are 1.00, 1.15, 2.05. The so-called dried form is of variable composition.

Sodium acetate—has $3H_2O$ in its hydrated form. The quantity relative to anhydrous required is 1.66:1.00.

Sodium carbonate—available anhydrous, $1H_2O$ (soda ash) or $10H_2O$ (washing soda). The relative quantities required are 1.00, 1.26, 2.69.
Although specifications are frequently quoted in terms of the anhydrous salt, this is more difficult to dissolve than the stable monohydrate, sold as soda ash (note: this is available in a range of purities—many too impure for photographic use). The decahydrate, washing soda, tends to lose water of crystallisation and go powdery: its composition is then indefinite.

Sodium dihydrogen orthophospate—usually with $2H_2O$. The quantity required relative to the anhydrous material is 1.30:1.

Sodium sulphate is available in the anhydrous form and with $10H_2O$. The relative quantities are 1.00 and 2.27. The anhydrous form may be unreliable unless dried before use.

Sodium sulphite—anhydrous, $7H_2O$ or $10H_2O$. Relative quantities required are 1.00, 2.00, 2.27.

Sodium thiosulphate—has $5H_2O$ in hydrated form. Quantity required relative to anhydrous is 1.57.

Trisodium phosphate—has $12H_2O$ in hydrated form. Anhydrous and hydrate are not interchangeable by equivalent weight as the latter is more alkaline.

Alkali solutions

Sodium hydroxide—although the traditional form of sodium hydroxide is as sticks or pellets, a convenient form of purchase for the small user is as a 40 or 50% weight/volume solution, which keeps indefinitely if stoppered. The weights specified for pellets should be multiplied by 2·5 or 2 respectively. The pellets and sticks absorb both CO_2 and moisture readily.

Ammonium hydroxide—the standard form is '880 Ammonia', a reference to its density. This solution is 35% weight/volume. Dilution to ▶

20 and 25% requires dilution with water in the ratios 100:75 and 100:40 respectively.

Activity
When strict accuracy is essential, the pH-value may be checked with a pH-meter (test papers are not suitable) and adjusted to the standard value by the addition of caustic soda (sodium hydroxide) pellets or flakes or the 40 or 50% solutions mentioned above—it is safest to use the dilute solutions—to raise the pH-value or, if necessary, sodium metabisulphite or acetic acid to lower it. Liquid pH indicators, eg BDH, may be useful to the amateur, available from pharmacies.

Chemical suppliers
Most chemicals quoted in *The British Journal of Photography Annual* are available from Rayco Limited, Rayco Works, Blackwater Way, Ash Road, Aldershot, Hants, telephone 22725. Rayco are willing to add to their chemical lists, which can be obtained by sending a stamped addressed envelope, according to user requirements. Koch-Light Laboratories Limited, Colnbrook, Buckinghamshire SL3 0BZ, telephone: Colnbrook 2262-5, stock a very complete range of chemicals, especially organic ones, and are suppliers to the large scale user, trade, and industry. The Rexolin Division of W. R. Grace Ltd, Northdale House, North Circular Rd, London NW10 7UH supply EDTA, EDTA salts and chelating agents.

Negative Developers

FINE GRAIN FORMULAE

All the formulae included here will give some refinement of grain over the developers in the other sections at a given exploitation of a film's speed. The actual degree of refinement will closely relate to the film speed reached *vis-à-vis* the normal ASA rating. Any increase in speed will give some increase in grain, although this can be kept to a minimum in carefully balanced formulae. On the other hand, very fine grain will only be obtained at some, say ½ stop, loss of film speed. When maximum sharpness and definition are required, refer to the Acutance Developer section; this gain may be at the expense of a slight increase in granularity and some loss of middle-tone gradation.

MEDIUM FINE GRAIN
D-76

Metol	2.0g
Sodium sulphite, anhydrous	100.0g
Hydroquinone	5.0g
Borax	2.0g
Water to	1000.0ml

D-76 Replenisher
Metol	3.0g
Sodium sulphite	100.0g
Hydroquinone	7.5g
Borax	20.0g
Water to	1000.0ml

This developer has come to be taken as a standard against which the granularity, speed, sharpness and definition given by other developers is compared. Thus a formula will be said to give such and such speed increase or loss, increased or less granularity, or higher acutance than D-76. It is also marketed as ID-11. The use of the replenisher quadruples the life of the developer, which is otherwise about ten films per litre. Use of replenisher without dilution to maintain level of solution in tank D-76 gives some rise in activity on use and storage, the addition of 14g/litre of boric acid crystals provides additional buffering, which will even out its action an give greater contrast control, with a 10-20% increase in developing time.

Adox M-Q Borax

Metol	2.0g
Sodium sulphite, anhydrous	80.0g
Hydroquinone	4.0g
Borax	4.0g
Potassium bromide	0.5g
Water to	1000.0ml

This variant formula of D-76 gives slightly better sharpness with a slower contrast rise. Development times are 10-20% longer. It is closely related to the ASA developer for miniature films, and the Ansco M-Q Borax formula.
For a Phenidone variant of this formula, see FX-3 and FX-18 (preferred) below.

Adox M-Q Borax Replenisher

Metol	3.0g
Sodium sulphite, anhydrous	80.0g
Hydroquinone	5.0g
Borax	18.0g
Water to	1000.0ml

Add 15-20ml of replenisher for each 36 exposures of 35mm film or 120 size rollfilm in one litre or more, discarding some developer if necessary. This maintains quality and developing time.

ID-68 Ilford P-Q Fine Grain formula

Sodium sulphite	85.0g
Hydroquinone	5.0g
Borax	7.0g
Boric acid	2.0g
Phenidone	0.13g
Potassium bromide	1.0g
Water to	1000.0ml

This buffered borax formula gives a marked film speed increase over D-76—about 30-60%, with a minimum increase in granularity, and good sharpness. Times 6-12min at 68°F. The developer, to be used undiluted, has a minimum change of activity with use. Results are comparable to Ilford 'Microphen'.

D-23

Metol	7.5g
Sodium sulphite, anhydrous	100.0g
Water to	1000.0ml

Increase development time by 10% after each film, until 8-10 films per litre have been processed. Use of replenisher extends life to 25 rolls per litre. Negligible film speed loss.

D-23 Replenisher

Metol	10.0g
Sodium sulphite, anhydrous	100.0g
Kodalk	20.0g
Water to	1000.0ml

Add 20ml for each 36 exposure length or 120 size rollfilm, discarding some developer if necessary. The amount applies to replenishment of 1 litre of developer or more. Replenisher identical to that for D-25.
This developer by R. W. Henn and J. I. Crabtree is the simplest medium fine grain formula. In general it gives good sharpness with slight resolution loss on some films; it is softer working than the D-76 type, and may give a slight increase in granularity; film speed very closely approaches normal. Those workers beginning to weigh and make up their own solutions are recommended to try this formula in use with slow, medium speed films. Diluted 1+3 it resembles the Windisch compensating formula—see page 170—developing time 20-30min

approximately for slow and medium speed films. Use once and discard. With the Metol reduced to 5g it becomes Ferrania R23, giving still greater compensation for exposure errors and high contrast.

D-76d, D76b, Agfa 14, Agfa15

D-76d is a 'buffered borax' version of D-76 (see also notes to D-76) giving greater contrast control, more consistent results on re-use, with a slight speed loss, and 25-50% time increase. Agfa 14 gives results similar to D-23 with similar times. D-76b is a motion picture and variable density sound track developer giving softer results than D-76 with similar times. Agfa 15 is suitable for some modern films notably the slow and medium speed ones, times 25% less than D-76 or ID-11, times in which are given in manufacturer's data sheets. The use of these formulae has fallen off in recent years, with the exception perhaps of D-76d. (See also the Ilford published P-Q fine grain formula ID-68 for a Phenidone buffered-borax developer above). The Ferrania developer R18 is identical to D-76d.

Constituents	Quantities in grams			
	D-76d	Agfa 14	D-76b	Agfa 15
Metol	2	4.5	2.75	8
Sodium sulphite, anhydrous	100	85	100	125
Hydroquinone	5	—	2.75	—
Sodium carbonate, anhydrous	—	—	—	11.5
Borax	8	—	2.5	—
Boric acid	8	—	—	—
Potassium bromide	—	0.5	—	1.5
Water			to 1 litre	

FX SERIES

This series of fine grain formulae was proposed by G. W. Crawley after lengthy research into the development process. *(Brit J Photog,* Vol 107, 2, 9, 16, 23, 30 December (1960) and *ibid,* Vol 108, 6, 13, 27 January (1961)). He found that when the third quality of acutance was added to the requirements of minimum granularity and full film speed, changes might be advantageously made to the type of alkalinity and buffer system employed in a developer. Furthermore, makes and types of film differed in the alkali-buffer restrainer system required to obtain best definition. FX-4 is a variant of the Adox and ASA evolution of D-76 referred to above, giving higher film speed and more compensation, FX-5 gives very fine grain with the natural concomitant slight speed loss. FX-11 is balanced solely to give the fullest possible speed increase with the minimum granularity increase. FX-19 is a D-23 type formula giving, however, fuller emulsion speed. All modern films may be developed in any of these developers. FX-15 is the more suitable for the very fastest, as it gives the biggest contrast rise on extended development for low brightness range subjects. FX-18 is a P-Q version of D-76 claiming slightly higher resolving power, with a slight reduction in grain and minimal speed increase allowing use at stock strength without speed loss. FX-15, added to the formulae series in the 1983 *Annual* is a further development of FX-3, now omitted, giving ⅓rd stop effective speed increase over FX-3, with similar grain and an improved characteristic curve, similar to Paterson Acutol-S, now discontinued.

Approximate meter-settings/makers rating

FX-5	−30%
FX-18	+30%
FX-19	+30%
FX-4	+60%
FX-15	+60%
FX-11	+80% − 100%

Constituents	Quantities in grams					
	FX-5	FX-19	FX-15	FX-4	FX-11	FX-18
Metol	5	—	3.5	1.50	—	—
Phenidone	—	0.75	0.1	0.25	0.25	0.10
Hydroquinone	—	7	2.25	6	5	6
Glycin	—	—	—	—	1.50	—
Sodium sulphite anhydrous	125	100	100	100	125	100
Borax	3	—	2.5	2.5	2.5	2.5
Sodium carbonate	—	—	1.0	—	—	—
Sodium metabisulphite	—	—	0.5	—	—	0.35
Boric acid	1.5	—	—	—	—	—
Potassium bromide	0.5	—	1.5	0.5	0.5	1.6
Water			to 1 litre			

In the FX-4 and FX-5 formulae dissolve a pinch of the sulphite first, then the metol, next the rest of the sulphite. Always dissolve the hydroquinone with or before the Phenidone, to prevent any temporary oxidation of the latter.

Average Capacity

FX-5	4-5 films per 600ml, 20% increase after each film. 8-10 films per 1200ml, 10% increase after each film.
FX-19	5 films per 600ml, 10% increase after each film.
FX-11, FX-15	5-6 films per 600ml, 10% increase after each film.
FX-18, FX-4	6-8 films per 600ml, 10% increase after second or third and the subsequent ones.

Development times

In minutes at 20°C (68°F), using one tank inversion a minute or the normal in larger vessels.

Ilford	FX-19	FX-15	FX-4	FX-11	FX-18
Pan-F (MF)		4	4		6.5
Pan-F (RF)	as for	5	5		7.5
FP4 (MF)	FX-15	5	4.5		9
FP4 (RF)	but	7.5	7		9
HP5 (RF)	slower	8	7	as for	8
HP5 (MF)	contrast	7	6	FX-15	7
	rise				
Mark 5		7	6		7

Kodak	FX-19	FX-11 FX-15	FX-5	FX-4	FX-18
Pan-X (MF)		5	8	5	5.5
Pan-X (RF)	as for	6	9	5.5	6
Plus-X Pan (MF)	FX-15	5	9	5	5
Plus-X Pan but					
Prof (RF)	slower contrast	6.5	9	6	7
Veripan	rise	7	10	7	7.5
Tri-X (MF)		7	10	7	8
Tri-X (RF)		9	12	9	10
Royal-X		10-15	Pointless	9-15	15

Changes in development times

Make a note of film batch numbers, and when using a new batch, watch for any unusual contrast change and adjust development time in future ▶

accordingly. The brief times above (e.g. on Ilford slow materials) will be found most convenient once temperature and agitation are standardised. Alteration of times by 25% will not affect meter setting in normal work, if required for contrast adjustment. FX-18 times are usually similar to those for D-76 and ID-11.

VERY FINE GRAIN
FX-5b

Metol	4.5kg
Sodium sulphite, anhydrous	125.0g
Kodalk (sodium metaborate)	2.25g
Sodium metabisulphite	1.0g
Potassium bromide	0.5g
Water to	1000.0ml

FX-5b Replenisher
Metol	7.0g
Sodium sulphite, anhydrous	125.0g
Kodalk (sodium metaborate)	25.0g
Sodium metabisulphite	—
Potassium bromide	1.0g
Water to	1000.0ml

Twenty per cent development time increase after first film until four or five films have been processed per 600ml or 10% increase until eight or ten films have been developed in 1200ml. Use replenisher to maintain level of tank until twenty-five rolls per litre are processed. Visual contrast is lower than the printing contrast. This formula gives true fine grain with good sharpness and the minimum loss of film speed (30-50%) necessary to achieve very fine grain. Results resemble those in the original two-powder pack 'Microdol', found very suitable for Ilford films amongst others, although replaced in Kodak usage by the later formula Microdol-X, giving improved definition on Kodak films.

Development times
In minutes at 20°C (68°F).
Pan F (MF)—10, Pan F (RF)—12, FP4 (MF)—8, FP4 (RF)—12, HP5 (MF)—11, HP5 (RF)—13.

ACUTANCE FORMULAE

For maximum sharpness at some loss of fine grain

Pyrocatechin Surface Developer (Windisch)

Stock A
Pyrocatechin	80.0g
Sodium sulphite, anhydrous	12.5g
Water to	1000.0ml

Stock B
Sodium hydroxide	100g in 1000ml

N.B. The excess Pyrocatechin with minimum sulphite gives the surface development effect.

Working solution
Take 25ml of *A*, 15ml of *B* and make up to 1000ml. Develop 15-20min at 20°C according to film type. The developer keeps reasonably in stock, but deteriorates rapidly when mixed. It is used once and then discarded. Specially recommended by Windisch for Adox/Efke films. Emulsion speed approximately doubled.

N.B. It is best not to make up more of *B* than will be used rapidly since the activity will decrease with solution of atmospheric CO_2. If possible hold only *A* as a stock, and add sodium hydroxide weighed up and dissolved on the occasion of use. Working concentration is 1.5g sodium hydroxide per litre.

The Beutler Developer

Stock A
Metol	10.g
Sodium sulphite, anhydrous	50.0g
Water to	1000.0ml

Stock B
Sodium carbonate, anhydrous	50.0g
Water to	1000.0ml

Working solution: 1 part *A*, 1 part *B*, 8 parts water.
Developing times: 8-15min at 20°C (68°F).
See notes on making up FX-1 below for further details of preparing concentrated liquid developers.

'FX' Acutance Developers
The following formulae were proposed by G. W. Crawley after research into the design of acutance developers.
FX-1 is fundamentally a variant of the Beutler formula claiming better contrast control, together with a mechanism to enhance 'adjacency' effects; these are also enhanced by the lower concentration of developing agent.

FX-1 High acutance developer, speed increase ½-1 stop

Working solution
Metol	0.5g
Sodium sulphite, anhydrous	5.0g
Sodium carbonate, anhydrous	2.5g
Potassium iodide 0.001% solution	5.0ml
Water to	1000.0ml

Use once and discard. Do not use Calgon, etc.

Concentrated stock solutions *(do not use Calgon, etc)*

A	Metol	5.0g
	Sodium sulphite, anhydrous	50.0g
	Potassium iodide 0.001%	50.0ml
	Water to	1000.0ml
B	Sodium carbonate, anhydrous	25.0g
	Water to	1000.0ml

Making up
A Use water boiled for just 3min then cooled to about 30°C. Dissolve a pinch of the weighed sulphite before the metol. Filter and bottle. This solution will keep a year unopened or until discoloration begins—a light tint can be ignored. If 50ml of the water is replaced by isopropyl alcohol, keeping qualities are improved and precipitation in extreme cold avoided. (See FX-2, Making up, *A* for general observations on making up concentrated liquid developers.) Amber glass bottles are preferable to plastic ones.
B Dissolve in water prepared as for *A*.
The 0.001% solution of potassium iodide can be obtained by dissolving 1g in 1000ml of water; if 100ml of that solution is diluted to 1000ml, then 100ml of this solution again diluted to 1000ml will give a 0.001% solution. This keeps for two years at least.
Working solution—use once and discard.
One part *A*, one part *B*, eight parts water. Mix for 2min and allow to stand to ensure homogeneity.

Single solution concentrate
Quantities for *A* and *B* may be dissolved together in 1000ml of water to form a single solution developer, reject for use when discoloured. 50ml of the water may be replaced by isopropyl alcohol (see making up *A* above).

Agitation

4 inversions each minute in small tanks up to 300ml capacity, 6-8 in larger ones. (See also notes to FX-2).

General Notes

FX-1 demands first-class lenses, precise exposure and no camera movement; also first-class enlarging lenses. Highest resolution and definition will be obtained on Kodak Technical Pan film which will then resolve a *BJ* classified advertisement page at 10-12ft from a suitable 50mm lens on the 35mm stock.

Development times for FX-1 and FX-2 at 20°C (68°F):

Agfapan 25 (MF)	12min
Agfapan 25 (RF)	13min
Agfapan 100 (RF)	14min
Agfapan 100 (MF)	13min
Ilford Pan F (MF)	12min
Ilford Pan F (RF)	14min
Ilford FP4 (MF)	13min
Ilford FP4 (RF)	14min
Kodak Technical Pan (MF)	12min
Kodak Pan-X (MF)	13min
Kodak Pan-X (RF)	15min
Kodak Plus-X Pan (MF)	11min
Plus-X Pan Professional	12min
Kodak Verichrome-Pan	14min

Equipment contrast variations are more obvious in nonsolvent developers and these times may need individual adjustment, particularly in FX-2. For future 'Changes in development times,' see under that heading in FX series of Fine Grain developers, page 168.

FX-1b* Acutance Developer, ½ stop speed increase

Add to FX-1 working solution (with or without iodide) 40g per litre of anhydrous sodium sulphite. The bare solvent action removes surface flare and image spread. Films faster than ASA160 show a definition and grain disadvantage over normal solvent developers. A 2% acetic acid bath may sometimes be necessary to remove white scum. Times approximately two-thirds FX-1 and 2 (see above).
Originally numbered FX-13.

FX-2 Acutance developer, 80% speed increase

Working solution

Metol	2·5g
Sodium sulphite, anhydrous	3·5g
Glycin	0·75g
Potassium carbonate, crystalline	7·5g
*Pinacryptol Yellow 1:2000 solution 5ml	3.5ml
Water to	1000.0ml

Do not use Calgon, etc.

Stock solutions (see making up below)

A Metol	25.0g
Sodium sulphite, anhydrous	35.0g
Glycin	7.5g
B Potassium carbonate (crystals, not dried)	75.0g
Water to	500.0ml
C Pinacryptol Yellow 1:2000 solution	

Making up

Weigh all constituents of *A* and *B* and place on plain pieces of paper separately.
A In 1400ml of water, boiled for just 3min, then cooled to about 30°C, dissolve a pinch of the sulphite, next the metol, then the rest of the sulphite and add the glycin. If the glycin remains as a yellow suspension after 3min mixing, add a pinch from the weighed carbonate and restir, repeating the operation if it still fails to dissolve. Alternatively replace 50ml of the water by isopropyl alcohol which will dissolve the glycin. (Isopropyl alcohol is available without licence on order from any chemist quite cheaply. Its addition also improves keeping qualities and prevents precipitation in extreme cold, and it is used for these purposes in some commercial developers.) Make up to 500ml. Filter and store in filled bottles. This solution should keep a year unopened, but should be rejected when discoloured to a *deep* yellow (glycin developers are usually a golden tint on making up); partly used concentrate should also be rejected when deeply discoloured. Fresh glycin is a reflectant gold yellow in colour. For best keeping, do not aerate whilst mixing and use spotless vessels. Concentrated liquid developers keep indefinitely until oxidation commences, usually from foreign matter in the solution; deterioration then proceeds rapidly once initiated. The use of distilled water is unnecessary; if used, the mixed solution should still be filtered. Do not use Calgon or other sequestering agents in high dilution developers.
B Dissolve the potassium carbonate crystals (the bulk remaining if any was necessary to dissolve the glycin in *A*) in 400ml water prepared as for *A* and make up to 500ml. This solution maintains activity indefinitely in a full bottle, renew after two months if half used, for consistency.
C Keeps indefinitely away from strong light. After two years, however, reject as an increase in activity may occur thereafter. For working solution, take *A* 50ml, *B* 50ml, *C* 3.5ml to make 1 litre developer. Mix well. Use once and discard.

Developing times

As for FX-1.

General notes

If agitation is reduced to every other minute or third minute with an increase in time up to ⅓ to ½, negatives of interesting internal gradation and acutance may be obtained. Agitation can be abandoned altogether with a further increase in time. Dilution may be doubled or trebled to form stand developers over 1-2hr at room temperature. This developer is more 'pictorial' than FX-1, which is designed for maximum resolution and definition primarily; FX-2 is far less sensitive to flare, and less demanding on apparatus.

See also Diluted DK-50, page 172.

FX-16 (Grain effects on high-speed films)

This developer has been specially designed to produce an obtrusive grain structure on films of ASA400 and over, whilst retaining excellent contour sharpness. This retention of sharpness assists in preventing the loss of image quality often found where grain texture has been utilised to give a special effect. The formula is related to the above FX-2 Acutance Developer for slow and medium speed films.

Working solution

50% speed increase

Metol	0.5g
Glycin	0.5g
Sodium sulphite, anhydrous	4.0g
Sodium carbonate, anhydrous	50.0g
(vide also General Notes)	
*Pinacryptol Yellow 0.05% solution	250.0ml
Water to	1000.0ml
*For Kodak Royal-X Pan 350ml/1000ml.	

*If unavailable, 0.5g/litre potassium bromide must be substituted to balance the formula, at some sharpness loss but giving fluffier grain.

Making up

Dissolve the solids in half the total quantity of water at around 30°C, ▶

171

90°F. Add the dye and make up to the total volume. Make up when required. Use within 6hr, adding dye just before use. Use once and discard. Pinacryptol Yellow dissolves readily in hot, not quite boiling water. The 0.5% solution —1:2000—keeps indefinitely in a brown bottle away from the light: see note C to FX-2.

Development times at 68°F (20°C) in minutes.

Kodak

Royal-X Pan	20
Tri-X (RF)	12
Tri-X (MF)	12

Ilford

HP5 (RF)	12
HP5 (MF)	10

Agitation
Should be thorough. 10sec/min either rotation or inversion.

General notes
The grain pattern texture produced by FX-16 disturbs resolution of fine detail but sharpness of contours and medium detail is enhanced markedly, hence print impact is excellent. FX-16 is primarily intended as a developer for operators wishing to experiment with grain structure for special effects, but it can also be used with advantage as an 'acutance' developer for fast films when big enlargements are not required. Texture obtrusiveness can be adjusted by varying the negative area used for enlarging, or using different focal length lenses from the same camera position. With slow and medium speed films there is no gain over FX-2 and 'acutance' developers, and contrast difficulties may occur.
If the carbonate is replaced by 50g/litre of sodium metaborate or 'Kodalk' a fluffier grain texture is produced. Development times remain the same or slightly shorter.

GENERAL PURPOSE FORMULAE

Although Universal formulae (see page 174) can be used for general purpose negative development, this term is usually applied to formulae unsuitable for development of enlarging papers, and in which some attempt has been made to obtain contrast control or some particular advantage or negative quality obtainable by the use of a developing agent of special properties. Such developers do not make use of a 'solvent' effect, and therefore are not classed as fine-grain developers (see Fine-Grain Developers), as they do not give the minimum graininess possible at a given film-speed. Best control is obtained when such formulae are buffered against changes of alkalinity, for example, D-61A and DK-50. Both these formulae can be used for Kodak Royal-X Pan; the Universal Formulae given on page 174 may give unacceptable fog.

Ilford General Purpose Negative Developer
free from organic restrainers

Sodium sulphite, anhydrous	75.0g
Hydroquinone	8.0g
Sodium carbonate, anhydrous	37.5g
Phenidone	0.25g
Potassium bromide	0.5g
Water to	1000.0ml

This concentrated developer is diluted as follows:
For *Dish development of plates and films:* 1+2 water.
Developing time: 4min.

For *Tank development:* 1+5 water.
Developing time: 8min.
Developing temperature: 20°C, 68°F.

Kodak General Purpose Negative Developers

Dissolve chemicals in this order	D-61A	DK-50
Metol	3.1g	2.5g
Sodium sulphite, anhydrous	90.0g	30.0g
Sodium metabisulphite	2.1g	—
Hydroquinone	5.9g	2.5g
Sodium carbonate, anhydrous	11.5g	—
Kodalk (sodium metaborate)	—	10.0g
Potassium bromide	1.7g	0.5g
Water to	1000.0ml	1000.ml

These buffered developers are recommended for development of medium to highest speed rollfilm, sheet film, and plates. D-61A is used in the dish at 1+1 dilution or in tanks at 1+3. Development times for 1+3, between 5 and 10min at 20°C. DK-50 is normally used as recommended by Kodak at full strength. A diluted form of this developer has been proposed independently as giving a useful balance of natural acutance, gradation and speed qualities with controlled contrast rise, this can be made up as follows:

Diluted DK-50 *Film speed normal, good sharpness*

Working solution

Metol	0.5g
Sodium sulphite, anhydrous	6.0g
Hydroquinone	0.5g
Kodalk (sodium metaborate)	2.5g
Potassium bromide	0.125g
Water to	1000.0ml

Stock solutions. Calgon may be used
A Make up DK-50 from the full strength formula on this page or from the packaged powder as directed on the commercial pack.
B Dissolve 80g Kodalk in 1 litre boiled, cooled water.
For working solutions use two parts *A*, one part *B*, seven parts water. Use once and discard.

Development times at 68°F (20°C)

Pan F (MF) 6min	Pan-X (RF) 12min
Pan F (RF) 7min	Veripan 13min
FP4 (MF) 8min	HP5 (MF) 10min
FP4 (RF) 9min	HP5 (RF) 12min
Plus-X (MF) 10min	Tri-X (RF) 13min
Plus-X Prof (RF) 11min	Royal-X Pan 15-20min
Pan-X (MF) 10min	

MANUFACTURERS' SPECIAL FORMULAE

D-19b (Kodak)
A high contrast developer for X-ray and aero films, also useful for general applied photography. Used undiluted at 20°C, the average time for tank development is 5min. Suitable also for photomechanical and document materials. A well-balanced developer of good keeping properties.

D-158 (Kodak)
Recommended by Kodak Ltd, as a developer for photomechanical and document copying materials. Dilute 1:1 for use with above material.

D-163 (Kodak)

Mainly a bromide and chlorobromide paper developer. For papers and lantern plates it is used diluted 1:1, 1:2, or 1:3 according to development speed required, development times being 1½ to 2min at 20°C. Useful also as a negative developer diluted 1:3, giving good contrast and brilliance. Develop 4-6min in a dish and 5-8min in a tank at 20°C.

DK-50 (Kodak)

A normal contrast developer suitable for all types of plates and films but specifically recommended for Royal-X Pan film. Particularly suitable for commercial and engineering subjects. Clean working and fog free, giving excellent gradation on super-speed plates and films, also recommended for processing long out of date films. The presence of 'Kodalk' as the alkali prevents hot weather blistering of the emulsion in the acid fixing bath. Use without dilution. 'Kodalk' is sodium metaborate. See also 'Diluted DK-50' under 'General Purpose Formulae' above.

ID-2 (Ilford)

The standard M-Q developer for films and plates, and a non-caustic developer for high contrast graphic arts films and plates. For normal use dilute 1:2 dish and 1:5 tank. For line and screen work use at stock solution strength.

ID-62 (Ilford)

A general purpose Phenidone-hydroquinone formula for films, plates and papers. For films and plates dilute 1:3 dish and 1:7 tank. For contact papers, contact and special lantern plates dilute 1:1. For enlarging dilute 1:3.

ID-20 (Ilford)

A metol-hydroquinone developer for all types of enlarging papers and specially recommended for Ilford bromide papers. For use when it is diluted 1:3, development time is 1½-2min at 20°C. With bromide paper the development time may be reduced to 1-1½min with double strength developer.

The formula of ID-20 P-Q is not published, the formula below being for ID-20 M-Q.

	Quantities in grams						
Constituents	D-19b	D-158	D-163	DK-50	ID-2	ID-62	ID-20
Metol	2.2	3.2	2.2	2.5	2	—	3
Hydroquinone	8.8	13.3	17	2.5	8	12	12
Phenidone	—	—	—	—	—	0.5	—
Sodium sulphite anhydrous	72	50	75	30	75	50	50
Sodium carbonate anhydrous	48	70	65	—	37	60	60
Kodalk	—	—	—	10	—	—	—
*Ilford IBT Restrainer solution	—	—	—	—	—	20ml	—
Potassium bromide	4	1.0	2.8	0.5	2	2	4
Water to 1 litre							

Where Ilford IBT or Kodak Anti-fog 1 is specified throughout the Annual formulae section, the same volume of a solution of 1% benzotriazole dissolved in hot water containing 10% anhydrous sodium carbonate may be substituted: e.g. 1g benzotriazole in 100ml water with 10g sodium carbonate.

PROCESS DEVELOPERS

These are used for copying and process materials, graticules, photomechanical papers, X-ray development, etc; they are not usually suitable for the development of ordinary general photographic materials.

Ilford formulae

Dissolve chemicals in this order

	High contrast	Med contrast
Sodium sulphite, anhydrous	150.0g	72.0g
Potassium carbonate, anhydrous	100.0g	—
Sodium carbonate, anhydrous	—	50.0g
Hydroquinone	50.0g	8.8g
Phenidone	1.1g	0.22g
Sodium hydroxide	10.0g	—
Potassium bromide	16.0g	4.0g
Benzotriazole	1.1g	0.1g
Water to make	1000.0ml	1000.0ml
	Dilute 1:1 for use	Use undiluted

Medium high contrast hydroquinone caustic developer

A Stock

Sodium metabisulphite	25.0g
Hydroquinone	25.0g
Potassium bromide	25.0g
Water to	1000.0ml

B Stock

Caustic soda	45.0g
Water to	1000.0ml

For use mix equal part of A and B and develop for 2min at 20°C. Rinse well before acid-fixing to avoid stain or use acid stop bath.

High contrast single solution hydroquinone-caustic developer Kodak D-8

Stock solution

Sodium sulphite, anhydrous	90.0g
Hydroquinone	45.5g
Caustic soda	37.5g
Potassium bromide	30.0g
Water to	1000.0ml

For use take 2 parts stock solution to 1 part water. Develop for 2min at 20°C. This developer keeps for several weeks bottled, and retains its energy for several hours in the open dish. Without loss of density, the caustic soda may be reduced to 28g in which case the stock solution will keep longer still.

MONOBATH

FX-6a (no film speed increase)

Sodium sulphite, anhydrous	50.0g
Hydroquinone	12.0g
Phenidone	1.0g
Sodium hydroxide	10.0g
Sodium thiosulphate	90.0g
Water to	1000.0ml

The bath is adjusted to mean contast. This can be varied to suit individual materials or conditions by altering the sodium thiosulphate content. Between 70g and 125g/litre this will give a continuously ▶

graded softening of contrast; softer results than obtained at 125g/litre are unlikely to be required. For still higher contrast, e.g. with process materials, increase hydroquinone to 15-17g.

Making up
A little Calgon may be used. The bath may be divided into two stock solutions; *A* developing agents and sulphite; *B* sodium thiosulphate. On mixing add 1 pellet of sodium hydroxide per working 30ml. This is quite accurate enough, and may be used whenever making up the bath.

Time
Slow and medium speed films will process in 4min. Normal processing time 5min for all films except Royal-X Pan (6min). Six minutes is the safe time for the bath at all stages. Agitate continuously for ½min on pouring in, then at each minute about 3-5 inversions according to tank size. Wash 5-20min.

Capacity
Nine to twelve films per litre according to density (over exposure prolongs life). Keeps in full containers until *deeply* discoloured. A cloudy deposit should form and can be filtered off if desired. If overworked and film is not fully cleared immerse at once in an acid fixer (logically, a rapid one; such a bath may be temporarily reactivated by adding 15-25g/litre of thiosulphate in an emergency).

BLACK AND WHITE REVERSAL

Originally this process* was used basically for reversal processing of cine film in rapid high output machine processors. Slight modifications have been carried out to make it work with almost all kinds of line and continuous tone materials. The rated emulsion speed can be used as a guide to experimentation, but, in practice, it is found that the speed is doubled. On the other hand the exposure latitude is very small, i.e. ¼ stop with line emulsions.

The recommended first developer is 'Qualitol' developer (May & Baker), diluted 1+1 with slight modifications: to the developer is added a quantity of a 20% solution of potassium thiocyanate. A stock solution of this can easily be made by dissolving 200g of potassium thiocyanate in about 750ml of water and making up the solution with water to 1000ml.

Water	600ml
'Qualitol' developer concentrate	200ml
a for line films: 20% sol potassium thiocyanate	20ml
or	
b for tone films: 20% sol potassium thiocyanate	30ml
Water to make	1000ml

1 Before attempting processing, all the solutions are poured into beakers and the first developer into the developing tank and kept at 20°C. The exposed film after being loaded into the spiral in total darkness, is put into the developing tank and developed for 2min. The agitation is continuous.

2 The film is rinsed in running water for 1min.

3 The rinsed film is transferred to a bleach bath made up as follows:

Water	500ml
Potassium dichromate	10g
Sulphuric acid concentrated	12ml
Water to make	1000ml

The film is bleached in this solution for 1min.

N.B. It is very important always to add the concentrated sulphuric acid to the water very slowly, stirring the solution at the same time. Otherwise the mixture can boil and spit acid.

*Y. S. Sahota, *British Journal of Photography* 16 May 1975.

4 The film is rinsed in the running water for 1min.

5 After rinsing it is put into a clearing solution made up of 'Thiolim' — (M & B fixer eliminator) diluted 1+9.

Water	500ml
'Thiolim'	100ml
Water to make	1000ml

The film is left in the clearing solution for 1min.

6 The film is again rinsed in running water and room lights are turned on at this stage. The spiral can be taken out of the rinse bath and held about 1ft away from a darkroom negative viewing box for about 10sec. This is more than sufficient for second exposure. The film is rinsed for 1min.

7 Next, the film is redeveloped in 'Qualitol', diluted 1+7, for 2min. For higher contrast the dilution can be 1+6.

Water	500ml
'Qualitol' developer concentrate	125ml
Water to make	1000ml

8 After this the film is given a quick rinse, and fixed in a high speed fixer, e.g. 'Super Amfix' diluted 1+4 for 1min. To the fixer acidified hardener is added to harden the softened emulsion.

9 The final rinse in water is of only 3min duration. The total time for the process is only 13min. In actual practice this time can be further reduced by cutting the rinse time in steps 2, 4 and 6 to 30sec, if one has a very efficient water rinse available. It is very important to use continuous agitation throughout the steps. For repeat results it is essential that 'Qualitol' developer is used fresh. As soon as the colour of the concentrated developer changes to pale yellow, it is found that the results are no longer consistent.

UNIVERSAL FORMULAE

The term 'universal' is applied to a formula suitable at various dilutions for the development of a wide range of sensitised materials—sheet films, enlarging and contact printing papers, etc. Used on negative materials, such formulae give rapid processing, but without any refinement of grain; they are therefore unsuited to the processing of miniature 35mm films except the slowest and then well diluted, or of rollfilms over ASA160 if any real degree of enlargement is required. Their use is not recommended for Kodak Royal-X Pan, which should be developed in DK-50, or D-61a.

Dissolve chemicals in this order

	Ilford Universal P-Q	BJ Universal M-Q
Metol	—	3.2g
Hydroquinone	12.0g	12.5g
Sodium sulphite, anhydrous	50.0g	56.0g
Sodium carbonate, anhydrous	60.0g	63.0g
Phenidone	0.5g	—
Potassium bromide	2.0g	2.0g
Benzotrialzole*	0.2g	—
Water to	1000.0ml	1000.0ml

Proprietary concentrated liquid antifoggants such as Ilford IBT or Kodak Anti-fog 1 may be substituted, about 35ml per stock litre is suitable. See also substitute organic, restrainer solution under 'Manufacturers Formulae for Specific Purposes' table, pages 172-173.

Print Developers

FX-12

This formula is recommended when a universal formula is more often to be used for developing of printing papers and positive materials of all kinds, since it is balanced to obtain stable image colour over the various grades.

Dilutions are: enlarging paper 1+3; contact papers 1+1; lantern slides 1+4; films in tanks 1+7. Development times for films will closely resemble those in recommended universal developers at the same dilutions. Warm-tone development of chlorobromides is possible by the usual dilution (e.g. 1+6) and over-exposure techniques. The chlorquinol should be obtained as fresh as possible—buff brown not deep brown.

For chlorobromide development only, better control latitude may be obtained by adding 15g/litre of potassium or (less readily soluble) sodium citrate. For this purpose, benzotraizole can be reduced by one-third. RC, resin coated, and polyester, PE base papers develop in 60-75 seconds. Paper based materials need 90-120 seconds.

Sodium sulphite, anhydrous	60.0g
Hydroquinone	10.0g
Chlorquinol	6.0g
Phenidone	0.5g
Sodium carbonate, anhydrous	60.0g
Potassium bromide	1.5g
Benzotriazole solution*	35.0ml
Water to	1000.0ml

*See formula given under 'Manufacturers' Formulae for Specific Purposes' table, pages 171-172.

STOP BATHS

Stop Bath 1

Acetic acid glacial	20ml
or	
Acetic acid 28%	75ml
Water to	1000ml

This bath is recommended for negative development and will remove any surface scum formed. It loses its vinegar smell as activity decreases. It is particularly suitable for use before an ammonium thiosulphate fixer.

Stop Bath 2

Sodium metabisulphite	25g
Water, to make	1000ml

An efficient and inexpensive bath, an acid smell denotes its acidity is maintained.

Stop Bath Hardener

Chromic potassium sulphate (chrome alum)	20g
Water to	1000ml

This stop bath has a hardening action and deteriorates in colour from its original purple to green blue as its action is lost. It is used for negative emulsions normally, although it can be used as a final hardener for paper based prints processed at high temperatures.

FIXERS

1 Ammonium Thiosulphate High-Speed Fixer

Ammonium thiosulphate	175g
Sodium sulphite, anhydrous	25g
Glacial acetic acid (98-100%)	10ml
Boric acid (crystalline)	10g
Water to	1000ml

A high-speed fixer with long working life. If hardening action is required, add 10g per litre of aluminium hydroxychloride after a further 5ml of glacial acetic acid to prevent appearance of a cloudy suspension. Fixing time 30-90sec films, 30-60sec papers. For slower action dilute 1+1.

2 Acid Fixing Bath

Sodium thiosulphate crystals ('Hypo')	250g
Sodium metabisulphite	20g
Water to	1000ml

This acid fixer is of standard composition and will work as a general purpose bath for all fixing purposes. If the acid smell is lost it can be topped up again with a little metabisulphite until it is regained.

3 Acid Fixing Bath (Buffered)

Sodium thiosulphite crystals ('Hypo')	250g
Sodium sulphite, anhydrous	25g
Acetic acid glacial	25ml
or Acetic acid 28%	80ml
Water to	1000ml

This is a 'buffered' fixing bath which has improved efficiency during use as a result—it has great tolerance to carry-over of developer.

4 Buffered Acid Fixer Hardener

Sodium thiosulphate crystals ('Hypo')	300g
Water to	1000ml

Add to the above whilst stirring slowly 250ml of the following stock hardening solution:

Sodium sulphite, anhydrous	75g
Acetic acid glacial	65ml
or Acetic acid 28%	235ml
Boric acid (crystals)	50g
Potassium alum	75g
Water to	1000ml

Dissolve these constituents in the order given in half the total quantity of water at about 50°C to dissolve the boric acid quickly.

Toning current black-and-white papers*

There are some fundamental differences between modern materials such as Kodabrome II RC Paper, Type 2450 and the traditional papers for which most of the toning formulae and techniques were originally designed. One reason for the differences is that nowadays photographic paper has to be formulated to conform with modern environmental and health and safety legislation.

Modern formulations, whether on resin-coated or non resin-coated support, do not always respond to traditional toning methods, which is why some users have experienced difficulties when attempting to produce toned prints. Vanadium (for green tones), gold (for blue tones)

*These suggestions are based on an article by John Hayday, Kodak Applications Laboratory, Harrow, which appeared in *Kodak Professional News No 24.* They are specifically designed for use with Kodak papers: further information on these may be obtained from Kodak Ltd, Customer Relations Dept, PO Box 66, Hemel Hempstead, Herts.

and selenium (for brown tones) are examples of traditional toners which do not convert modern formulations satisfactorily.

Toning methods
The techniques for toning print images fall conveniently into four broad categories, as follows:

1 Conversion of the silver image to silver sulphide or silver selenide.
2 Conversions of the silver image with a metal salt to give a colour silver salt or insoluble double salt.
3 Conversion of the silver image to a mordant on which a suitable dye can be deposited.
4 Formation of dye during development, using a colour developer.

Sulphide-selenide toning
Of all the toning methods, indirect sulphide toning using a ferricyanide bleach followed by a sulphide bath is probably the most common. It is reliable and provides acceptable sepia tones with nearly all papers. Sulphide toning also imparts a useful degree of protection to the image against atmospheric pollution and adverse print storage conditions.
RC paper respond well to indirect sulphide toning giving yellow-brown tones when dried at ambient temperatures but tending to purple-brown tones with the application of heat. Kodak Sulphide Sepia Toner T-7a (published formula) and Kodak Sepia Toner can be used with these papers, but the bleach solution should be used in a more concentrated form that is indicated in the current literature, to reduce the bleach time to an acceptable period. One system is to use one-sixth the current dilution to achieve one minute bleach times. The following bleach formulation has been used successfully:

Potassium ferricyanide	30g
Potassium bromide	12g
Sodium carbonate (anhydrous)	15g
Water	to make 1 litre

This bleach is stable and can be reused until it is exhausted. After bleaching, and a brief wash, prints are normally sulphided using a solution of sodium monosulphide. Sodium sulphide $Na_2S.9H_2O$ is deliquescent, and exposure to air forms thiosulphate which will reduce density by acting on bleached prints in the manner of Farmer's Reducer. Dilute sulphide solutions also tend to form thiosulphate. For this reason the best practice is to prepare fresh sulphide solutions by dissolving one or two sulphide crystals in a small quantity of warm water each time toning is to be done. The crystals are kept in sealed jars, but they can be covered with a film of mineral spirit to prevent deliquescence. Sulphiding must be carried out well away from all stocks of sensitised material and from rooms in which they are handled, because the hydrogen sulphide liberated from the sulphide bath is a powerful fogging agent. It is also toxic and unpleasant to smell, so that good ventilation is required.
Selenium toning does not normally give image tone changes with modern papers, but silver selenide is formed nevertheless, and provides substantial image protection.
Kodak Rapid Selenium Toner can be used at a dilution of 1+3 as a protective treatment. At this dilution, using papers which give no tone change, one litre of solution will treat 150 25.4 × 20.3cm (10 × 8in) prints, or an equivalent area. Modern papers can be protected with selenium toner without showing significant shifts in image tone.

Metal toners
Toning by forming the coloured ferricyanide of various heavy metals formed the basis for numerous traditional toning formulae, and included cadmium, cobalt, copper, iron, lead, molybdenum, nickel, titanium, uranium and vanadium. Modern papers do not seem to respond to many of these formulae, notable exceptions being iron (giving prussian blue tones) and copper (giving pink-brown tones). Copper-toned prints can also be treated with a weak acidified ferric chloride solution to produce green tones (ranging from cyan to dark green). In this process particularly some highlight loss is unavoidable

so that prints should be made somewhat darker than normal before toning. A copper toning solution is marketed as a two-part kit by Berg (Berg Brown/Copper Toner). It appears to work well with all papers.
Gold toning does not give appreciable tone shifts with modern papers, although Kodak Blue Toner (which is a gold toner) will provide blue-black images with Kodabrome II RC Paper Type 2450. Prints which have been sulphide toned can be treated with gold toners to yield pleasing red tones, ranging from 'red chalk' to carmine. Red chalk is the desired tone, and is especially suited to portrait studies against a white background. Kodak Blue Toner can be used for this treatment, as described in the Eastman Kodak publication *Creative Darkroom Techniques* available from Patrick Stephens Ltd, Bar Hill, Cambridge. Satisfactory red tones appear to be possible with most papers.

Mordanting processes
The mordanting of silver images can be achieved using copper toning bath, but the following formula which produces cuprous thiocyanate as a mordant, is more suitable:

Copper sulphate	20g
Neutral potassium citrate	60-100g
Acetic acid (glacial)	30ml
Ammonium thiocyanate (10% sol)	100ml
Water	to make 1 litre

The thiocyanate should be dissolved separately in a small volume of water and added to the main solution a little at a time, shaking the main solution after each addition. If mordanting is only required occasionally the thiocyanate should be stored separately and only added at the time of use. After mordanting, prints need to be washed until the whites are restored. They will then accept dye from a 1% solution of acetic acid which contains 1% of one or more of the following dyes: Thioflavine T, Methylene Blue, Fuchsine, Malachite Green and Methyl Violet. To clear the white after dyeing and washing, one method is to give a brief immersion in a weak solution of sodium hypochlorite (household bleach).
Dyed images are generally more prone to fading than image colours produced using metal salts. A convenient kit, containing a mordanting bath, a range of dyes, and a highlight clearing bath is available as the Berg Colour Conversion Kit For Black and White Photographic Images. Limited tests with one of these kits produced acceptable results with Kodabrome II RC Type 2450 and Kodabromide papers.

Rehalogenation and dye development
Black-and-white prints can be re-halogenised using the bleach formula given earlier for sulphide toning, and then re-developed in a colour developer containing appropriate colour couplers.
The colour couplers can be added to the colour developer singly, or mixed to provide appropriate image colours. It is generally more practical to produce the desired result using colour sensitised materials with appropriate filtration on the camera or at the printer/enlarger stage.

Sepia, Blue and Red Toners are marketed under the 'Barfen' label. Paper users who wish to experiment will find a comprehensive description of traditional toning methods in L. P. Clerc's *Photography Theory and Practice* (1971 edition).

Attention of readers is drawn to the potential health hazards associated with the use of some toners. Great care should be taken to read any warning notices accompanying necessary chemicals.

COLOUR
FILMS

THIS tabulation includes, we believe, all the known types of colour negative and reversal films and positive and reversal papers manufactured and marketed throughout the world. Not all of them are available in all countries, of course, but there is an increasing tendency for distribution to become more and more universal.

In a number of cases films are sold under brand names which are not those of the manufacturer, the so-called house brands or own-label films. No attempt has been made to include comprehensive coverage of such materials and only those which are of more than local interest have been included. In some instances, also, the manufacturer of such house-brand materials may change from time to time: many buyers for such chains do not wish to be restricted to a single supplier.

The identification of colour films for the purpose of adopting the correct processing procedure is, today, of less importance than it was formerly; in most cases manufacturers have modified their films, both colour negative and reversal, to be suitable for the Kodak C-41 and E-6 processing solutions respectively. The exceptions, as this Annual goes to press, are those manufacturers in Eastern Europe and Russia who continue to tailor their materials for the Agfacolor processes. It seems likely that this situation will change in due course and that C-41 and E-6 type materials will appear.

This classification of colour films by the processing procedure, either Agfa or Kodak, should not be confused with the classification by colour principle. The latter designation was first used when this tabulation was first published thirty years ago and in the meantime this clear-cut distinction has become somewhat blurred. Formerly colour films of the substantive type, in which the colour forming materials — the colour couplers — are incorporated in the emulsion layers at the time of manufacture, could be clearly differentiated into those which anchored the colour couplers in the appropriate layers by attaching a long hydrocarbon chain to the coupler molecule — Agfa-type couplers, and those which anchored them by dispersal in the emulsions after dissolving in a solvent with a high boiling point — Kodak-type couplers. Today films can incorporate couplers of both types and other methods of dispersing and holding immobile the colour forming components are commonly used. However, so long as materials of the older Agfa-type are still available it has been thought useful to maintain this classification.

Kodachrome is now the sole material in which the couplers are placed into the appropriate emulsion layers in processing. This system demands the use of a continuous processing machine and renders the often wished-for extension of formats available into rollfilm difficult, if not impossible.

Where the entry 'Service' appears under the processing heading this means that the material is usually sold with the cost of processing included in the purchase price. This implies that the film will be returned to the manufacturer's laboratory for this service. Where an alternative to 'Service' is indicated the material may be processed by the user, although, of course, the processing component of the purchase price is forfeited.

In some cases films, both negative and reversal, are designated 'Professional' in their brand name. This generally means that they have been manufactured to give their optimum colour balance *ab initio* and carries the implication that they will be stored under refrigeration until used and processed promptly after exposure. Films essentially intended for amateur use are manufactured so that they will display optimum balance after storage at normal temperatures for a reasonable period and may be processed after some delay. ▶

Colour Reversal Film

Film	Manufacturer or Distributor	Daylight / Tungsten	ISO speed	Disc	110	126	135	127	120	220	Bulk 35	Bulk 70	Sheet	Colour principle	Processing	Comments
Agfachrome 50 L Professional	Agfa-Gevaert, West Germany	T	50/18°				•		•		•		•	Agfa	Agfachrome 41 or Service	1, 2
Agfachrome 50 S Professional	Agfa-Gevaert	D	50/18°				•		•		•	•	•	Agfa	Agfachrome 41 or Service	2, 3
Agfachrome 100 Professional	Agfa-Gevaert	D	100/21°				•							Agfa	Agfachrome 41 or Service	
Agfachrome 200 Professional	Agfa-Gevaert	D	200/24°				•							Ektachrome	E-6	
Agfachrome CT 18	Agfa-Gevaert	D	50/18°				•	•	•					Agfa	Service	4
Agfachrome CT 18 PAK	Agfa-Gevaert	D	64/19°			•								Agfa	Service	4
Agfachrome CT 18 Pocket	Agfa-Gevaert	D	64/19°		•									Agfa	Service only	4
Agfachrome CT 21	Agfa-Gevaert	D	100/21°				•							Agfa	Service	
Agfachrome CT 64	Agfa-Gevaert	D	64/19°				•							Ektachrome	Service or E-6	5
Agfachrome CT 200	Agfa-Gevaert	D	200/24°				•							Ektachrome	Service or E-6	5
Alfochrome DC 21	Ringfoto, West Germany	D	100/21°				•							Ektachrome	Service or E-6	6
Alfochrome DC 27	Ringfoto	D	400/27°				•							Ektachrome	Service or E-6	6
Barfen CR 100	Barfen Photochem	D	100/21°				•				•			Ektachrome	E-6	6
Batacon CD18	Batacon, West Germany	D	50/18°				•							Agfa	Service	7
Batacon CD 21	Batacon	D	100/21°				•							Agfa	Service	7
Boots Colourslide 5	Boots, England	D	50/18°				•							Agfa	Service	8
Boots Colourslide 100	Boots	D	100/21°				•							Agfa	Service	8
Brillant Superchrome	Neckermann, West Germany	D	50/18°				•							Agfa	Service	9
Brillant High Speed	Neckermann	D	400/27°				•							Ektachrome	Service or E-6	10
Brillant Spezial	Neckermann	D	100/21°				•							Agfa	Service or Agfachrome 41	7
Ektachrome Infrared	Kodak	D	125/22°				•							Ektachrome	E-4	11
Ektachrome 50 Professional	Kodak	T	50/18°				•		•					Ektachrome	E-6	2
Ektachrome Professional Type 6118	Kodak	T	32/16°										•	Ektachrome	E-6	2
Ektachrome 64	Kodak	D	64/19°		•	•	•	•	•	•				Ektachrome	E-6	
Ektachrome 64 Professional	Kodak	D	64/19°				•		•	•	•	•	•	Ektachrome	E-6	2
Ektachrome 100	Kodak	D	100/21°				•							Ektachrome	E-6	
Ektachrome 100 Professional	Kodak	D	100/21°						•				•	Ektachrome	E-6	
Ektachrome 160	Kodak	T	160/23°				•							Ektachrome	E-6	
Ektachrome 160 Professional	Kodak	T	160/23°				•		•	•			•	Ektachrome	E-6	2
Ektachrome 200	Kodak	D	200/24°				•							Ektachrome	E-6	
Ektachrome 200 Professional	Kodak	D	200/24°				•		•	•			•	Ektachrome	E-6	2
Ektachrome 400	Kodak	D	400/27°				•							Ektachrome	E-6	
Ektachrome P800/1600 Professional	Kodak	D	800/30° to 1600/33°				•							Ektachrome	E-6	
FK Color RD 21	Fotokemika, Yugoslavia	D	100/21°				•		•					Ektachrome	Service or E-6	10
Focal Color Slide 100	K-Mart, USA	D	100/21°				•							Ektachrome	E-6	10
Focal Color Slide 400	K-Mart	D	400/27°				•							Ektachrome	E-6	10
Focal Color Slide 640T	K-Mart	T	640/29°				•							Ektachrome	E-6	10
Fomachrom D 18	Fotochema, CSSR	D	50/18°				•	•						Agfa	Service or Agfachrome 41	
Fomachrom D 20	Fotochema	D	80/20°				•	•						Agfa	Service or Agfachrome 41	
Fomachrom D 22	Fotochema	D	125/22°				•	•						Agfa	Service or Agfachrome 41	
Fortechrom	Forte, Hungary	D	50/18°				•							Agfa	Service or Orwo No 9165	9
Fotomat Color Slide	Fotomat, USA	D	100/21°				•							Ektachrome	E-6	12

Colour Reversal Film

Film	Manufacturer or Distributor	Daylight	Tungsten	ISO speed	Disc	110	126	135	127	120	220	Bulk 35	Bulk 70	Sheet	Colour principle	Processing	Comments
Fujichrome 50 Professional D	Fuji Photo Film, Tokyo, Japan	●		50/18°				●		●				●	Ektachrome	E-6	
Fujichrome 50	Fuji Photo Film	●		50/18°				●							Ektachrome	E-6	
Fujichrome 64 Professional T	Fuji Photo Film		●	64/19°				●		●				●	Ektachrome	E-6	
Fujichrome 100 Professional D	Fuji Photo Film	●		100/21°				●		●				●	Ektachrome	E-6	
Fujichrome 100	Fuji Photo Film	●		100/21°				●							Ektachrome	E-6	
Fujichrome 400	Fuji Photo Film	●		400/27°				●							Ektachrome	E-6	
Fujichrome 400 Professional D	Fuji Photo Film	●		400/27°				●							Ektachrome	E-6	
Fujichrome 1600 Professional D	Fuji Photo Film	●		1600/33°				●							Ektachrome	PZ (modified E-6)	
Ilfochrome 100	Ilford, England	●		100/21°				●							Ektachrome	E-6	13
Kodachrome 25	Kodak	●		25/15°				●							Kodachrome	Service only (except USA)	
Kodachrome 25 Professional	Kodak	●		25/15°				●							Kodachrome	Service only (except USA)	18
Kodachrome 40 Type A	Kodak		●	40/17°				●							Kodachrome	Service only (except USA)	
Kodachrome 64	Kodak	●		64/19°		●	●	●							Kodachrome	Service only (except USA)	
Kodachrome 64 Professional	Kodak	●		64/19°				●							Kodachrome	Service only (except USA)	18
Kodak Photomicrography Color	Kodak	●		16/13°				●							Ektachrome	E-4	14
Konica Chrome 100	Konishiroku, Japan	●		100/21°				●							Ektachrome	E-6	15
Labaphot CR 100	Labaphot, West Germany	●		100/21°				●							Ektachrome	E-6	6
3M Color Slide 100	3M Company, Italy	●		100/21°				●							Ektachrome	E-6	
3M Color Slide 64	3M	●		64/19°		●	●								Ektachrome	E-6	
3M Color Slide 400	3M	●		400/27°				●							Ektachrome	E-6	
3M Color Slide 640T	3M		●	640/29°				●							Ektachrome	E-6	
3M Color Slide 1000	3M	●		1000/31°				●							Ektachrome	E-6	
Minochrome 64	Minox, West Germany	●		64/19°				●							Agfa	Service only	16
Ogachrome	Obergassner, West Germany	●		100/21°				●							Ektachrome	E-6	10
Ogachrome High Speed	Obergassner	●		400/27°				●							Ektachrome	E-6	10
Ogachrome 1000	Obergassner	●		1000/31°				●							Ektachrome	E-6	10
Orwochrom UK 17	VEB Foto-chemisches Kombinat Wolfen, GDR		●	40/17°				●		●				●	Agfa	Service or Orwo No 9165	
Orwochrom UT 18	VEB FKW	●		50/18°				●		●				●	Agfa	Service or Orwo No 9165	
Orwochrom UT 20	VEB FKW	●		80/20°				●		●				●	Agfa	Service or Orwo No 9165	
Orwochrom UT 23	VEB FKW	●		160/23°				●							Agfa	Service or Orwo No 9165	
Orwochrom Professional S	VEB FKW	●		40/17°						●				●	Agfa	Orwo No 9165	17
Peruchrome C 19	Perutz, West Germany	●		64/19°				●							Ektachrome	Service	8
Polachrome Autoprocess	Polaroid, USA	●		40/17°				●							Autoprocess Linescreen	Desk processor	52
Porst S 18	Photo-Porst, West Germany	●		50/18°				●							Agfa	Service or Agfachrome 41	8
Porst S 19	Photo-Porst	●		64/19°	●										Agfa	Service only	8

▶

Colour Reversal Film

Film	Manufacturer or Distributor	Daylight Tungsten	ISO speed	Disc	110	126	135	127	120	220	Bulk 35	Bulk 70	Sheet	Colour principle	Processing	Comments
Porst S 21	Photo-Porst	•	100/21°				•							Agfa	Service or Agfachrome 41	8
Porst S 24	Photo-Porst	•	200/24°				•							Ektachrome	Service or E-6	8
Prinzcolor Slide	Dixons, England	•	100/21°				•							Ektachrome	Service or E-6	10
Revue Superchrome CU 19	Foto-Quelle, West Germany	•	64/19°		•	•								Ektachrome	Service or E-6	10
Revue Superchrome CU 21	Foto-Quelle	•	100/21°				•							Ektachrome	Service or E-6	10
Revue Superchrome CU 27	Foto-Quelle	•	400/27°				•							Ektachrome	Service or E-6	10
Revue Superchrome CU 29	Foto-Quelle	•	640/29°				•							Ektachrome	Service or E-6	10
Revue Superchrome CU 31	Foto-Quelle	•	1000/31°				•							Ektachrome	Service or E-6	10
Svemacolor CO-22	Shostka Film Factory, Soviet Union	•	25/15°				•							Agfa	Own process	
Svemacolor CO-32	Shostka Film Factory	•	40/17°				•							Agfa	Own process	
Svemacolor CO-90 L	Shostka Film Factory	•	64/19°				•							Agfa	Own process	
Sears Color Slide 100	Sears, Roebuck & Co, USA	•	100/21°				•							Ektachrome	E-6	10
Sears Color Slide 400	Sears, Roebuck & Co	•	400/27°				•							Ektachrome	E-6	10
Tacma CO-22	Kujbishev Film Factory, Soviet Union	•	25/15°				•							Agfa	Own process	
Tacma CO-32	Kujbishev Film Factory	•	40/17°				•							Agfa	Own process	
Tacma CO-90 L	Kujbishev Film Factory	•	64/19°				•							Agfa	Own process	
Tudorchrome 100	Tudor Photographic Group, England	•	100/21°				•							Ektachrome	Service or E-6	10

Colour Negative Film

Film	Manufacturer or Distributor	Daylight Tungsten	ISO speed	Disc	110	126	135	127	120	220	Bulk 35	Bulk 70	Sheet	Colour principle	Processing	Comments
Agfacolor XR 100	Agfa-Gevaert AG, Leverkusen, West Germany	•	100/21°		•	•	•	•	•		•			Kodak⁺	AP-70/C-41	
Agfacolor XR200	Agfa-Gevaert	•	200/24°				•		•					Kodak⁺	AP-70/C-41	
Agfacolor XR 400	Agfa-Gevaert	•	400/27°		•		•							Kodak⁺	AP-70/C-41	19
Barfen CN 100	Barfen Photochem Ltd, London	•	100/21°				•				•			Kodak	C-41	20
Boots Colourprint II	Boots England	•	100/21°		•	•	•							Kodak	C-41	21
Boots Colourprint 400	Boots	•	400/27°				•							Kodak	C-41	21

Colour Negative Film

Film	Manufacturer or Distributor	Daylight	Tungsten	ISO speed	Disc	110	126	135	127	120	220	Bulk 35	Bulk 70	Sheet	Colour principle	Processing	Comments
Contec 5247	MSI/Heritage Color Labs, USA; Continental Technics, Frankfurt, West Germany	●	●	see comment				●							Kodak+	ECN-2	23
Contec 5293	MSI/Heritage/ Continental	●	●	see comment				●							Kodak+	ECN2	24
Directacolor Print	PIAL, Canada	●		100/21°		●		●							Kodak	C-41	22
Dixons Colorprint 2	Dixons Colour Labs Ltd, Stevenage, England	●		100/21°		●	●	●							Kodak	C-41	21
Eastman Color Type 5247	Several distributors, USA	●	●	see comment				●							Kodak+	ECN-2	25
Eastman Color Type 5293	Several distributors, USA	●	●	see comment				●							Kodak+	ECN-2	26
FK Color NM 20	Fotokemika, Zagreb, Yugoslavia	●		80/20°				●		●					Kodak	C-41	21
Focal Color Print	K-Mart Supermarkets, USA	●		100/21°		●	●	●							Kodak	C-41	21
Focal Color Print 400	K-Mart	●		400/27°		●		●							Kodak	C-41	21
Fortecolor II	Forte, Vac, Hungary	●		100/21°		●	●	●		●					Kodak	C-41	21
Fortecolor 400	Forte	●		400/27°				●							Kodak	C-41	21
Fotomat Color Print	Fotomat Corp, St. Petersburg, Fla, USA	●		100/21°		●	●	●							Kodak	C-41	27
Foxprint Color Film	Fox Stanley Photo Stores, USA	●		100/21°		●		●							Kodak	C-41	21
Fujicolor HR 100	Fuji Photo Film Co Ltd, Tokyo, Japan	●		100/21°		●	●	●		●					Kodak+	CN-16/C-41	28
Fujicolor HR 200	Fuji Photo Film	●		200/24°				●							Kodak+	CN-16/C-41	
Fujicolor HR 400	Fuji Photo Film	●		400/27°		●		●		●					Kodak+	CN-16/C-41	29
Fujicolor HR 1600 D Professional	Fuji Photo Film	●		1600/33°				●							Kodak+	CN-16/C-41	
Fujicolor 80 Professional L	Fuji Photo Film		●	80/20°						●				●	Kodak+	CN-16/C-41	
Fujicolor 100 Professional S	Fuji Photo Film	●		100/21°						●				●	Kodak+	CN-16/C-41	
Fujicolor HR Disc Film	Fuji Photo Film	●		200/24°	●										Kodak+	CN-16A/C-41A	
Fujicolor 8518	Several distributors, USA	●	●	250/25°				●							Kodak+	ECN-2	30
Ilfocolor HR 100	Ilford Ltd, Basildon, Essex, England	●		100/21°		●		●							Kodak	C-41	13
Ilfocolor HR 200	Ilford, Ltd	●		200/24°	●			●							Kodak	C-41	
Ilfocolor HR 400	Ilford Ltd	●		400/27°				●							Kodak	C-41	13
Kameracolor	Woolworth, USA	●		100/21°		●		●							Kodak	C-41	21
Kodacolor II	Kodak	●		100/21°		●	●			●	●				Kodak+	C-41	
Kodacolor VR 100	Kodak	●		100/21°				●							Kodak+	C-41	
Kodacolor VR 200	Kodak	●		200/24°				●							Kodak+	C-41	
Kodacolor 400	Kodak	●		400/27°		●				●					Kodak+	C-41	
Kodacolor VR 400	Kodak	●		400/27°				●							Kodak+	C-41	
Kodacolor VR 1000	Kodak	●		1000/31°				●							Kodak+	C-41	
Kodacolor HR Disc Film	Kodak	●		200/24°	●										Kodak+	C-41A	
Konica Color SR 100	Konishiroku Photo Industry Co, Ltd, Tokyo, Japan	●		100/21°		●	●	●		●					Kodak	CNK-4/C-41	31

▶

Colour Negative Film

Film	Manufacturer or Distributor	Daylight / Tungsten	ISO speed	Disc	110	126	135	127	120	220	Bulk 35	Bulk 70	Sheet	Colour principle	Processing	Comments
Konica Color SR 200	Konishiroku	●	200/24°				●							Kodak	CNK-4/C-41	
Konica Color ISO 400	Konishiroku	●	400/27°		●		●	●						Kodak	CNK-4/C-41	31
Konica Color HR Disc Film	Konishiroku	●	200/24°	●										Kodak+	CNK-4A/C-41A	
Kranzcolor 100	Kranz GmbH, Düren, West Germany	●	100/21°		●	●	●							Kodak	C-41	32
Kranzcolor 400	Kranz GmbH	●	400/27°				●							Kodak	C-41	32
Labaphot Profi Film CN 100	Labaphot GmbH, West Berlin	●	100/21°				●							Kodak+	C-41	20
M-Film	Migros Supermarkets, Switzerland	●	100/21°				●							Kodak+	C-41	20
3M HR 100 Color Print	3M Company, Milan, Italy	●	100/21°		●	●	●		●					Kodak+	CNP-4/C-41	
3M HR 400 Color Print	3M Company	●	400/27°				●							Kodak+	CNP-4/C-41	
3M Color Disc Film	3M Company	●	200/24°	●										Kodak+	CNP-4A/C-41A	
3M HR 200 Color Print	3M Company	●	200/27°				●							Kodak+	CNP-4/C-41	
Minocolor	Minox GmbH, Giessen, West Germany	●	80/20°											Kodak	C-41	33
Mitsubishi Color II	Mitsubishi, Tokyo, Japan	●	100/21°		●	●	●							Kodak	C-41	27
Negracolor II	Negra, Barcelona, Spain	●	100/21°		●	●	●							Kodak	C-41	27
Negracolor 400	Negra	●	400/27°				●							Kodak	C-41	27
Ogacolor 100	Obergassner KG, Munich, West Germany	●	100/21°		●	●	●							Kodak	C-41	21
Ogacolor 400	Obergassner KG	●	400/27°		●		●							Kodak	C-41	21
Orwocolor NC 19	VEB Fotochemisches Kombinat Wolfen, GDR	● ●	64/19°				●		●	●			●	Agfa	Orwo 5166	35
Orwocolor NC 20	VEB FKW	●	80/20°		●									Agfa	Orwo 5166	36
Orwocolor NC 21	VEB FKW	●	100/21°		●		●	●	●				●	Agfa	Orwo 5166	37
Orwocolor Professional	VEB FKW	● ●	40/17°						●					Agfa	Orwo 5166	37
Orwocolor Professional L	VEB FKW	●	40/17°										●	Agfa	Orwo 5166	1, 37
Perucolor 100	Perutz, Munich, West Germany	●	100/27°		●	●	●							Kodak	C-41	36
Porst Color N21	Photo-Porst, Schwabach, West Germany	●	100/21°		●	●	●							Kodak	C-41	36
Porst Color N 27	Photo-Porst	●	400/27°		●		●							Kodak	C-41	36
Revue Supercolor CN 21	Foto-Quelle, Nürnberg, West Germany	●	100/21°		●		●							Kodak	C-41	21
Revue Supercolor CN 27	Foto-Quelle	●	400/27°		●		●							Kodak	C-41	21
Revue Supercolor Disc Film	Foto-Quelle	●	200/24°	●										Kodak	C-41A	21
Sakuracolor II Professional L	Konishiroku	● (T)	64/19°						●				●	Kodak	CNK-4/C-41	1, 38
Sakuracolor II Professional S	Konishiroku	●	64/19°						●				●	Kodak	CNK-4/C-41	3, 38
Sears Color Print	Sears, Roebuck & Co, Chicago, Ill, USA	●	100/21°		●	●	●							Kodak	C-41	21
Sears Color Print 400	Sears, Roebuck	●	400/27°				●							Kodak	C-41	21
Shanghai Light Colour	People's Republic of China	●	100/21°				●		●					Kodak	C-41	39
Svema DS-5	Shostka Film Factory, USSR	●	40/17°				●		●	●				Agfa	Probably Orwo 5166	40

Colour Negative Film

Film	Manufacturer or Distributor	Daylight	Tungsten	ISO speed	Disc	110	126	135	127	120	220	Bulk 35	Bulk 70	Sheet	Colour principle	Processing	Comments
Svema LN-8	Shostka	•		100/21°				•		•	•			•	Agfa	Probably Orwo 5166	40
Tacma Color Film	Kujbishev Film Factory, USSR	•	•	see comment				•		•	•			•	Agfa	Probably Orwo 5166	41
Turacolor II	Tura GmbH, Düran West Germany	•		100/21°		•	•	•		•					Kodak	C-41	32
Turacolor II 400	Tura GmbH	•		400/27°						•					Kodak	C-41	32
Valcolor II	Valca, Bilbao, Spain	•		100/21°		•	•	•		•	•				Kodak	C-41	42
Vericolor II Professional Type L	Kodak		•	80/20°						•	•			•	Kodak+	C-41	1
Vericolor III Professional Type S	Kodak	•		160/23°						•	•			•	Kodak+	C-41	3
Voigtländer C 100	Voigtländer GmbH, Braunschweig, West Germany	•		100/21°		•	•								Kodak	C-41	32

Colour Instant Picture Materials (Self Processing)

Film	Manufacturer	ISO-Speed	Packaging and size	Type	Nominal processing time	Comments
Fuji Fotorama F1-10	Fuji Photo Film Co Ltd, Tokyo, Japan	150/23°	Film pack for 10exp 6.8 x 9.1cm	Integral single sheet	60sec	43, 3
Kodamatic Instant Color Film HS 144-10	Kodak	320/26°	Film pack for 10exp 6.8 x 9.1cm	Integral single sheet	4min	44, 3
Kodak Instant Color Film PR144-10-2	Kodak	150/23°	Film pack for 10exp 6.8 x 9.1cm	Integral single sheet	4min	45
Kodak Instant Trimprint Color Film HS144-10	Kodak	320/26°	Film pack for 10exp 6.8 x 9.1cm	Integral single sheet separable after processing	6 min	
Polacolor 2 Type 88	Polaroid Corp, Boston, Mass, USA	80/20°	Film pack for 8exp 8.2 x 8.6cm	Peel-apart (two sheet)	60sec	57
Polacolor 2 Type 108	Polaroid Corp	80/20°	Film pack for 8exp 8.3 x 10.8cm	Peel-apart (two-sheet)	60sec	
Polacolor 2 Type 808 Professional	Polaroid Corp	80/20°	Sheet films 8 x 10in	Two-sheet lamination in special processor	60sec	46
Polacolor Type 58	Polaroid Corp	80/20°	Sheet films 4 x 5in	Peel-apart (two-sheet)	60sec	46
Polacolor ER Type 59	Polaroid Corp	80/20°	Sheet films 4 x 5in	Peel-apart (two-sheet)	60sec	46, 47
Polacolor ER Type 559	Polaroid Corp	80/20°	Film pack for 8exp 4 x 5in	Peel-apart (two-sheet)	60sec	46, 47
Polacolor ER Type 669	Polaroid Corp	80/20°	Film pack for 8exp 8.2 x 8.6cm	Peel-apart (two-sheet)	60sec	46, 47
Polacolor ER Type 809	Polaroid Corp	80/20°	Sheet film 8 x 10in	Two-sheet lamination in special processor	60sec	
Polaroid 600 High Speed Color Land Film	Polaroid Corp	640/29°	Film pack for 10exp 8.7 x 10.8cm	Integral single sheet	90sec	44, 3
Polaroid Super Color Time-Zero SX-70 Land Film Type 778	Polaroid Corp	100/21°	Film pack for 10exp 8.7 x 10.8cm	Integral single sheet	4min	44, 46
Polaroid SX-70 Land Film Type 708	Polaroid Corp	100/21°	Film pack for 10exp 8.7 x 10.8cm	Integral single sheet	4min	48
Polaroid SX-70 Land Film Type 779	Polaroid Corp	640/29°	Film pack for 10exp 7.9 x 8.0cm	Integral single sheet	4min	46, 49

▶

EXPLANATORY NOTES

Colour sensitisation type

Daylight Balanced for use in daylight (conventionally assigned a colour temperature of 5500°K) and for electronic or blue bulb flash.

Tungsten Balanced — with one exception — for use with studio incandescent lamps with a nominal colour temperature of 3200°K; such films are usually coded Type B, L or T. The exception is Kodachrome 40 Type A which is balanced for a nominal colour temperature of 3400°K.

Note: Most ISO 400/27° (ASA400, 27 DIN) and faster films, both reversal and negative, although basically of daylight balance have the peak sensitivities of the three colour layer sensitisations adjusted to minimise the differences in rendering under mixed or lower colour temperature lighting. A few negative films are claimed to be of 'universal' type for both daylight and tungsten (e.g. Contec, Orwocolor NC19). Most daylight colour negative films can be exposed under artificial lighting with correction by filtration during printing, at the expense of some exposure latitude.

Film sizes

Disc Disc film for disc cameras only (negative size 8 x 10.5mm, 15 exposures).

110 16mm film in cartridge (12, 20 or 24 exposure pack) for exposures 13 x 17mm.

126 35mm single-perforation film in cartridge (12, 20 or 24 exposure pack) for exposures 28 x 28mm.

135 35mm double-perforated film in metal or plastic cassette (12, 20, 24 or 36 exposure loadings) for exposures 24 x 36mm, or less commonly 24 x 24mm or 18 x 24mm with correspondingly more exposures per packing.

127 Paper-backed rollfilm on narrow-diameter spool for 8 exposures 4 x 6.5cm, 12 exposures 4 x 4cm or 16 exposures 3 x 4cm.

120 Paper-backed rollfilm on large diameter spool for 8 exposures 6 x 9cm, 10 exposures 6 x 7cm, 12 exposures 6 x 6cm and 15/16 exposures 4.5 x 6cm or 4 x 4cm. Some specialised wide-angle cameras and backs for sheet-film cameras use this size for panoramic formats 6 x 17cm and 6 x 12cm. **620** is an obsolescent version of 120 on a small diameter spool with minor differences in backing paper and film length; now available only in a restricted range of very commonly used amateur films.

220 Rollfilm with paper leader and trailer of same width as 120 rollfilm but allowing twice the number of exposures per loading. Absence of backing paper necessitates special film holder or adjustment to film pressure plate by comparison with 120.

Bulk 35 Bulk rolls of 35mm wide double-perforated film in a range of standard lengths. Minimum length is generally 30 metres or 100ft.

Bulk 70 Bulk rolls of 70mm wide double-perforated film in a range of standard lengths. Minimum length is generally 30 metres or 100 ft, but occasionally 15ft.

Sheet Flat film on heavy acetate or polyester base for use in the appropriate film holders. Not all films marked in this category will be available in all sizes but all will be available in 4 x 5in and most in 5 x 7 and 8 x 10in.

Colour principle — reversal films

Agfa Dye couplers incorporated in emulsion and immobilised by long-chain hydrocarbon residue to prevent diffusion.

Ekta-chrome Resin-protected dye couplers dispersed in emulsion after being dissolved by solvent with high initial boiling point. The distinction between the Agfa and Kodak or Ektachrome methods of holding colour forming components immobile in the correct emulsion layers is today becoming less distinct. The materials intended for processing in the E-6 process solutions may actually use a mixture of colour forming components. The old distinction is however, maintained in the tabulation for the time being to avoid confusion in processing.

Koda-chrome Dye couplers incorporated in separate colour developer solutions: film is selectively light reversed, layer by layer.

Auto-process line-screen Black-and-white film emulsion for silver salt diffusion process having small colour filters (red, green, blue) incorporated in film base in line form for additive colour reproduction.

Colour and masking principle — negative films

Agfa Dye couplers incorporated in emulsion and immobilised by long-chain hydrocarbon residue to prevent diffusion. Automatic azo masks are based on the Kodak principle, but with Agfa-type couplers.

Kodak Resin-protected dye couplers dispersed in emulsion after being dissolved by solvent with high initial boiling point. Masking by azo dye components (Kodak principle).

Kodak⁺ Dye coupling as mentioned before, but red azo mask coupler is of the Agfa type. (This variation is said to be used in Kodak and Fuji colour negative films.)

Note: all **'instant'** films use diffusion-transfer principles. Further details are given under the heading 'type' in the appropriate table.

Processing — reversal films

Agfa-chrome 41 Agfachrome Professional Process 41 (not to be confused with Kodak C-41 colour negative process).

E-4 Old Kodak Ektachrome Process E-4.

E-6 Kodak Ektachrome Process E-6 or equivalent (for instance Agfachrome Process AP 44 or Fuji Process CR-56).

Orwo 9165 Orwochrom processing formula No 9165.

Service Film processing charge included in purchase price. With some films mounting in cardboard or plastic slide mounts is also included.

Processing — negative films

AP-70 Agfacolor Process AP-70 (compatible with C-41).

C-41 Kodak colour negative process C-41.

C-41A Variation of C-41 for disc films (with high agitation in developer solutions).

CN-16 Fuji colour negative process CN-16 (compatible with C-41).

CN-16A Fuji colour negative process CN-16A (compatible with C-41A).

CNK-4 Sakura colour negative process CNK-4 (compatible with C-41).

CNK-4 Sakura colour negative process CNK-4A (compatible with C-41A).

CPN-4 3M colour negative process CNP-4 (compatible with C-41)

CNP-4A 3M colour negative process (compatible with C-41 A).

ECN-2 Eastman Color cine film process ECN-2 (not compatible with C-41).

Orwo 5166 Orwo colour negative process No 5166.

Comments

1. Film balanced for longer exposure times
2. Exact batch speed (to 1/3 stop) is given on the instruction leaflet packed with film
3. Film balanced for shorter exposure times
4. In course of replacement by a medium-speed E-6 compatible material, Agfachrome CT64.
5. New E-6 compatible materials
6. Fujichrome material
7. Fomachrom material
8. Agfachrome material
9. Orwochrom UT18 material
10. 3M Color Slide material
11. Infrared-sensitised 'false-colour' material (colour rendering varies according to filter used: for general or technical photography it is designed to be used with yellow or orange filter in which case infrared reflecting subjects are rendered red-magenta)
12. Sakurachrome material
13. Material made in Japan (by Konishiroku) to Ilford specification
14. High-contrast material with high resolving power for technical and scientific photography
15. New trade mark for Sakuracolor, Europe and USA
16. Minox miniature film cassette only
17. Orwochrom Professional Film is available only on the East German home market in small quantities; it has polyester base
18. Manufactured to colour balance aim point
19. Improved type replacing former Agfacolor CNS 400 film
20. Fujicolor material (old type)
21. 3M colour film material
22. Probably Agfacolor material
23. Actually Eastman Color Negative Film Type 5247 for both prints and slides. Can be exposed at EI 100-400
24. Actually Eastman Color Negative Film Type 5293 for both prints and slides. Can be exposed at EI 400, 800 or 1600 (by pushing)
25. Cine negative films distributed for making prints and/or slides. Can be exposed at EI 100-400
26. Cine negative films distributed for making prints and/or slides. Can be exposed at EI 400, 800 or 1600 (by pushing)
27. Sakuracolor material
28. New improved film which replaces former Fujicolor FII
29. New improved film which replaces former Fujicolor FII 400
30. Cine negative film distributed for making prints and/or slides
31. New trade mark for Sakuracolor, Europe and USA
32. Agfacolor material
33. Probably Kodak colour film, available in Minox miniature cassette only
34. Probably 3M material
35. Also available in 'SL' rapid loading 35mm cassette. NC 19 will be replaced by new NC 21 film
36. Available in 'Cassette 16' which is not fully compatible with 110 pocket cassette although having same negative size. It is expected to be replaced by new NC 21 film
37. Available in German Democratic Republic only
38. The trade mark 'Sakuracolor' is being restricted to South-east Asia and some other markets only in favour of 'Konicacolor' for Europe and USA
39. This film is said to be an own development of the Chinese photochemical industry (otherwise it could be Sakuracolor material)
40. There might be other film types available besides DS-5. They are not exported
41. Same material as 'Svema', available in different types in USSR only
42. Probably Sakuracolor material
43. Available in Japan only
44. Picture is seen with 90% of final saturation and density, result can be judged but development continues at an exponentially slowing rate for a time to effective equilibrium
45. Film is compatible with older Kodak instant cameras when 'lighten' control on camera is changed for two steps
46. Balanced for electronic flash
47. Extended tonal range film
48. Without battery pack in film cassette
49. For endoscopic photography

Colour Print Papers (Negative/Positive)

Material	Manufacturer Distributor	Sheet	Roll	Glossy	Matt	Silk	Lustre	Processing	Base	Colour principle	Comments
Agfacolor CS Type 6	Agfa-Gevaert	●	●	●	●			Agfacolor Process 92, Ektaprint-2	Resin coated	Kodak	50
Agfacolor CN Type 7	Agfa-Gevaert	●	●	●	●			Agfacolor Process 92, Ektaprint-2	Resin coated	Kodak	63
Ektacolor Plus	Kodak	●	●	●	●		●	Ektaprint-2 (modified)	Resin coated	Kodak	51
Ektacolor 74 RC Type 2524	Kodak	●		●	●	●		Ektaprint-2	Resin coated	Kodak	
Ektacolor 78 RC Type 2524	Kodak	●	●	●	●		●	Ektaprint-2	Resin coated	Kodak	52
Ektaflex PCT Negative Film and Paper	Kodak	●		●	●			'Printmaker' desk processor	Paper	Dye Diffusion	
FK Color II	Fotokemika, Yugoslavia	●		●	●			Ektaprint-2	Resin coated	Kodak	53
Fomacolor PM 21	Fotochema, CSSR	●		●				Orwo 7362	Paper	Agfa	
Fomacolor PM 30	Fotochema	●		●	●	●		Agfacolor Process 85, Foma Process SM-20	Resin coated	Agfa/Perutz	
Fomacolor PM 31	Fotochema	●		●	●	●		Ektaprint-2	Resin coated	Kodak	
Fortecolor P-II	Forte, Hungary	●		●			●	Ektaprint-2	Resin coated	Kodak	54
Fotocvet color paper	Chemical factory for photographic papers, USSR	●		●				Own 3-bath process	Paper	Agfa	

▶

Colour Print Papers (Negative/Positive)

Material	Manufacturer Distributor	Sheet	Roll	Glossy	Matt	Silk	Lustre	Processing	Base	Colour principle	Comments
Fotoncolor Type 7	Bydgoszczie Zaklady Fotochemiczne, Poland	•		•				Fotoncolor Process	Paper	Agfa	
Fujicolor Type 8909	Fuji Photo Film Co, Japan	•	•	•	•	•	•	Fuji Process CP-21, Ektaprint-2	Resin coated	Kodak	
Konica Color	Konishiroku, Japan	•	•	•	•	•	•	Ektaprint-2	Resin coated	Kodak	
Konica Color PC Paper Type SR	Konishiroku, Japan	•		•	•	•	•	Ektaprint-2	Resin coated	Kodak	55
Labacolor CPN	Langebartels West Germany	•	•	•	•	•	•	Ektaprint-2	Resin coated	Kodak	56
3M Color Paper High Speed	3M, USA and Italy	•	•	•	•	•	•	Ektaprint-2	Resin coated	Kodak	
3M Easy Strip Paper	3M	•	•					Ektaprint-2	see comment	Kodak	69
Mitsubishi Color KER 3000	Mitsubishi Paper Mill, Japan	•		•	•	•	•	Ektaprint-2	Resin coated	Kodak	
Oriental Color RP-II	Oriental, Japan	•	•	•	•	•		Ektaprint-2	Resin coated	Kodak	
Sakuracolor PC Type SII	Konishiroku, Japan	•		•	•	•	•	Ektaprint-2	Resin coated	Kodak	
Sakuracolor Professional Type SP	Konishiroku Photo Industry Co Ltd, Japan	•	•	•	•			Sakura Process CPK-12, Ektaprint-2	Resin coated	Kodak	
Turacolor Type II	Tura, West Germany	•	•	•	•	•		Turaprint, Ektaprint-2	Resin coated	Kodak	
Valcolor VRC 1	Valca, Spain	•		•	•			Ektaprint-2	Resin coated	Kodak	
Valcolor VRC 2	Valca	•		•	•			Ektaprint-2	Resin coated	Kodak	

Colour Print Papers (for prints from slides and print-to-print)

Material	Manufacturer Distributor	Sheet	Roll	Glossy	Matt	Silk	Lustre	Processing	Base	Colour principle	Comments
Agfachrome CU	Agfa-Gevaert West Germany	•		•	•			Agfachrome Process R/ Ektaprint R-14	Resin coated	Kodak	
Agfachrome-Speed	Agfa-Gevaert	•			•			Agfachrome-Speed	Plastic	Dye diffusion	58
Cibachrome-A II CPS-A-1K	Ilford	•		•				Cibachrome Process P-30	Plastic	Silver dye bleach	
Cibachrome-A II CRC-A-44M	Ilford	•					•	Cibachrome Process P-30	Resin coated	Silver dye bleach	
Cibachrome CPS-1K	Ilford	•	•	•				Cibachrome Process P-3	Plastic	Silver dye bleach	
Cibachrome CRC-44M	Ilford	•	•				•	Cibachrome Process P-3	Resin coated	Silver dye bleach	
Cibachrome Copy Paper CCO	Ilford	•	•	•			•	Cibachrome camera processor Process P-22 or Process P-17	Resin coated	Silver dye bleach	59
Copycolor Negative Film CCN and Papers	Agfa-Gevaert Belgium	•		•	•			Copycolour Process for Copyproof machine	Paper	Dye diffusion	60
Ektachrome 21	Kodak	•	•	•	•			Ektaprint R-3	Resin coated	Kodak	61
Ektachrome 22	Kodak	•	•	•	•			Ektaprint R-3	Resin coated	Kodak	
Ektaflex PCT Reversal Film and Paper	Kodak	•		•	•			'Printmaker' desk processor	Paper	Dye diffusion	
Fotocvet color paper	Chemical Factory for Photographic Papers, USSR	•		•				Own 6 bath process	Paper	Agfa	

Colour Print Papers (for prints from slides and print-to-print)

Material	Manufacturer Distributor	Availability		Surface				Processing	Base	Colour principle	Comments
		Sheet	Roll	Glossy	Matt	Silk	Lustre				
Fujichrome Type 31	Fuji Photo Film Co Ltd, Japan	•	•	•	•			Ektaprint R-100	Resin coated	Kodak	62
Fujichrome (New Type)	Fuji	•	•	•	•			Ektaprint R-3	Resin coated	Kodak	63
Fuji CB Print	Fuji	•	•	•				Cibachrome Process P-3	Plastic	Silver-dye bleach	64
Labachrome CPR 312	Langebartels, West Germany	•			•			Ektaprint R-14	Resin coated	Kodak	65
TTspeed Colorumkehrpapier	Tetenal, West Germany	•		•	•			Ektaprint R-14, Tetenal UK II or UK 3	Resin coated	Kodak	65

EXPLANATORY NOTES

Colour principle

Agfa — Dye couplers incorporated in emulsion and immobilised by long-chain hydrocarbon residue to prevent diffusion.

Kodak — Resin-protected dye couplers dispersed in emulsion after being dissolved by solvent with high initial boiling point.

Perutz — Non-protected dye couplers dispersed in emulsion after being dissolved by solvent with low initial boiling point (only in combination with Agfa principle).

Dye diffusion — Dye transfer to imbibition paper (Ektaflex PCT) or to top layers of same material (Agfachrome-Speed). Processes make use of two-step and one-step instant print technology respectively.

Silver-dye bleach — Layers contain azo dyes which are destroyed in the bleach baths according to the black-and-white silver image developed in the first processing stage. This is a non-reversal direct positive process.

Comments — colour print papers (negative/positive)
50 Material manufactured by Konishiroku

51 Modified to provide better dark storage properties, with lower colour developer replenishment rate
52 High brilliance, especially for enlargements
53 Under licence from 3M Company, only available in Yugoslavia
54 Under licence from 3M Company
55 So-called 'Century Paper'; modified to give better dark storage properties
56 Manufactured by Fuji
57 Special stripping material. The surface depends on the material the layers are transferred to.

Comments — colour print papers (prints from slides and print-to-print)
58 One-step dye diffusion material
59 Higher contrast for reproductions
60 Half-tone prints available by using a special screen
61 For reproduction of original prints
62 To be replaced by a new R-3 compatible type
63 In preparation
64 Cibachrome material marketed and processed in Japan under Ilford licence
65 Private label material

Colour Print Films (Duplicate, Display, Overhead etc)

Material	Manufacturer/ Distributor	Purpose		Availability				Processing	Colour principle	Comments
		for	from	Sheet	Rolls	Bulk	135			
Agfachrome CU-COP	Agfa-Gevaert, West Germany	duplicate	slide				•	Agfachrome Process AP-41	Agfa	67
Cibachrome-A II CTD F7	Ilford Limited	display	slide	•				Cibachrome Process P-30	Silver dye bleach	68
Cibachrome II Transparent CTD F7	Ilford Limited	display	slide	•				Cibachrome Process P-3	Silver dye bleach	69
Cibachrome Copy Film CTF F7	Ilford Limited	overhead	slide	•				Cibachrome Process P-17 resp. P-22	Silver dye bleach	
Copycolor	Agfa-Gevaert, Belgium	overhead	slide, print	•				Copycolor Process in Copyproof apparatus	Dye diffusion	

▶

Colour Print Films (Duplicate, Display, Overhead etc)

Material	Manufacturer/Distributor	Purpose for	Purpose from	Sheet	Rolls	Bulk	135	Processing	Colour principle	Comments
Duplichrome D13	Agfa-Gevaert, Belgium	duplicate	slide	•				Agfachrome Process AP-41	Agfa	71
Duratrans Display Film Type 4022	Kodak	display	negative	•	•			Ektaprint-2 Process	Kodak	72
Ektachrome 14 Film Type 5437	Kodak	overhead	slide, print	•	•			Ektachrome R-14 Process	Kodak	73
Ektachrome Overhead Film	Kodak	overhead	slide, print	•	•			Ektachrome R-3 Process	Kodak	74
Ektachrome SE Duplicating Film Type SO-366	Kodak	duplicate	slide			•	•	Process E-6	Kodak	75
Ektachrome Slide Duplicating Film Type 5071	Kodak	duplicate	slide			•	•	Process E-6	Kodak	67
Ektachrome Duplicating Film Type 6121	Kodak	slide	slide	•				Process E-6	Kodak	67
Ektagraphic Overhead Transparency Film	Kodak	overhead	negative, slide	•				Ektaflex Process for 'Printmaker' and other desk processors	Dye diffusion	76
Fujichrome CDU	Fuji Photo Film Co, Japan	duplicate display	slide	•				Process E-6	Kodak	
3M Posterprint Film	3M Company, USA	display	negative	•	•			Ektaprint-2 Process	Kodak	
Oriental Color Transparent Film	Oriental Photo Industry Co, Japan	display	negative	•	•			Ektaprint-2 Process	Kodak	72
Orwochrom UD 2	VEB Fotochemisches Kombinat Wolfen, GDR	duplicate	slide			•		Orwo No C 9165	Agfa	
Orwocolor PC 7	VEB Fotochemisches Kombinat Wolfen, GDR	slide display	negative	•		•		Orwo No 7181	Agfa	77
Sakura Wide Color Film	Konishiroku Photo Industry Co Ltd, Japan	display	negative	•	•			Process C-41	Kodak	
Turacolor Transparent Film	Tura GmbH, West Germany	display	negative	•	•			Ektaprint-2 Process	Kodak	72
Vericolor Internegative Film	Kodak	inter-negative	slide	•		•		Process C-41	Kodak	67,78
Vericolor Print Film Type 4111	Kodak	slide	negative	•	•			Process C-41	Kodak	
Vericolor Slide Film Type SO-279	Kodak	slide, display	negative			•		Process C-41	Kodak	67
Vericolor Slide Film Type 6072	Kodak	slide,	negative			•		Process C-41	Kodak	79

EXPLANATORY NOTES

Purpose
Duplicate Reproduction of positive in form of transparency.
Display Giant transparency.
Overhead Foil transparency for overhead projection.
Slide Positive transparency from negative film.

Availability
Sheet Sheet film in a range of sizes.
Rolls Film rolls in greater width than 'bulk' below.
Bulk Bulk film rolls in 35mm, 46mm, 61.5mm or 70mm width.
135 35mm film cassette (type 135) with 36 exposures.

Colour Principle
Agfa Dye couplers incorporated in emulsion and immobilised by long-chain hydrocarbon residue to prevent diffusion.
Kodak Resin-protected dye couplers dispersed in emulsion after being dissolved by solvent with high initial boiling point.
Dye diffusion Dye transfer to imbibition film. Process makes use of two-step instant print technology.
Silver-dye bleach Layers contain azo dyes which are destroyed in the bleach baths according to the black-and-white silver image developed in the first processing stage. This is a non-reversal direct positive process.

Comments — colour print films

67 Sensitised for tungsten light (3200K)
68 Amateur material
69 Professional material
70 Two-step process with Negative Film Type CCN and Overhead Film
71 For use in the graphic arts field
72 With white-pigmented, opaque base
73 To be replaced by the new Ektachrome Overhead Film
74 For exposure in a reproduction camera or under an enlarger
75 Sensitised for electronic flash
76 For printing from negatives Ektaflex PCT Negative Film must be exposed, for printing from slides Ektaflex PCT Reversal Film
77 Probably to be replaced by the new Orwocolor Positive Film PC 12
78 Also may be used for reproduction from reflection originals
79 Also may be used for colour reproductions from black-and-white originals

PROCESSING
COLOUR

General Instructions

Making up solutions

In making up the solutions which follow it is assumed that where the quantities of other liquid components permit, the solids will be dissolved, in the order indicated, by starting with about three-quarters of the final volume of water. Deionised or demineralised water at a temperature between 20 and 40°C is to be preferred and the incorporation of a sequestering agent, Calgon, in the formulations permits the concentrates, if used, to be diluted with tap water. Where a large volume of a liquid component has to be incorporated, as in making up some of the concentrated solutions, the starting volume of water must be proportionately reduced.

Difficulties are sometimes encountered in making up colour developing solutions when the developing agent is dissolved in the otherwise complete solution. With developers containing carbonate, the strongly acid nature of the agent may cause effervescence with loss of carbon dioxide changing the acidity and thus the activity of the resulting solution. Whatever alkali is being used, it is possible for the agent to be released as the free base which floats in oily globules difficult to redissolve. To avoid these effects with any of the solutions given on the following pages, the agent together with the hydroxylamine salt (if any) should be dissolved in half of the water and the remaining ingredients in the other half; the first solution is then poured slowly into the second with continuous stirring. After mixing it is advisable to let the solution stand for four to twenty-four hours before use. In addition, the precautions regarding containers suitable for the mixing of solutions on page 165 of the general instructions for black-and-white processing should be followed carefully.

Colour developing agents

The following colour developing agents are those which are, or have been, in common use; others are used in some specialised colour processes, such as Kodachrome K-14, but are not supplied or needed for those processes which are generally available.

N,N-Diethyl-*p*-phenylenediamine hydrochloride = Activol H (Johnson), Colour Developer 1 (chloride) (Merck), CD-1 (Kodak).

N,N-Diethyl-*p*-phenylenediamine sulphate = Colour Developer 1 (sulphate) (Merck). More sulphate than hydrochloride will be needed in the ratio 262:200.

N,N-Diethyl-*p*-phenylenediamine sulphite = Genochrome (May & Baker), Activol No. 1 (Johnson), S28 (3M/Ferrania).

2-amino-5-diethylaminotoluene hydrochloride = Tolochrome (May & Baker), Colour Developer 2 (Merck), CD-2 (Kodak).

4-amino-N-ethyl-N-(ß-methanesulphonamidoethyl-*m*-toluidine sesquisulphate monohydrate = Mydochrome (May & Baker); Activol No 3 (Johnson), Colour Developer 3 (Merck); CD-3 (Kodak).

4-[N-ethyl-N-2-hydroxyethyl]-2-methlyphenylenediamine sulphate = Colour Developer 4 (Merck), CD-4 (Kodak).

N-Ethyl-N-(ß-hydroxyethyl)-*p*-phenylenediamine sulphate = Droxychrome (May & Baker), Activol No 8 (Johnson), T32 (Orwo), Colour Developer 32 (Merck).

N-n-butyl-N(4 sulpho-n-butyl)1,4-phenylediamine = Ac60 (Agfa), Colour Developer 60 (Merck).

This list is retained although some of the chemicals are no longer available under the trade names indicated here, since readers have found it of assistance in tracking them down. The main suppliers are: Rayco Ltd, Ash Road, Aldershot, Hants. Telephone: 0252 22725 and Hogg Laboratory Supplies, Sloane Street, Birmingham B1 3BW.

Times

All times, including those for washing or rinsing, should be adhered to in order to obviate the possibility of colour casts. The specified treatment items include 10-15sec drainage.

Temperature

Maintenance of constant temperature throughout first (black-and-white) development in reversal processing and (colour) development in negative processing is absolutely essential if consistent results are to be achieved. In the other solutions, the tolerance is wider, although the specified limits should be respected. Even so, it is important that excessive temperature differences between successive solutions and wash water, especially in transferring to the wash following colour development, be avoided, otherwise there is a risk of reticulation. The washing times given in the procedures apply at the recommended temperatures; if water at lower temperatures is used times must be extended by 50% per 5°C.

Agitation

The recommended agitation is indicated immediately after the procedure. It should be adhered to strictly in the developers but in other solutions should be regarded as a minimum; more vigorous agitation can only be advantageous in expediting solution changes in the emulsion.

Lighting

The individual procedures clearly show at what stage normal room lighting may be resumed when use of an open processing tank necessitates initial darkroom working. At the same stage, the lid of a light-tight tank may be removed.

Second exposure

Where second exposure to light is the manufacturer's recommended procedure the recommended lamp wattage and distance are shown at the appropriate point. The film should preferably be removed from the spiral and see-sawed through a dish of cold water below the lamp, front and back being exposed approximately equally. If the exposure is carried out with the film in a transparent-ended spiral, best immersed in cold water in a white bowl, the time should be extended 1½ (35mm) or 2½ (120) times. Care should be taken not to splash the hot lamp with water and not to work near the sink or taps unless the lampholder is properly earthed. Three or four electronic flashes on each side of the film may also be used although this may give odd colour casts with some films.

Wetting agents

If a final wash completes the procedure, the material should be passed for about 1 min through water containing around 1 ml/l of wetting agent in order to accelerate draining and drying, thereby inhibiting drying marks. The wetting agent may be either of the anionic type — eg American Cyanamid Aerosol OT (sodium di-iso-octysulphosuccinate), Union Carbide Tergitol 7 and Ciba Invitol — or the non-ionic type — eg Rohm and Hass Triton X-100, Francolor Sunaptol OP and Union Carbide Tergitol NPX. The wetting agent is conveniently stored as a 10% solution and made up as a 10% solution of this, thus forming a 1% solution. The working strength solution keeps indefinitely but should be discarded after use.

Drying

Should be performed under protection from air currents and dust.

Storage

The keeping time of used solutions may be diminished by 20-65% depending upon conditions of use and storage (fullness and sealing of bottles, darkness and temperature). Well stoppered dark glass bottles should be used at temperatures not exceeding 20°C. However, first and colour developers should, in any case, be used as fresh as possible. If bleach and fixer are made up as triple-strength stocks, they will be found to have excellent storage properties.

General

The formulae quoted produce results closely corresponding with those from official kits, but deviations occasionally occur owing to variations in reagents from different suppliers. To compensate for these, where necessary, or to provide controls to suit the individual user's taste, the following notes on the less usual ingredients may be helpful:

Citrazinic acid (CZA or 2,6-dihydroxyisonicotinic acid) is employed as a *specialised restraining agent* and serves to prevent what would otherwise be an excessively dense and contrasty dye image. A deficiency produces a dense greenish image, but an excess produces a thin pinkish image; a 10% change in concentration shows markedly in the result.

Ethylenediamine tetra-acetic acid tetrasodium salt (EDTA Na$_4$) acts as an *accelerator*. A deficiency produces a thin yellowish image, whereas an excess produces a heavy bluish image; a 10% variation has a quite noticeable effect.

Benzyl alcohol acts as a *penetrating agent* making the otherwise waterproof dye-former particles accessible to the colour developer products. It is particularly important to ensure that this liquid is completely dissolved before any other reagent of the colour developer is added.

Variations in the amount of *colour developing agent* produce effects rather similar to those of the EDTA salt, the balance travelling from thin and warm to dense and cool as the concentration is increased.

Precaution

Colour developers contain derivatives of para-phenylenediamine, which in certain persons may produce a form of skin irritation. Persons who are sensitive to chemicals of this kind should take precautions to avoid contact with the developer by using rubber gloves. In all cases, when the skin has been in contact with the solution, it should be rinsed well in clean water, preferably made acid with a few drops of acetic or hydrochloric acid, before using soap. Where processing chemicals are used in premises subject to the provisions of the Health and Safety Act, 1974 (eg in professional use or in commercial processing plants) the Act should be consulted for the safety precautions to be observed. In all cases warnings printed on chemical package labels should be strictly complied with. Fuller details of precautions to be observed in the handling of particular materials may be found in the Royal Society of Chemistry publication, *Hazards in the Chemical Laboratory* (3rd edition) by L. Bretherwick.

Reversal
Films

AGFACHROME 50S, 50L and 100
(and AGFACOLOR CT18, CT21 and CK20)

Agfachrome 50S, 50L and 100 are intended for professional use and are sold without processing rights. Agfa CT18, CT21 and CK20 materials are of similar type but are intended for amateur use and are sold inclusive of processing; available in the usual formats. **Agfachrome 200** is sold in the United Kingdom both exclusive and inclusive of processing and mounting but like the newer **CT64** and **CT200** films, is intended for the **E-6 process** and *not* the solutions which follow.

Formulae
First developer (pH:10.2 ±0.1)

Calgon	2.0g
Metol	3.0g
Sodium sulphite (anhydrous)	40.0g
Hydroquinone	6.0g
Sodium carbonate (anhydrous)	50.0g
Sodium thiocyanate	1.8g
Potassium bromide	2.0g
Potassium iodide, 0.1% solution	6.0ml
6-nitrobenzimidazole nitrate 0.2% solution* (optional)	20.0ml
Water to	1000.0ml

*If 6-nitrobenzimidazole is available a 0.2% solution of the nitrate may be prepared by adding 1g to 500ml water previously acidified by the addition of 0.4ml nitric acid. The mixture should be shaken to dissolve the compound.

Stop bath (pH:5.2±0.2)

Acetic acid 98-100% (glacial)	10.0ml
Sodium acetate (3H$_2$O)	40.0g
Water to	1000.0ml

Colour developer (pH:11.8±0.2)

Calgon	2.0g
Sodium sulphite	2.0g
Potassium carbonate (anhydrous)	80.0g
Hydroxylamine sulphate	2.0g
or hydrochloride	2.2g
Ethylenediamine (anhydrous)	8.0g
or ß-phenylethylamine	3.0g
Potassium bromide	2.0g
Water to	1000.0ml

Add before use:

Droxychrome or Activol X	6.5g
(or the equivalent quantity of a 20% solution)	

One may also use as the colour developing agent diethyl para-phenylenediamine sulphate or hydrochloride or even Genochrome may also be used at 5.0g/litre.

Bleach (pH:5.4±0.2)

Potassium ferricyanide	80.0g
Potassium bromide	20.0g
Diosodium hydrogen orthophosphate (12H$_2$O)	27.0g
Sodium or potassium bisulphate	12.0g
Water to	1000.0ml

Fixer (pH: 7.0-7.8)

Sodium thiosulphate (crystalline)	200.0g
Sodium sulphite (anhydrous)	10.0g
Water to	1000.0ml

Ammonium thiosulphate, 120g/litre, may be used to accelerate fixing, replacing the sodium salt.

▶

Stabilising and wetting agent

Wetting agent 10% soln	5-10ml
Formaldehyde 35-40% soln	10ml
Water to	1000ml

Procedure

		At 20°C	At 24°C
1	First developer	18-20min 20±0.5°C	13-14min 24±0.25°C
2	Rapid rinse	30sec 16-20°C	30sec 20-24°C
3	Stop bath	4min 18-20°C	3min 22-24°C
4	Wash	10min 16-20°C	7min 20-24°C
5	Re-exposure	500W at 3ft, 1min each side	
6	Colour developer	14min 20±0.5°C	11min 24±0.25°C
7	Wash	20min 16-20°C	14min 20-24°C
8	Bleach	5min 18-20°C	4min 22-24°C
9	Wash	5min 16-20°C	4min 20-24°C
10	Fixer	5min 18-20°C	4min 22-24°C
11	Wash	10min 16-20°C	7min 20-24°C
12	Stabiliser and Wetting agent	1min 16-20°C	1min 20-24°C
13	Dry	Maximum 30°C	
	Total	94.5min	70.5min

Notes

A Recommended agitation is 30sec, continuous then two periods of 5sec every minute.

b After Stage 4, the processing may be interrupted and the film dried, processing being completed later. In this case, washing should be prolonged to 5min, and the re-exposure to artificial light may be dispensed with. Once dry, the film should be kept in darkness to obviate any possibility of solarisation. If the intermediate drying procedure is followed it is *not* necessary to wet the film before proceeding to Stage 6.

KODAK EKTACHROME FILMS

The generic name for Kodak user-processable reversal materials is Ektachrome and all current materials of this type except two—Ektachrome Infrared and Photomicrography Color Film 2483—are processed by **Process E-6**. These two exceptions continue to use the earlier **Process E-4**, which introduced for the first time the use of a chemical reversal bath to replace reversal by a second exposure. The reversal bath used in Process E-4, however, contains components which are toxic and require care in handling which may not be appropriate to some amateur circumstances. Formulae are given on p195.

EKTACHROME E-6

The Ektachrome E-6 process, like its predecessor the E-4 process, is intended for machine use and is usefully shorter, needing around 40min in the solutions. The shorter process time is achieved by raising the solution temperatures to 38°C. From the user's point of view the process has been improved in two directions; the somewhat aggressive preliminary hardener has been eliminated by hardening the film emulsion in manufacture and the highly toxic tertiary butylaminoborane used as a reversing agent in the colour developer has been replaced by the much less dangerous stannous chloride in a reversing bath which precedes the colour development stage.

Like the C-41 process for colour negative development the E-6 process uses separate bleach and fix stages but with the bleach action performed by a ferric-EDTA complex as is now common in bleach-fix solutions. Intermediate rinses are practically eliminated, and washing times are shortened, thus permitting substantial economies in water consumption (and probably in energy also, despite the high working temperature). And, thanks to the hardened emulsion, which is more resistant and less retentive of water, drying is much more rapid, the more so as it withstands the necessary higher air temperatures.

Formulae

These formulations give results of comparable quality to those obtained by the use of the manufacturers' chemistry. In one or two of the baths deriving from the E-6 process we propose some variants as in the first developer and the bleach. They are both derived from E-4 and only require adaptation for the new products; this should make the work of preparation easier. Quantities are indicated in grammes per litre or ml per litre.

First developer (pH: 9.6±0.1)

Calgon	2.0g
Sodium sulphite (anhydrous)	15.0g
Potassium hydroquinone monosulphonate (pure)	20.0g
Diethylene glycol	15.0ml
Potassium carbonate (anhydrous)	15.0g
Phenidone	0.4g
Sodium thiocyanate (20% solution)	8.0ml
Potassium bromide	1.8g
Potassium iodide (1% solution)	4.0ml
Water to	1000.0ml

Alternative first developer (pH: 9.6±0.1)

Calgon	2.0g
Sodium sulphite (anhydrous)	15.0g
Potassium carbonate (anhydrous)	15.0g
Hydroquinone	6.0g
Phenidone	0.4g
Sodium thiocyanate (20% solution)	8.0ml
Potassium bromide	2.0g
Potassium iodide (1% solution)	5.0ml
Water to	1000.0ml

Reversal bath (pH: 5.8±0.1)

Propionic acid	12ml
Stannous chloride	1.65g
p-Aminophenol	0.5g
Sodium hydroxide	4.8g
BDH Calcium Complexing Agent No 4	15ml
Water to	1000ml

Notes: 1 The very small quantity of p-Aminophenol can best be measured by making a 0.1% solution (1g/1000ml) in 1% solution (10ml/1000ml) of propionic acid. This solution does not keep well and should be discarded after a week or so. **2** If the solution, particularly when made up as a 20x concentrate, does not clear on adding the calcium complexing agent in the above quantity a little more should be added slowly until it does. **3** If reversal is carried out by exposure to light the reversal bath must be replaced by a stop bath consisting of 2% acetic acid for 1min at 38°C, followed by a rinse for the same time and temperature in running water. The operation is carried out in the dark.

Colour developer (pH: 11.6±11.7)

EDTA Na$_4$	3.0g
Potassium carbonate (anhydrous)	40.0g
Sodium sulphite (anhydrous)	4.0g
Potassium bromide	0.5g
Potassium iodide (1% solution)	3.0ml
Citrazinic acid	1.2g

| | Hydroxylamine hydrochloride | 1.5g |
| | Water to | 1000.0ml |

| | Add before use: CD-3 | 10.0g |
| | *or* CD-4 | 7.5g |

These two chemicals can be kept without difficulty as 20% stock solutions with the addition of 2-3g per litre of potassium or sodium metabisulphite.

Conditioning bath (pH: 6.1±0.1)

Sodium sulphite (anhydrous)	10.0g
EDTA Acid	8.0g
Thioglycerol	0.5ml
Water to	1000.0ml

Notes: 1 If only EDTA Na$_4$ is available or EDTA Na$_2$ then 12g of the former or 10g of the latter may be used with the pH adjusted with dilute acetic acid. **2** The inclusion of thioglycerol is optional. **3** For our purposes, perfect results have been obtained with the use of the E-3 clearing bath with a small modification and with the pH adjusted if necessary by adding alkali—sodium or potassium carbonate. The bath is as follows:

Potassium metabisulphite (crystalline)	15.0g
Hydroquinone	1.0g
Water to	1000.0ml

Bleach (pH: 5.5-5.7)

Potassium nitrate (crystalline)	30.0g
Potassium bromide	110.0g
EDTA NaFe or NH$_4$Fe (Merck)	110.0g
Water to	1000.0ml

Note: The nitrate is optional and acts as a protection for stainless steel tanks.

Alternative bleach (pH: 6.7-6.9)

The formulae established for the E-4 process also gives excellent results. Here is a simple and efficient variant of it:

Potassium ferricyanide (crystalline)	100.0g
Potassium bromide	35.0g
Disodium phosphate (crystalline)	20.0g
Water to	1000.0ml

Fixer (pH:6.6-6.7)

Ammonium thiosulphite (crystalline	70.0g
Potassium metabisulphite (crystalline)	12.0g
Sodium sulphite (anhydrous)	7.0g
Water to	1000.0ml

Note: The E-3 or E-4 fixing baths work just as well.

Stabiliser

Wetting agent (Aerosol OT, anionic or any similar product) (10% solution)	5.0ml
Formaldehyde (35-40%)	6.0ml
Water to	1000.0ml

Stock concentrated solutions

Solutions prepared as concentrates and diluted just before use have markedly increased shelf life—by a factor of two or three. The solutions we have used are as follows and they give a worthwhile saving of time and effort.

	Concentration	Dilution
First developer	X2	1+1
Colour developer	X4	1+3*
Reversal	X20	1+19
Conditioner	X10	1+9
Bleach	X2	1+1
Fixer	X5	1+4
Stabiliser	X20	1+19

The CD-3 or CD-4 may be kept separately by making a 20% solution from which may be measured the required quantity by pipette.

CD-3 or CD-4	20.0g
Potassium metabisulphite (crystalline)	3.0g
Water to	100.0ml

Influence of pH

The E-3 process used solutions whose pH differed considerably from one bath to the next. These variations were considerably reduced from E-4. The high temperature working proposed with E-6 allows only minor pH differences between baths—with the exception of the first and colour developers. Fluctuations, intentional or not, in the colour developer pH, can result in variations in the colour balance of the subject matter of the exposures. Variations in first developer pH chiefly affect its activity, raising or lowering its reducing power, and resulting in an increase or reduction in the speed of development.

Colour Developer
 pH too low: blue cast
 pH to high: yellow cast
 Colour developer too dilute: magenta cast
 If the reversing bath is too dilute or exhausted: green cast.

Notes

A The *temperature* of the developer must be maintained with the utmost possible accuracy. We recommend the use of a stainless steel tank immersed in a tank of water at a temperature of 39°C, from which it is removed for agitation and immediately re-immersed.
B The *times* given include the time needed to empty the tank: this should not exceed a maximum of 10sec.
C Each operation should be timed from the moment the tank is filed with the processing solution.
D An initial agitation of 20sec should be given, during which the tank should be tapped on a hard surface (table or sink) to disperse the bubbles of air trapped in the spiral against the emulsion surface.
E For *drying*, the spiral should, after removal from the stabiliser, first be well shaken to remove so far as possible loose drops of solution; the film is removed and then allowed to dry in a well aired but dust free situation (left overnight at a temperature of 20-25°C) or stretched in special drying clips for this purpose, or otherwise suspended. (At 20-25°C drying will then take about ½hr.)

Processing at temperatures other than 38°C

The physico-chemical processes which are involved in processing photographic material are intrinsically related to working temperature. In other words, there is a relationship between the speed of a chemical and physical reaction and the temperature at which it occurs, the speed increasing with the temperature.

For black-and-white development stage it is particularly necessary to have as exact a knowledge as possible of this parameter (speed), since it is this which determines the quality of the image: gradation, colour, rendering, density or the silver image deposit in the various zones of the image and hence the dyes in the final image.

The diagram illustrating the relation between temperature and development time is the result of our own experimental work; it can be of use to those who wish (or who are obliged) to work at a temperature other than 38°C. This must not however be below 32-33°C since this will seriously affect the colour rendering of the transparency. (The permeability of the emulsion diminishes too greatly to permit adequate exchange of solutions through the gelatine.)

Processing times as a function of temperature in the range 32-40°C. Line 1—black-and-white developer and EDTA Fe bleach; 2—ferricyanide bleach; 3—fix; 4—reversal bath and conditioner; 5—wash.

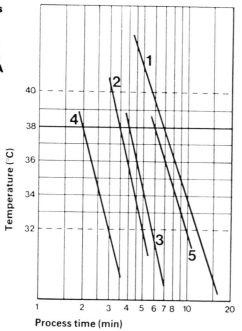

Process time (min)

Exposure	Relative speed	Development modification
−2 stops	4x	+5½min
−1 stop	2x	+2min
+1 stop	0.5x	−2min

Colour rendering is slightly affected:

+1 stop	overexposure:	reduction of contrast and deterioration of colour rendering
−1 stop −2 stops }	underexposure:	diminution of maximum density diminution of exposure latitude shift of colour rendering increase of contrast

From our personal experience, underexposure by 1 stop (as for example ASA800 for Ektachrome 400) still gives excellent results, of quality not perceptibly inferior to that resulting from correct exposure. Not all E-6 process films from other manufacturers behave identically and these development times may require modification in the light of experience. Special recommendations and process control strips are made for the recently introduced **Ektachrome Professional P800/1600** material which is designed for this type of 'push-processing'.

Keeping properties and working capacities

	dm² per unit of			
	0.5l	1l	2l	Keeping
First developer	22	46	100	8-10 weeks
Colour developer	22	46	100	12 weeks
Reversal or stop bath	50	130	280	8 weeks
Conditioner	50	130	280	8 weeks
Bleach	50	130	280	6 months
Fixer	50	130	280	4-6 months
Stabiliser	preferably use fresh			

NB: one 36exp 35mm film = 5.8 dm²; one 20exp 35mm film = 3.8 dm²; 1 × 120 film = 5.1 dm²; 1 × 220 film = 10.2 dm².

Partially used solutions and working solutions generally have their keeping life reduced by 50% and their useful capacity reduced by 20%.

Procedure for large tanks (exceeding 2 litres)

Stage	Time	Temp	Agitation
	min	°C	
1 First development	6	38±0.3	1 × 20sec, then 2 × 5sec, per min
2 Rinse	2	33-39	1 × 10sec then leave undisturbed
3 Reversal	2	33-39	1 × 10sec then leave undisturbed
4 Colour development	6	38±0.6	1 × 20sec then 2 × 5sec/min
5 Conditioner	2	33-39	1 × 10sec then leave undisturbed
6 Bleach	6	,,	2-4 × 5sec/min
7 Fix	4	,,	2-4 × 5sec/min
8 Wash, running water	4	,,	at least 2 changes per min
9 Stabiliser	½	,,	no agitation
	32.5		

Procedure for small tanks (½ litre)

1 First development	7	38±0.3	
2 Rinse	2	33-39	
3 Reversal	2	,,	
4 Colour development	6	38±0.6	
5 Conditioner	2	33-39	
6 Bleach	7	,,	

Modification of processing procedure

A Reversal: It is possible to dispense with *chemical* reversal and instead have recourse to the classic procedure of re-exposure of the emulsion to light: 2 electronic flash exposures to each side of the tank spiral after removal from the tank and preferably kept immersed in water, at a distance of about 30cm; or two 2min exposures to a photoflood at a distance of about 1 metre; or yet again intermediate drying in diffused light (not direct sunlight!)

B Recourse may be had to *intermediate drying* in order to defer completion of processing to a later time. After drying, the film should be kept in relative darkness. For completion of procesing, it is rewound into the spiral and, preferably, soaked in water for 1min before treatment in the colour developer (this is recommended but not obligatory).

C Should the re-exposure procedure be adopted in place of chemical reversal, this soaking treatment should be replaced by 1min in a stop bath of 2% acetic acid and followed by 1min wash before opening the tank.

D Bleach: It is possible to bleach the film in 2-3 minutes by treatment in a potassium ferricyanide bleach bath of the E-3 or E-4 type, adjusted to a pH of 6.4±0.2 followed by 2min rinse before fixing. The temperature of 38°C should also be maintained throughout these stages.

E Where it is desired to *keep* these various solutions, in view of the fact that there is a risk of each solution being contaminated by traces of the previous bath, we recommend an *intermediate rinse* of ½ to 1min after each bath excepting reversal and conditioner solutions where the action must be allowed to continue in the following solutions. The small increase in overall processing time thus occasioned can only be of benefit to working capacity and keeping quality.

Exposure for a speed other than the nominal rating

Films compatible with the E-6 process can be 'uprated' to higher emulsion speeds by up to 2 stops or downrated by 1 stop compared with nominal values. To compensate for this, first development should then be modified in accordance with the following table:

7 Fixer	4	33-39
8 Wash	6	,,
9 Stabiliser	1	,,
	37	

Drying: max 49°C

Agitation: as for large-scale processing (above); agitation may be by inversion, if tank is water-tight.

EKTACHROME E-4

Special attention is drawn to the warnings as to the extremely noxious nature of some of the chemicals used in these formulae. Their use should not be attempted by workers unaccustomed to handling such chemicals.

Process E-4 when introduced presented two departures from earlier processes.

1 Re-exposure before colour development was discontinued; reversal is effected by chemical fogging of the emulsion during colour development. This solution contains an organic chemical—TBAB (tertiarybutylaminoborane)—which enables all parts of the emulsion which have not been developed by the black-and-white first developer to react to the colour developer. TBAB is *very toxic* and must be handled with the greatest care to avoid contact with the skin and respiratory organs. It should be noted, however, that in the substitute formula for the colour developer this additive may be dispensed with, provided the film is re-exposed to light in the customary fashion; the colour characteristics of the film are practically unaffected.

2 To improve the mechanical resistance of emulsions destined for Process E-4 treatment at 29°C, it is necessary to treat them in a preliminary hardening bath containing, in addition to formaldehyde, 2,5-dimethoxytetrahydrofuran (DMTF), a liquid whose vapour is very aggressive in its action upon the respiratory system and eyes, and is very rapidly absorbed by the cutaneous tissues. It is therefore essential to avoid any contact with the liquid. Should the skin become contaminated with it, the affected part should be very thoroughly washed for 15min. Should the eyes exhibit symptoms of irritation a doctor should immediately be consulted. So far as formaldehyde is concerned, amateurs will already be familiar with its very active tanning and irritant properties, and we are confident that they will automatically take the utmost precautions.

Formulae
Pre-hardener (pH: 4.9-5.0)

6-nitrobenzimidazole nitrate	0.03g
Sodium or potassium bisulphate	0.8g
2,5-dimethoxytetrahydrofuran	5.0ml
Sodium sulphate (anhydrous)	136.0g
Formaldehyde (35-40% solution)	30.0ml
Potassium bromide	3.0g
Water to	1000.0ml

Neutraliser (pH: 5.1-5.2)

Hydroxylamine sulphate	20.0g
Acetic acid, (98-100% glacial)	10.0ml
Sodium acetate, ($3H_2O$)	24.0g
Potassium bromide	16.0g
Sodium sulphate (anhydrous)	25.0g
Potassium metabisulphite (crystalline)	5.0g
Sodium hydroxide	6.0g
Water to	1000.0ml

First developer (pH: 10.1-10.3)

Calgon	2.0g
Metol	6.0g
Sodium sulphite (anhydrous)	50.0g
Sodium carbonate (anhydrous)	30.0g
Hydroquinone	6.0g
Potassium bromide	2.0g
Sodium thiocyanate	1.3g
Sodium hydroxide (pellets)	2.0g
Potassium iodide (0.1% solution)	6.0ml
Water to	1000.0ml

Stop bath (pH: 3.4-3.6)

Sodium acetate ($3H_2O$)	5.3g
Acetic acid (98-100% glacial)	30.0ml
Water to	1000.0ml

Colour developer (pH: 11.8 ± 0.2)

Calgon	2.0g
Trisodium phosphate ($12H_2O$)	40.0g
Sodium hydroxide (pellets)	5.0g
1,2-diaminoethane (hydrate)	3.8ml
or ethylenediamine sulphate (crystalline)	7.6g
Benzyl alcohol (35% solution*)	10.0ml
Tertiary butylaminoborane (TBAB)	0.1g
Citrazinic acid	1.3g
EDTA Na4, EDTA tetrasodium salt	3.0g
Sodium sulphite (anhydrous)	5.0g
Potassium bromide	1.0g
Potassium iodide (0.1% solution)	20.0ml
Water to	1000.0ml

Add before use:

Kodak CD-3	11.3g

*Benzyl alcohol, 35% solution

Benzyl alcohol	35.0ml
Diethylene glycol (digol)	45.0ml
Water to	100.0ml

Bleach (pH: 6.6-7.0)

Potassium ferricyanide	112.0g
Potassium bromide	24.0g
Disodium hydrogen orthophosphate ($12H_2O$)	62.0g
Monosodium dihydrogen orthophosphate (anhydrous)	15.6g
Sodium thiocyanate	10.0g
Water to	1000.0ml

Fixer (pH: 4.5-4-9)

Ammonium thiosulphate (crystalline)	120.0g
Potassium metabisulphite (crystalline)	20.0g
Water to	1000.0ml

Stabiliser

Formaldehyde (35-40% solution)	3.0ml
Wetting agent (10% solution)	10.0ml
Water to	1000.0ml

▶

Procedure

1	Preliminary hardener	3min	29.5±0.5°C
2	Neutraliser	1min	28-31°C
3	First developer	6min	29.5±0.25°C
4	First stop bath	2min	28-31°C
	Normal room lighting may be resumed		
5	Wash, running water	4min	27-32°C
6	Colour developer	9min	27-32°C
7	Second stop bath	3min	27-32°C
8	Wash, running water	3min	27-32°C
9	Bleach	5min	27-32°C
10	Fixer	6min	27-32°C
11	Wash, running water	6min	27-32°C
12	Stabiliser	1min	27-32°C
	Dry		43°C
	Total	49min	

Notes

A Recommended agitation is continuous for the first 15sec, then 5sec every minute.

B Complete transparency of the film is reached only when it is perfectly dry. It should be noted that it is permissible to *dry off the film temporarily* after completion of Stage 5. The film should then be stored in diffused light or preferably in total darkness until processing is to be completed.

C The pre-hardener chemicals should be dissolved in water at 38-40°C with continuous agitation until solution is complete. At least 10min must be allowed to elapse before use to allow the DMTF to become transformed by hydrolysis into succinicaldehyde, a powerful gelatin tanning agent. The solution becomes effective after this transformation is complete.

D Should it not be possible to obtain the commercial ethylene diamine (1,2-diaminoethane) hydrate (80% ethylene diamine) (beware of noxious fumes) for the colour developer, the sulphate, which is easier to handle, may be used. In this case, the pH-value may need to be adjusted by adding a few millilitres of a 10% solution of caustic soda. The TBAB, supplied by Kodak Limited in pellet form, should be crushed in a little water, using a glass rod or small pestle, then the remaining solution added. The TBAB can be dispensed with if the usual procedure of reversal by exposure to light is followed (see above).

E It should be emphasised that any contamination of one solution by another must absolutely be avoided. As the intermediate washes have been reduced to a strict minimum, all utensils employed in processing must be thoroughly cleansed and dried before use for a succeeding solution.

F The two stop baths should be kept separate to avoid contamination.

G Time of development in the first developer should be increased in accordance with the use it has had. For 20exp 35mm films, or approximately 0.37sq ft material per film, the times should be as follows:

1-4 films	6min
5-7 films	6min 15sec
8-10 films	6min 30sec
11-12 films	6min 50sec

H This process is suitable for use with **Kodak Photomicrography Color Film PCF 2483** and **Ektachrome Infrared**. These are the only current Kodak E-4 process materials on the general market.

Keeping properties and working capacities

Solution	Keeping time	135-20	135-36	120
Pre-hardener	4 weeks	12	7	8
Neutraliser	3 months	12	7	8
First developer	3 months	12	7	8
colour developer:				
without CD-3	6 weeks	—	—	—
with CD-3	4 weeks	12	7	8
Stop baths	6 months	12	7	8
Bleach	6 months	18	10	12
Fixer	6 months	12	7	8
Stabiliser	6 months	should be used fresh		

Other manufacturers' materials compatible with the E-4 process

As a result of the worldwide dissemination of the Kodak Ektachrome E-4 process, many other manufacturers produced materials suitable for processing in E-4 solutions. By now all have been superseded by E-6 process films: particular care should be taken to distinguish between older E-4 and the current process materials. By now most E-4 process materials are many years out of date.

ORWOCHROM UT18 and UT21

Introduction

The procedure is in accordance with the manufacturers' instructions. The working temperature is 25°C, which is much easier to maintain than the traditional 18°C of the old emulsion. The manufacturers have succeeded in sufficiently hardening the emulsion, which formerly had a reputation for being very susceptible to mechanical damage, to allow processing at the higher temperature.

Formulae

Apart from that for the first developer, which makes use of Phenidone, all formulae are as specified by the manufacturers.

First developer: (pH: 10.2-10.4)

Calgon	2.0g
Sodium sulphite (anhydrous)	40.0g
Sodium carbonate (anhydrous)	34.0g
Phenidone	0.8g
Hydroquinone	6.0g
Potassium bromide	2.5g
Sodium thiocyanate	1.2g
Potassium iodide (0.1% solution)	6.0ml
Water to	1000.0ml

Alternative first developer: (pH: 10.3±0.1)

Calgon	2.0g
Sodium sulphite (anhydrous)	40.0g
Sodium metaborate	5.0g
Phenidone	0.8g
Hydroquinone	5.0g
Potassium bromide	2.5g
Sodium thiocyanate	0.8g
Potassium iodide (0.1% solution)	6.0ml
Caustic soda (pellets*)	about 0.8g
Water to	1000.0ml

*To adjust pH to required value.

Stop bath G37 (pH: 4.2±0.1)

Sodium acetate ($3H_2O$)	15.0g
Acetic acid (98-100%)	25.0g
Water to	1000.0ml

Colour developer C15 (pH: 10.7±0.2)

Calgon	4.0g
Hydroxylamine sulphate	1.2g
Sodium sulphite (anhydrous)	2.0g
Potassium carbonate (anhydrous)	75.0g
6-nitrobenzimidazole nitrate (0.2% solution)	5.5ml
Potassium bromide	2.5g
Water to	1000.0ml

Add before use:

Diethyl paraphenylenediamine sulphate	3.0g

Bleach bath C57 (reinforced) (pH: 4.2±0.2)

Potassium ferricyanide	100.0g
Potassium bromide	30.0g
Sodium dihydrogen orthophosphate (2H$_2$O)	5.8g
Disodium hydrogen orthophosphate (12H$_2$O)	4.3g
Water to	1000.0ml

Fixer C73 (for quick fixing) (pH: 6.6±0.3)

Sodium thiosulphate (crystalline)	200.0g
Ammonium chloride or sulphate	80.0g
Water to	1000.0ml

Procedure

1	First developer	10min	25±0.25°C
2	Wash, running water	1min	13-24°C
3	Stop bath	2min	18-24°C
	Normal room lighting may be resumed		
4	Re-exposure, 500W at 1m	2 ×2½min	
5	Colour developer	12min	25±0.25°C
6	Wash, running water	20min	13-24°C
7	Bleach	5min	18-24°C
8	Wash, running water	5min	13-24°C
9	Fixer	5min	18-24°C
10	Final wash	15min	13-24°C
11	Wet	1min	18-24°C
12	Dry		30°C max
	Total	81min	

Note

A Recommended agitation is continuous for 2min, then 5sec every minute.

Negative Films

AGFACOLOR 80S and CNS2 (and PERUCOLOR)

Agfacolor 80S was supplied in the usual 'amateur sizes': 120/620, 35mm (20- and 36-exposures and 30m rolls) and 126 cartridge for 12 and 20 exposures. It was balanced for daylight (approximately 5500°K) xenon lamps or electronic flash.

Agfacolor CNS2, introduced originally as Agfacolor Pocket Special for 110-format cameras, was available in sizes up to and including 120 roll film. *Note* that **Agfacolor 400 and 100** and **Agfacolor XR100, XR200 and XR400** films are intended for Process AP70 which is equivalent to Kodak C-41: these newer materials have now replaced the CNS2 and 80S materials. Fuji-manufactured film marketed as **Agfacolor Professional N100S and N80L** is also intended for Process AP70/C-41.

Mask formation

The two masks in Agfacolor 80S and CNS2 films are each formed in a special way, which differs from the coloured coupler process employed by, among others, Kodak, Orwo and Fuji.

The red mask of the cyan layer is formed in the bleach bath by oxidation coupling of the residual coupler (which has not reacted during the colour development) with an auxiliary mask-forming substance incorporated in this layer of the emulsion. (The process is the same as that which characterised the old Gevacolor Mask, where the mask formed was an alkyl derivative of 3-amino-guanidine.)

The yellow mask former (which is actually a slight yellow-tinted coupler) is transformed into a colourless derivative in those parts of the image where the magenta dye is formed in direct proportion to the amount of magenta dye (by coupling of the oxidation product with the colour former). The residual yellowish coupler is transformed into a definite yellow mask by oxidation in the bleach bath.

Comparative colour rendering and quality

Prints made from a double-masked negative, when compared with those from an unmasked negative, show a very decided improvement in general colour rendering: yellow is more saturated, blue is more luminous, green is purer and less blue, magenta is more bluish and less intense, red is more saturated and cyan is greener and more luminous. The grain is relatively fine; definition is sufficient easily to permit enlargement of 12-14 diameters (30 x 40cm from a 24 x 36mm negative). The exposure latitude is sufficient to give good-quality images over a range of −1 to +2 stops, equivalent to a range of speed ratings from ASA20 to 160.

Formulae

Colour developer (pH; 11.0-11.3)

Calgon	2.0g
Hydroxylamine hydrochloride or sulphate	1.4g
Sodium sulphite (anhydrous)	2.0g
Potassium carbonate (anhydrous)	75.0g
Potassium bromide	2.5g
Water to	1000.0ml

Add, some hours before use:

Diethyl paraphenylenediamine sulphate	2.8g

Intermediate bath (pH: 10.2-10.5)

Magnesium sulphate (crystalline)	30.0g
Colour developer (used)	30.0ml
Water to	1000.0ml

Bleach: (pH: 5.8-6.2 (critical))

Potassium ferrocyanide	5.0g
Potassium ferricyanide	20.0g
Potassium bromide	12.0g
Sodium dihydrogen orthophosphate (2H$_2$O)	0.9g
Disodium hydrogen orthophosphate (12H$_2$O)	2.7g
Water to	1000.0ml

Fixer (pH: 7.0-7.8)

Sodium sulphite (anhydrous)	10.0g
Sodium thiosulphate (crystalline)	200.0g
Water to	1000.0ml

▶

Keeping properties and working capabilities

Solution	Keeping time	Working capacity per litre		
		135-36	120-620	sq ft
Colour developer: without diethyl ppd	4 months	—	—	—
Complete*	2 weeks	4-5	5	2½
Intermediate bath		should be used fresh		
Bleach	4-6 months	8	10	5
Fixer	4 months	6	8	4
Wetting agent	1 year	should be used fresh		

*To ensure greater uniformity in negative characteristics, we advise using fresh colour developer every time.

Procedure (as specified by Agfa)

1	Colour developer	8min	20±0.2°C
2	Intermediate bath	4min	20±0.2°C
3	Wash, running water	14min	14.20°C
4	Bleach	6min	20±0.5°C

Normal room lighting may be resumed (actually after 1min in bleach bath)

5	Wash, running water	6min	14-20°C
6	Fixer	5min	18-20°C
7	Final wash	10min	14-20°C
8	Wetting agent	½min	14-20°C
	Total	52½min	

Notes

A Recommended agitation is continuous for the first 15sec, then 5sec twice a minute.

B Any increase in treatment time or excessive agitation in the bleach (Step 4) may result in the formation of a too dense masks. In our opinion, it is preferable to give 5sec agitation only once a minute in this bath and (from our own experience) to cut the time to 4min.

C Depending upon the contrast required, development may be for 7-9min.

D Diethyl paraphenylenediamine sulphate has an annoying tendency to form oil droplets of the free base when dissolved in the remainder of the colour developer. It is of advantage to dissolve it separately in 20ml pure water and add this solution with continuous agitation. It also possible to prepare a 20% stock solution, measuring off the requisite quantity as required:

Diethyl paraphenylenediamine sulphate	20.0g
Potassium metabisulphite	2.0g
Water to	1000.0ml

This solution keeps for 2-3 months in a well-sealed bottle in the dark.

KODAK COLOUR NEGATIVE FILM PROCESSES

All Kodak colour negative emulsions currently available—and those from most other major manufacturers—are designed for **Process C-41**. These include amateur **Kodacolor VR100, VR200, VR400** and **VR1000** and professional **Vericolor II** and **III** films in cartridge, miniature, roll and sheet formats as well as specialised materials for making intermediate negatives from colour transparencies and print transparencies from colour negatives. However, some colour negative films, particularly 'own brand' types sold by retail chains and multiple stores, required the earlier **Process C-22** and details of that process are given here. There is some very limited compatibility between the two types of material and the two processes: this topic was discussed in an article in *The British Journal of Photography* ('C-41 and C-22: the question of compatibility', Neville Maude, p405, 9 May 1975 issue).

C-41 PROCESS

Introduction

Until mid-1983 there were two 'amateur' colour negative emulsions supplied by Kodak, Kodacolor II with a speed of ASA100/21 DIN and Kodacolor 400 rated at ASA400/27 DIN. Both were available in 110, 135 and 120 formats. The ASA100 version is additionally available in some of the less used miniature and roll sizes. In 1979 an improved version of Kodacolor 400 was introduced, first in the USA, the packaging being identified by a red blob. Improvements in granularity and colour differentiation over the earlier material are claimed.

During 1983 a new range of Kodacolor VR films was introduced, with speeds of ASA100/21 DIN, ASA200/24 DIN, ASA400/27 DIN and ASA1000/31 DIN. Improved sharpness and colour rendering, coupled with reduced graininess is claimed for the three slower films. They incorporate experience and methods gained during development of materials for the ultra-miniature 'disc' format. Kodacolor VR1000 incorporates thin plate-like silver halide grains which, aligned parallel to the emulsion surface, show enhanced sensitivity without as large a penalty in graininess as shown by conventional emulsions. All these VR films were initially available in 35mm only.

Vericolor II Professional Films Type S (daylight balance, exposures shorter than 1/10sec) and Type L (3200K balance, exposures, from 1/50 to 60sec) were introduced in June 1975. The Type S material (ASA100) is available in 35mm, 120/220 and 70mm roll formats and in sheet sizes up to 8 x 10in: Type L (ASA25-80, dependent on exposure time) is supplied in 120 roll and in sheet sizes. In 1979 Vericolor Commercial Type S in 120 and sheet formats was introduced. This material has a higher contrast than Type S—in this it resembles Type L—but a similar ASA100 speed rating. Improved Vericolor III materials were announced at photokina in October 1982 and have now superseded Vericolor II films.

As with the earlier C-22 process, many manufacturers now produce materials compatible with C-41 processing. Reference should be made to the tabulation of colour negative films on pp 180-183.

The brevity of the processing steps of the C-41 process may well *a priori* worry the amateur: it is true that it is difficult simultaneously to maintain a high processing temperature together with regular agitation for a time calculated 'to the second', especially in colour development. This is a process intended primarily for automatic processing installations with a view to increasing throughput and profitability. Our experiments have confirmed that the C-41 procedure *can* be carried out efficiently in a small tank—so long, that is, as the time, temperature and agitation recommendations are carried out. One advantage, however, is that the solutions contain only chemicals of weak toxicity; environmentally undesirable substances have been banned from the formulation.

C-41 Procedure (after Kodak)

1	Colour development	3min/15sec	37.8±0.15°C
2	Bleach	4min/20sec	24-40°C
3	Wash	1min/05sec	24-40°C
4	Fix	4min/20sec	24-40°C
5	Wash	3min/15sec	24-40°C
6	Stabilisation	1min/05sec	24-40°C
7	Dry	—	<43°C
	Total	17min/20sec	

Operational Steps

1 Prepare a water bath at 41°C: this provides a thermal reservoir.

2 Bring the solutions up to 38°C before use.

3 Fill the developing tank with the necessary quantity of developer, agitate continuously for 20sec, then plunge it in the water bath to within 2-3cm of the top of the lid.

4 Take the tank out again and agitate—preferably by inversion—for 5sec. Put it back in the water bath. Repeat this cycle giving 6 agitations each minute.

5 Empty the tank 10sec before the elapse of the required time. Shake it well so that as little colour developer as possible is left inside.
6 Pour in the bleach and carry out the same agitation rhythm as above.
7 When the bleach stage is finished, the tank may be opened to simplify washing.
8 Once it has come out of the stabilising bath, the film is hung up to dry in the usual manner. In a normally heated and ventilated room it will be dry in about 30-40min.

Variations When processed mechanically, the film is wiped before passing into the bleach bath. When working with a spiral tank this is unfortunately not possible, so that a rapid contamination of the bleach oxidising solution takes place, together with rise in pH. We have therefore introduced a small variation to overcome this inconvenience: after the end of colour development, we pour into the tank a stop—1% acetic acid or the C-22 stop bath—and agitate continuously for 30sec. The solution is then poured out and a 30sec wash in water at 38°C given before pouring in the bleach bath. The Kodak procedure is then resumed. It is also possible to work with the classic ferricyanide bleach bath, using the following procedure:

1	Colour development	3min/15sec	38±0.2°C
2	Stop bath C-22	0min/30sec	38±0°C
3	Wash in running water	2min/30sec	38±3.0°C
4	C-22 bleach	2min/30sec	38±3.0°C
5	Wash in running water	1min/30sec	38±3.0°C
6	C-22 fix	4min/20sec	38±3.0°C
7	Wash in running water	3min/15sec	38±3.0°C
8	Stabilisation	1min/05sec	38±3.0°C
9	Drying	—	<43°C
	Total	18min/55sec	

Results with this procedure are identical to those obtained following the official process.

Formulae
The quantities are given in grams per litre. The chemicals are dissolved in the indicated order.

Colour Developer (pH: 10.0-10.1)

Calgon	2.0g
Sodium sulphite (anhydrous)	4.25g
Potassium bromide	1.5g
Potassium carbonate (anhydrous)	37.5g
Hydroxylamine sulphate	2.0g
Water to make	1000.0ml

Add 6hr before use:

CD-4	4.75g
or CD-4 (20% solution)	24.0ml

CD-4 stock solution

The following keeps well for about 2 months in the cool away from light.

CD-4	20.0g
Potassium metabisulphite (crystalline)	3.0g
Water to make	1000.0ml

Bleach

EDTA NaFe	100.0g
Potassium bromide	50.0g
Ammonia 20%	6.0ml
Water to make	1000.0ml

Fix (pH: 5.8-6.5)

Ammonium thiosulphite	120.0g
Sodium sulphite (anhydrous)	20.0g
Potassium metabisulphite (crystalline)	20.0g
Water to make	1000.0ml

Stabiliser

Wetting agent (10% solution)	10.0ml
Formaldehyde (35-37% solution)	6.0ml
Water to make	1000.0ml

Capacity (1 litre) and shelf life of fresh solutions

Solution	Keeping	Working capacity				dm^2 approx
		110/ 20ex	126/ 20ex	135 36ex	120	
Colour developer without CD-4	6 weeks	—	—	—		—
Colour developer with CD-4	1 month	30	12	5	6	30
Bleach	8-12 weeks	120	45	20	24	100-120
Fixer	8-12 weeks	60	22	10	12	60
Stabiliser	1 year	use once only				—
Stop bath	1 year	use once only				—

Notes
1 Partially used solutions have a 30-50% lower shelf life, depending on the actual storage conditions (darkness, well-stoppered bottle, temperature 14-20°C).
2 Work whenever possible with fresh solutions to ensure optimum consistency of results. However, for 110 format film, Kodak advise the division of 1 litre of developer into two 500ml quantities. This enables films to be developed in batches of 3, and 5 or 6 batches can be processed before throwing the developer away. If this is done, processing times should be modified according to the following table.

Development time for 110 format (min/sec)

Film	No of films developed at once	1st batch	2nd	3rd	4th	5th	6th	Total films (in 500ml)
110/20ex	3	3/15	3/22	3/30	3/37	3/45	—	15
110/12ex	3	3/15	3/20	3/26	3/31	3/37	3/43	18

3 It is desirable to keep the bleach solution, unlike others, in a half full container. It should be shaken vigorously after use for about 10sec to reoxidise the ferrous complex Fe^{++} (formed during bleaching) to the ferric complex Fe^{+++}, so that its activity can be maintained. Replenishment is not advisable in amateur usage and the solution should therefore be thrown away after the indicated number of films has been processed.
4 The C-41 colour developer is also suitable for processing Ektacolor 78RC Paper, adding 45ml/l benzyl alcohol.
5 Instead of separate Bleach and Fixing baths, the use of a combined bleach/fix is possible. That given for 78RC paper is suitable (4min): pH 5.8-6.2.

Other major manufacturers' materials compatible with C-41 processing:
Agfacolor 100 and 400, Agfacolor Professional N100S and N80L Agfacolor XR films, Sakuracolor II and Sakuracolor II 400, Konicacolor SR films, Fujicolor F-II and F-II 400, Fujicolor HR films, Ilfocolor 100 and 400, Ilfocolor HR films, 3M Color Print and Color Negative 100 and 400, 3M HR films.

▶

C-22 PROCESS
Formulae
Colour developer (pH: 10.6-10.7)

Calgon	2.0g
Benzyl alcohol	5.0ml
or benzyl alcohol (solution 35%) (see E-4)	15.0ml
Sodium metaborate (crystalline) or Kodalk	85.0g
Sodium sulphite (anhydrous)	2.0g
Potassium bromide	1.6g
CD3	5.3g
Water to	1000.0ml

Stop bath (pH: 4.3-4.7)

Glacial acetic acid	20.0ml
Sodium sulphite (anhydrous)	10.0g
Water to	1000.00ml

Hardener (pH: 10.4-10.8)

Formaldehyde (35-40% solution)	20.0ml
Sodium carbonate (anhydrous)	10.0g
Water to	1000.0ml

Bleach (pH: 6.6-7.0) (See also formula E-4 bleach, which acts faster)

Potassium nitrate (crystalline)	25.0g
Potassium ferricyanide	20.0g
Potassium bromide	8.0g
Boric acid	5.0g
Disodium tetraborate	1.0g
Water to	1000.0ml

Fixer (pH: 4.4-4.6)

Ammonium thiosulphate (crystalline)	120.0g
Potassium metabisulphite	20.0g
Water to	1000.0ml

Keeping properties and working capacities

Solution	Keeping time	Working capacity per litre		
		Roll films (120 or 620)	35mm (20 exp)	Sheet film 4 × 5in
Colour developer:				
with CD-3	2 weeks	6-8	8-10	25
without CD-3	6 months	—	—	
Stop bath	indefinite	6-8	8-10	25
Hardener	1 year	12-16	16-20	50
Bleach	6 months	12-16	16-20	50
Fixer	6 months	12-16	16-20	50

Procedure
The several stages are those specified by Kodak:

1	Colour developer	13min	75±0.5°F
2	Stop bath	4min	68-76°F
3	Hardener	4min	68-76$F
	Normal room lighting may be resumed		
4	Wash	4min	68-76°F
5	Bleach	6min	68-76°F
6	Wash	4min	68-76°F
7	Fixer	8min	68-76°F
8	Final wash	8min	68-76°F
	Total	51min	

Notes

A Recommended agitation is continuous for the first 15sec, then two periods of 5sec every minute.

B For electronic flash exposures, it was established that the colour characteristics of the negative are often improved by increasing the development time by 2min to 16min.

C Films are transferred from the colour developer direct to the stop bath, taking care to carry as little developer over as possible. However, it was confirmed that a brief rinse (20sec) does no harm and extends the life of the stop bath. The same applies to transferring the film from the stop bath to the hardener.

D For sheet films after every three 4 x 5in films the time of development should be increased by 35-45sec. For example:

Film number:	1-3	4-6	7-9	10-12 etc
Minutes:	14	14¾	15½	16¼ etc

For maximum uniformity of results it is advisable to develop at least 2-9 films together (by the use of suitable dishes) and to use considerable quantities—5l or more—of solution. In this case an increase of developing time will be necessary only every 12-15 4 x 5in films.

E Here, as in all photographic processing, scrupulous cleanliness throughout is essential. Care should be taken to avoid contamination of one solution by another except in the case of the stop bath and hardener, where as officially prescribed by Kodak the film passes straight from the developer into the stop bath and thence into the hardener without any intermediate rinse. It is, however, as well to drain films before immersing them in that solution. It is in fact possible to increase the life of the stop bath and hardener by giving the film a quick rinse (5sec) in water between solutions. For our part we prefer this method which better conforms with our own niceties of practice.

F The pH-value of the solutions may be adjusted if need be by varying the buffer proportions (disodium hydrogen orthosphosphate, disodium tetraborate, boric acid).

G It is recommended that the CD-3 be added immediately before use; this greatly extends the life of the stock solution. A practical procedure is to make up a 20% stock solution of CD-3, the requisite quantity being abstracted with a pipette immediately before use:

Potassium metabisulphite	5.0g
CD-3	20.0g
Water (30°C) to	100.0ml

H By adjusting the proportion of potassium bromide in the colour developer, contrast can be controlled to an appreciable degree: within limits a higher bromide content increases contrast. It can be reduced to as little as 1g/l, which at the same time gives a gain in emulsion speed of about ¼ stop but with the risk of increasing colour fog (depending upon the emulsion).

I For rollfilms and 35mm films the time of development should be increased by 30-45sec for each film developed.

Other manufacturers' materials designed for C-22 processing
The following major manufacturers' materials may be processed by the C-22 process. Note that these and most of the 'own brand' type have been superseded by C-41 process materials. Care should be taken to avoid confusion. Most of the C-22 process materials are by now many years beyond their expiry date.
Fujicolor N100 and **NK**
GAF (Ansco) **Color Print Film**
Sakuracolor N100

Colour Print
Papers

AGFACOLOR MCN 310/317/319 TYPE 4 (RC resin coated)

Introduction
The characteristics of these colour papers were adapted to the presence of the masks in older Agfacolor films. The manufacturers recommend that the paper should if possible be stored at a temperature below 10°C (in a refrigerator) and that the relative humidity should not exceed 60%. In view of the high sensitivity of the paper, it should not be exposed for more than 2min to the light of an Agfa-Gevaert 08 safelight, using a 15W lamp at a minimum distance of 30in. **Agfa Type 7** paper is processed in **AP92**, which is compatible with Ektaprint 2 solutions, and not in the formulae quoted here.

Formulae
The formulae are as specified by Agfa. The developing agent recommended by the manufacturers is N-n-butyl-N(4-sulpho-n-butyl) 1,4-phenylenediamine (Ac 60). This substance may be replaced by a number of other colour developing agents: the use of one or other of these agents requires slight modification of filter values. Diethyl paraphenylenediamine sulphate is also very suitable and gives results which are close to those obtained with Ac 60, without modification of the developing time.

Colour developer (pH: 10.8-11.0)

Calgon	1.4g
Hydroxylamine sulphate	2.7g
Sodium sulphite (anhydrous)	2.7g
Sodium bromide	0.7g
Potassium carbonate	67.0g
Water to	1000.0ml

Add, some hours before use:

Ac 60 (Agfa) *or* Colour Developer 60 (Merck) *or*	4.0g
T32 *or* Droxychrome *or* S5 *or*	3.3g
diethyl paraphenylenediamine sulphate	2.0g

Bleach-fixer (pH: 7.4-7.7)

EDTA Na$_4$	25.0g
Disodium tetraborate (crystalline)	30.0g
EDTA NaFe	30.0g
Potassium dihydrogen orthophosphate (anhydrous)	15.0g
Sodium sulphite (anhydrous)	2.0g
Thiosemicarbazide*	3.0g
Sodium thiosulphate (crystalline)	290.0g
Water to	1000.0ml

*Provided replenishment of solutions is carried out, this substance may be omitted.

Stabiliser (pH: 6.5-8.0)

Brightening agent	4.0g
Sodium acetate (3H$_2$)	3.0g
EDTA Na$_4$	2.0g
Formaldehyde (30% solution)	80.0ml
Water to	1000.0ml

Brightening agents—an industrial product such as:
Leucophore B, R (Sandoz)
Blancophore BBU, BUP, BP (Bayer)
Uvitex CF conc, PRS (Ciba)
Tinopal BV (Geigy)
Photine C, B (Hickson & Welch)
Celumyl, B, R, S (Bezons)

Substitute solutions
It is possible to replace the original stop-fixer and bleach-fixer solutions by alternative formulae without any sacrifice of quality. These are simpler and therefore easier to prepare, and since they can be used equally well with the majority of current colour papers, this simplification has an obvious advantage.

Stop bath: use 2% acetic acid.

Bleach-fixer (pH: 6.7-7.2)

EDTA NaFe	50.g
EDTA NA$_4$	5.0g
Sodium carbonate (anhydrous)	1.0g
Sodium sulphite (anhydrous)	10.0g
Sodium thiocyanate (20% solution)	50.0ml
Potassium iodide	2.0g
Ammonium thiosulphate (crystalline)	120.0g
Water to	1000.0ml

The use of ammonium thiosulphate enables the time of treatment to be almost halved (3min at 20°C, 2min at 5°C). For the rest, we suggest the following modifications in procedure
1 After colour development, immerse the prints for 10-15sec in a 1% solution of acetic acid instead of rinsing in running water.
2 Rinse the prints for 15sec in running water before passing them into the bleach-fixer.

Procedure

Hand processing in dishes	25°C	30°C
1 Colour development	5min	3min
2 Stop (5% acetic acid)	1-2min	1min
3 Rinse	1-2min	1min
4 Bleach-fix	4-5min	3-4min
5 Wash	3-5min	2-3min
6 Stabilise	2min	1min
7 Rinse	¼min	¼min

Recommended agitation is continuous for the first 15sec in the colour developer, then 5sec 3-4 times per minute. In other baths agitation is continuous.

Small drum processing	30°C	35°C
1 Preheating (water temperature is indicated by drum manufacturer's nomogram)	1min	¾min
2 Colour development	3min	2min
3 Stop 5% acetic acid)	¾min	½min
4 Rinse	¾min	½min
5 Bleach-fix	2¼min	1½min
6 Wash	2¼min	1½min
7 Stabilise	1min	½min
8 Rapid rinse	10sec	5sec

The prints should be dried at temperatures not exceeding 90°C.

▶

Keeping properties and working capacities

Solution	Keeping time	Working capacity per litre	
		10 × 15cm	sq ft
Colour developer:			
without Ac 60	3 months	—	—
Complete	3-4 weeks	40	6
Bleach-fixer	3-4 months	120	18
Stabiliser	3 months	120	18

Other manufacturers' materials compatible with MCN310/4 processing

The following materials may be processed in the same manner as MCN310/4:

Fomacolor PM, Type 30 (RC) paper
Valcolor RC paper (Spain)
Fortecolor CN4, Type 4 (resin-coated) Hungary.

EKTACOLOR 74RC and 78RC

Introduction

Ektacolor 74RC is basically a faster version of the earlier 37RC, the increase in speed being achieved by changing the relative sensitivity of the layers. The blue sensitivity remains virtually unchanged, the green is appreciably increased, while the red-sensitive layer is some 4-5 times faster. Filtration adjustments are thus necessary but processing is as for 37RC. In Europe 74RC is being progressively replaced by 78RC for which higher colour saturation and contrast are claimed. Processing characteristics are unchanged.

Procedure

1 Dish processing

The times given below include 20sec for draining at the conclusion of each processing stage.

Solution	Time (minutes)	Temperature (°C)
Colour developer	3½	31.1±0.3
*Bleach fix	1½	31.1±1.2
Wash	2	31.1±1.2
Stabiliser	1	31.1±1.2
Total	8	—
Drying		not above 107°C

*To obviate an excessive rate of exhaustion of the bleach fix solution due to carry-over contamination, the print may be treated for one minute in a stop bath (for example Stop Bath C-33, or a 3% solution of acetic acid) followed by one minute rinse.

Clearing

Normal room lighting may be resumed following the bleach fix stage, or even before it, if the stop bath has been used.

Agitation

If only one print is processed at a time, the dish may be lightly rocked, 3 or 4 times per minute. If a number of prints are processed together, immerse the first print, emulsion side down, then at 20sec intervals, the second print, the third, and so on, in each case emulsion side down. When all prints are immersed, bring the bottom print to the top, and the others in succession. Continue this procedure until the processing time of each has elapsed.

Capacity

One litre of colour developer will develop 3 to 4 20 x 25cm prints. It should then be discarded. So far as the other solutions are concerned,

they should serve to process (in 1 litre) 7-8 prints of the same format. If the additional stop bath is employed, it is even possible to process at least 1 to 1½m² of paper in 1 litre of 'blix'.

2 Processing in small drums

The advantage of this procedure is obvious: the quantity of colour developer used is so very small (60ml for the smallest model, sufficing for development of one 20 x 25cm—8 x 10in—print); this corresponds to a capacity of 0.8m²/litre. For the other solutions the capacity is at least doubled: that is to say, one could use the 60ml twice, or alternatively use four times as much solution (250ml), permitting the consecutive processing of at least 10-12 prints before discarding it. Bearing in mind the cost of chemicals, the economy this represents is obvious, quickly offsetting the initial cost of the drum. This is over and above the immense advantage of being able to work in ordinary light, once the print has been inserted and the drum closed.

Below is a table of procedure for each of three different temperatures from which the most suitable can be chosen to meet local conditions.

Treatment times (min)

Solution		t=31°C	33°C	38°C±0.3	Remarks
1	Pre-warming/wetting	¾	¾	¾	
2	Colour developer	3½	3	2	
3	Wash*	¾	¾	½	2 changes
	or				
3a	Stop Bath C-22	½	½	½	
3b	Wash*	½	½	½	2 changes
4	Blix	1¾	1½	1	
5	Wash*	2	1½	1	
6	Stabiliser†	1	¾	½	
	Total	10	8¼	6-6¼	

Drying temperature 107°C

*Four changes of water may be considered equivalent to one minute of wash.
†The use of a stabiliser is now optional. The simplified 2-bath process gives equally good results.
In this case the final wash must be prolonged to 4, 3 and 2min respectively.

Agitation

About 20-30 cycles/min (according to size of drum). The times given include 10-20sec for emptying the drum. Note that in the case of large models, treatment times should be prolonged by 15sec for the developer and 30sec for the other solutions to allow for the greater quantities of liquid which have to be emptied.

Temperature

In the case of drums where this information is provided this will be determined by reference to the nomograms provided with the drum; this takes account of the ambient temperature (=temperature of solutions) to indicate that of the water for pre-warming and washing. Other small drums including the Paterson and the Unicolor are also supplied with full temperature instructions.

Alternative formulae

The formulae which we give below yield results which are comparable, both qualitatively and quantitatively, with those obtained with the official procedure. Quantities are quoted throughout in grams or millilitres. Where water is the base of a solution, the components should be dissolved in the order indicated in water at 30-35°C.

Colour developer (pH: 10.1-10.2)†

1 Working solution

Calgon	2.0g
Hydroxylamine sulphate	3.4g

Sodium sulphite (anhydrous)	2.0g
Potassium carbonate (anhydrous)	32.0g
Potassium bromide	0.4g
Benzyl alcohol (50% solution)*	30.0ml
Water to	1000.0ml

Add before use:

CD-3	4.4g
(or 22% solution)*	20.0ml

See 2—preparation of concentrated stock solutions.

2 Preparation of concentrated stock solutions

		Quantity to be taken per litre of working solution
Solution A		
Benzyl alcohol	500ml	
Diethyleneglycol	500ml	30ml
Total	1000ml	

Solution B		
Calgon	20g	
Hydroxylamine sulphate	34g	
Potassium bromide	4g	100ml
Sodium sulphite (anhydrous)	20g	
Potassium carbonate (anhydrous)	320g	
Water to	1000ml	

The potassium carbonate should be added slowly in small amounts because of the evolution of CO_2.

Solution C		
Potassium metabisulphite crystalline	2g	
CD-3	22g	20ml
Water to	100ml	

Bleach fix (pH: 6.2-6.5)

1 Working Solution		
EDTA NaFe or NH_4FE (Merck)	40g	
EDTA Acid	4g	
Potassium iodide	1g	
Ammonia (20% solution)	10ml	
Ammonium thiosulphate (crystalline)	100g	
Sodium sulphite (anhydrous)	2g	
Sodium thiocyanate (20% solution*)	50ml	
Water to	1000ml	

pH: to be adjusted to 6.2-6.5 by the addition
of ammonia or acetic acid as necessary.
*Ammonium thiocyanate may be used in place of
the sodium salt in the same proportion*

2 Preparation of concentrated stock solutions

		Quantity to be taken per litre of working solution
Solution A (pH: 7.2-7.5)		
EDTA NH_4Fe	200g	
EDTA Acid	20g	200ml
Ammonia (25% solution)	60ml	
Water to	1000ml	

Solution B (pH: 5.8-6.2)		
Ammonium thiosulphate (crystalline)	500g	
Sodium (or amonium) thiocyanate	50g	200ml
Potassium metabisulphite (crystalline)	10g	
Potassium iodide	5g	
Water to	1000ml	

Stabiliser (pH: 3.6±0.1)

1 Working solution	
Sodium carbonate (anhydrous	2.5g
Acetic acid (glacial)	12.5ml
Citric acid (crystalline)*	7g
Water to	1000ml
*or Tartaric acid	8g

		Quantity to be taken per litre of working solution
2 Concentrated stock solution		
Acetic acid (glacial	170ml	
Citric acid (crystalline)	95g	
(or Tartaric	106g)	75ml
Sodium carbonate (anhydrous)	33g	
Water to	1000ml	

Substitute for CD-3 in the colour developer

A number of other colour developing agents currently used in colour laboratories have been examined as possible substitutes for CD-3 in the colour developer. The results obtained with many of them have been excellent and the colour quality has been comparable with that obtained with the orginal formula with CD-3. The activity of each agent is a function of its chemical structure and account has been taken of this in modifying the concentrations in the colour developer. In addition the effective emulsion speed of the paper is also affected and exposure and activity factors are given based on the use of CD-3 and 4.4g/litre of working solution.

Developing agent	g per litre	pH	Relative activity	Relative exposure
CD-3 Kodak	4·4	10·16	100	1·0
CD-4 Kodak	3·0	10·18	130	0·75
Ethylhydroxyethyl-ppd				
H_2SO_4	5·0	10·10	115	0·85
Diethyl-ppd H_2SO_4	2·4	10·10	145	0·70
Ac60 Agfa	4·0	10·7	50	2·0
CD-2 Kodak	2·4	10·2	145	0·70

The filtration required during printing was very similar with all the agents examined. Using a test negative on Ektacolor Professional Film Type S, the values were near 80Y 40M, except with Agfa developing agent Ac60 which required a filtration adjustment to 100Y 60M and a correction of the pH of the solution to 10·6 ±1·0 by the addition of 0·5 to 1·0g/litre of caustic soda. The findings are summarised in the table.

Notes

All processing was carried out using the three-bath process. At the concentration given the diethyl-paraphenylenediamine produces a light greenish overall fog. It is necessary to reduce the concentration to 2-2·2g/litre to improve the result.

Other major manufacturers' materials compatible with Ektaprint 2 and 3 processing

The following materials may be processed in the same manner as Ektacolor 74 and 78RC papers:
Agfacolor Type 589 Paper, RC and Type 6, **Agfacolor** CN310/7
Fujicolor Type 8967 Paper, RC
Sakuracolor Paper, PC
3M Colour Paper, RC

▶

Reversal Papers

CIBACHROME PRINT

Since all those Cibachrome materials which used the P-10 and P-18 processing formulations have now been discontinued for several years it is felt that no useful purpose would be served by reprinting the alternative solution formulas worked out by Ernest-Charles Gehret for these materials. The new Cibachrome II amateur and professional print materials are, respectively, processed in P-30 and P-3 solutions, the formulations for which have not been disclosed. However a number of workers have devised alternatives for some of the processing solutions and of these the recommendations of Carl E. Krupp in *Darkroom Techniques* (Vol 4, No 3) have proved to give good results. The divided developer that Krupp recommends was first proposed for Cibachrome by Richard Bisbey II in *Dignan Photographic Report* for September 1977.

With Cibachrome II the black-and-white developer which is the first solution used in processing has to generate what is in effect, a chemical mask. This novel and elegant improvement to the process has the effect of lowering the rather steep gradation of these silver dye-bleach materials and of improving the blue reproduction and giving more saturated yellows and oranges. In order to produce the masking effect the developer includes a silver halide solvent, sodium thiosulphate.

Alternate developers

Krupp recommends that a fast way to make up an alternative Cibachrome II developer is to take one litre of Dektol, diluted 1:1 and add 1.7g of crystalline sodium thiosulphate. The thiosulphate should be added to the developer just before use; do not add it to the stock solution. This is not the same solution as the Cibachrome II developer marketed by the manufacturer which is more complex in order to keep the sodium thiosulphate from precipitating out the silver in the developing dish.

Where Dektol is not available other print developers such as Ilford PQ Universal, Kodak D 163, May and Baker Suprol or Paterson Acuprint can be used at the dilutions recommended for paper processing.

However, an even better Cibachrome II developer is a two-step solution which acts as a compensating developer — holding down highlights and bringing up the shadow areas. The formula recommended by Krupp is:

Black and white developer

Solution A	
Metol	6.5g
Sodium sulphite	35g
Hydroquinone	2.8g
Potassium bromide	2.8g
Sodium chloride	6.0g
Water to make	1 litre
Solution B	
Sodium carbonate (anhyd)	90g
Sodium thiosulphate (cryst)	1.8g
Water to make	1 litre

In mixing, start with about three-quarters of the total volume of water at about 35°C and add the chemicals in the order given, dissolving each before adding the next. Table salt should not be used in place of sodium chloride in Solution A since it now commonly contains additives such as sodium hexaferrocyanate and magnesium sulphate to prevent caking.

Bleach

Since the chemistry in the Cibachrome II bleach solution is hard to duplicate, Krupp suggests that it is preferable to use the manufacturer's product which is available as BL 313 Bleach Starter Kit in 3.5 gallon size and Type 30 in amateur size quantities. The newer Cibachrome II bleaches work faster and better than the older ones.

Fixer

With Cibachrome II the fixer is exhausted more quickly than formerly, probably due to the extra layers in the material. Krupp recommends Edwal Quick-Fix diluted 1:3 which gives reliable fixing in five minutes.

Where Edwal Quick-Fix is not available other rapid fixers, without hardener, can be used. Alternatives are Ilford Hypam, Kodak Rapid Fix, May and Baker Amfix or Paterson Acufix. All these alternatives should be used diluted as for film. Ilford technicians stress that the fixing bath should have a pH near 6.8. If the pH is below 6.0 the fixer will destroy the cyan colour layer and affect both colour and density of the print. A higher pH will soften the emulsion.

Processing procedure (dish)

Developer Solution A	1min 24°C±1
Developer Solution B	3min 24°C±1
Stop bath	30sec 24°C±1
Bleach	4min 24°C±1
Fix	5min 24°C±1
Wash	3min 24°C±1

Working with the developer

It is critical that the print remains in Solution A for one minute and in Solution B three minutes. Using the Dektol formula the print must remain in the developer at least three minutes. Developing 11 x 14 prints in dishes it is best to have at least a litre of each of the two working solutions. There will be an 05Y colour shift between the first and fifth print in this quantity of solutions due to hypo depletion in Solution B. One way to correct this is to add 90ml of fresh Solution B after each print is developed. Then completely replace Solution B after processing eight to ten prints.

Working with the bleach

Krupp found that four minutes in dish processing and six minutes in a drum processor is essential to get good clean whites and pastel colours. Excessive bleaching, more than 10 minutes, will lighten delicate colours.

Working with the fixer

To be on the safe side Krupp uses two-bath fixing. Using the same dilution in both fixing baths (i.e. 1:3 with Edwal Quick-Fix) the print is fixed in the first bath for two minutes and then transferred to the second for the remaining three minutes. In practice after processing about ten 11 x 14 prints per litre the first fixing bath is thrown away, the second fixing bath used as the first and a fresh second bath made up.

EKTACHROME 14RC

Although Ektachrome 14RC paper was introduced as long as ten years ago it has been progressively improved during its life. Now, however, this excellent material is in course of being replaced by a further improved product, Ektachrome 22 paper. Since this introduction is taking place slowly and progressively throughout the world there are likely to be stocks of the older product available for some considerable time. There are, in addition colour reversal papers intended for the Ektachrome R-14 process available from Agfa-Gevaert, Fuji and Konishiroku and these too will, in all probability, continue to be available for some time.

It is important to note that the new product, **Ektachrome 22 paper** can be processed only in a new process, coded **Ektachrome R-3** and this process is not suitable for the older R-14 process paper. The alternative solutions which are given below are, therefore, offered to permit the continued processing of the older material for as long as it continues to be available.

Processing method

Ektachrome 14RC is a resin-coated material and so may be processed rapidly at high temperature. As a general rule Ektachrome 14RC may be processed between 28 and 38°C. In amateur usage, unless a proper temperature control system is available with thermostat-controlled water bath, we recommend the 28-32°C range, which it is easiest to maintain. Dish development is possible, but it is better to work using one-shot baths in a processing drum, for example, a Durst, Jobo, Paterson, Unicolor or similar. Besides, it is more pleasant to work in ambient light than in complete darkness and, anyway, the reproducibility of results is improved, since fresh solution is used each time.

The scheme given below applies to both dish and drum development.

This time-temperature diagram gives the relationship between time of immersion and temperature for the three baths and the final wash. Curve 1 refers to the first, black-and-white, development, 2 to the colour developer, 3— identical to 2—to the bleach-fix, and 4 to the final wash. The corrected times may be considered valid over the range 28-38°C.

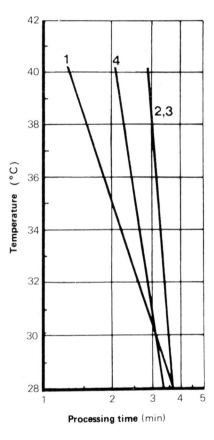

Processing time (min)

Temperature:	30°C		34°C		38°C	
	min	sec	min	sec	min	sec
1 *Pre-soak	1	—	—	50	—	40
2 B & W development	3	—	2	5	1	30
3 Wash Min 4 changes	3	—	2	45	2	30
4 Re-expose	100W at 40cm, minimum 10sec on face of paper only during last minute of wash					
5 Colour development	3	30	3	15	3	—
6 Rinse 1-2 changes	1	—	—	50	—	40
7 Bleach/fix	3	30	3	15	3	—
8 **Final wash	3	30	3	15	3	—

*Follow the tank or drum manufacturer's recommendations.
**Minimum of 6 changes in a drum, but preferably made in running water in a tank, washbowl, or other container.

The time/temperature graph gives indications for immersion in the baths, for the adopted or necessary working temperature within a 28-38°C range.

Dish processing

Agitation: a slow, steady rocking motion. When finished, drain the print for 5-15sec, according to format, as it is taken out of each bath.

Temperature maintenance: this is critical in the first developer: ±0.3°C. Use either a water bath, or a dish warmer, equipped with thermostat control.

Safelighting: none. Absolute darkness is essential during first development and the first two minutes of the following wash. The subsequent steps may be carried out in normal lighting.

Re-exposure to light: to be made during the last 30sec of the wash following black and white development. Only expose the emulsion side of the print to the light.

Drum processing

Working with a drum, re-exposure is carried out by taking the print briefly out of the drum. This should be kept filled with water at the indicated temperature, so that work may continue afterwards without delay.

A stop bath

Is not absolutely necessary. However, it is possible to use one between first development and the wash before re-exposure, composed of 2% acetic acid for 30sec.

Drying

After having taken the prints from the final wash in the dish or container, they should be wiped or sponged on both sides to remove most of the water, and then hung freely in the air, or in a drying cabinet; this latter appears, however, clumsy and unnecessary. In passing it may be noted that a hairdryer works perfectly well and is quite cheap. Care must be taken not to char prints by holding them too close to the outlet!

Capacity

In a drum, allow 45-50ml of black and white or colour developer for each 20 x 25cm sheet (500cm^2). A second sheet may be treated in the same quantity of bleach/fix. In our own practice, we prefer to use double quantities of the baths, using the developers twice and the bleach/fix four times. A litre of black and white or colour developer can be used to process 1-1.1m^2 of paper and the bleach/fix has twice that capacity. These figures include at least a 20% safety margin.

Working in a dish, when it will be necessary to use a relatively large amount of solution, one litre of black and white or colour developer should easily process 12-15 20 x 25cm sheets. The bleach/fix capacity is 2-2.5 times more. It is a good idea to work out the volume needed for the number of prints to be processed at a time, since part-used solutions do not keep.

Keeping qualities of unused solutions:
Black and white developer: 2-3 months
Colour developer, without CD-4: 3 months
Colour developer made up: 2-4 weeks
Bleach/fix made up: 1-2 months
A and B not mixed: 3-4 months

The keeping qualities of part-used bottles are reduced by 30-50%, according to the storage conditions—darkness, well-stoppered bottles and temperature 18-20°C—and exhaustion.

Formulae
Black and white developer (pH: 10.1-10.2)

Phenidone (*or* metol: 2.0g)	0.5g
Sodium sulphite (anhydrous	40.0g
Hydroquinone	6.0g
Sodium carbonate (anhydrous)	40.0g
Potassium bromide	1.4g
Sodium thiocyanate 20% solution	7.0ml

▶

Potassium iodide 0.1% solution	6.0ml
Sodium hydroxide 40% solution	
as required to adjust pH	0.5-2ml
Water to make	1000.0ml

Colour developer (pH: 10.1-10.2)

Benzyl alcohol 50%	40.0ml
Hydroxylamine sulphate	3.0g
Sodium sulphite (anhydrous)	2.5g
Sodium carbonate (anhydrous)	30.0g
Potassium bromide	1.0g
6-nitro-benzimidazole nitrate 0.2% soln	10.0ml
Sodium hydroxide 40%	
as required to adjust pH	2.5-3ml
Before use add: CD-4 (Kodak)	4.0g
Water to make	1000.0ml

A 25% CD-4 solution may be conveniently used, taking 16ml per litre:

CD-4	25.0g
Potassium metabisulphite (crystalline)	2.0g
Water to make	100.0ml
	(keeps 2-3 months)

It is best to mix the 50% benzyl alcohol, first by stirring into 700ml of water before adding the solid chemicals. The 50% solution is made up:

Benzyl alcohol	250.0ml
Diethylene glycol	250.0ml
Total	500.0ml

The print base whiteness may be improved by adding 5-10ml/l of a liquid optical brightener, such as Sandoz Leucophore SHR, to this solution.

Bleach/fix (pH: 7.0-7.2)

Solution *A:*	
EDTA acid	6.0g
EDTA NaFe or NH$_4$Fe (Merck)	60.0g
	(see note below)
Potassium iodide	2.0g
Ammonia 33%	
as required to adjust pH	12-14ml
Water to make	500.0ml
Solution *B:*	
Ammonium thiosulphate (crystalline)	120.0g
Potassium metabisulphite (crystalline)	5.0g
Water to make	500.0ml

In use take 1 part *A* with 1 part *B*. The pH of this bath when ready to use should be between 6.5 and 6.8. Any adjustment necessary can be made with ammonia or 20% acetic acid.

The ferric-ammonium salt of EDTA is much more easily soluble than Sequestrene NaFe, but the latter may be substituted and costs rather less.

Conclusions and general notes

With the alternative formulae given we have obtained excellent colour prints, comparable with those from the makers' own solutions.

Ektachrome 14RC Improved has better thermal stability than its predecessor. It may be kept for 1-2 months in an ambient temperature of 18-25°C without its characteristics being noticeably changed. Nevertheless, it is advisable, as far as possible, to keep it at a lower temperature, around 10°C, or even in a deep freeze, −18°C to −22°C, which gives it a life expectancy of up to a year. Do not forget that the main enemy of photographic material is damp. On taking the boxes from the deep freeze or refrigerator, let them temper for 2-4hr before opening, so as to avoid the formation of condensation.

Exposure latitude has been improved compared with the earlier paper and a 6-12sec bracket gave acceptable prints, when the true exposure was 8sec. However, 4sec gave marked under-exposure. These tests were carried out with a low contrast transparency.

14RC Improved has greatly increased speed, considerably higher than that of Cibachrome—a fact which can sometimes be inconvenient, especially for small and medium-size prints. For instance we found it necessary to work with the following exposure conditions when enlarging an Ektachrome 35mm transparency on to a 20 x 25cm paper: using a Chromega B enlarger with dichroic head and a 48mm Angenieux lens, a 6sec exposure at f/11 with 20Y 20M filtration was required, compared with 14sec at f/5.6 with 50Y 10C filtration for Cibachrome.

The colour balance is very satisfactory, approaching that of Cibachrome. Visual contrast seems to us slightly lower than on the earlier RC14. As regards definition, image sharpness, although entirely acceptable, is not as good as Cibachrome.

In short, our view is that the Ektachrome 14RC Improved paper provides a first-class material for positive/positive printing, easy to handle, simple to process, whose rendition will satisfy many amateur enthusiasts looking for a material with a good quality to price balance.

We must reiterate that Ektachrome 14RC paper is in course of replacement by Ektachrome 22 paper. The new material *cannot* be processed in the Ektaprint R-14 process or the alternative solutions given above but must be processed in the new Ektachrome R-3 process.

REFERENCES

The majority of the formulations given in the colour processing sections derive from independent investigations by the late Ernest Ch. Gehret and were originally published in *The British Journal of Photography*. The author continued to bring these up to date as the materials evolved until his death in April 1981. Subsequent revision has been carried out by George Ashton.

The principal references including those of obsolete processes no longer included in *The British Journal of Photography Annual* are:

Reversal colour processing
Agfachrome 50S/50L, *2 February 1974*
Ektachrome E4, *25 April 1969*
GAF 64, 100, 200, 500, T/190, *11 March 1966*
Orwochrom UT18 and UT21, *28 February 1966*
Peruchrome C18, *9 September 1960*
Ektachrome E-6, *28 August and 4 September 1981*

Colour negative films
Kodacolor X, Ektacolor Professional, *13 February 1959 and 15 July 1960*
Kodacolor II, *12 July 1974*

Colour print papers
Ektacolor 37RC, *11 January and 18 June 1974*

Colour reversal papers
Cibachrome Print, *26 December 1975*
Ektachrome 14RC Improved, *15 April 1977.* ∎

BRONICA

BRINGS OUT THE PROFESSIONAL IN YOU

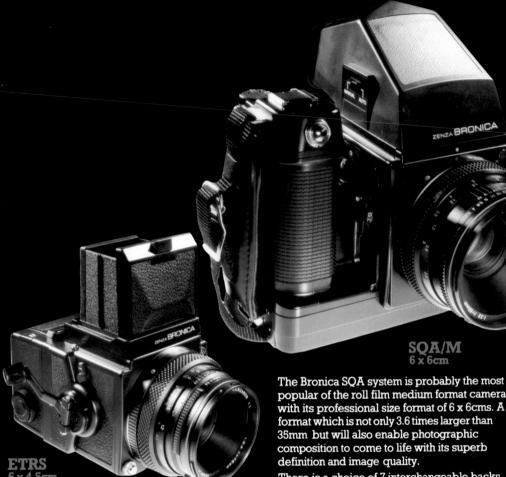

SQA/M
6 x 6cm

ETRS
6 x 4.5cm

GS-1
6 x 7cm

The Bronica ETR-S is the baby of the range and its compact size enables simple and easy handling for amateur or professional. Its 6 x 4.5cm format is 2.7 times larger than 35mm and provides the photographer with high definition, finer grain enlargements and easier photograph composition.

The system offers a choice of 5 interchangeable backs including 6 x 4.5cm, 35mm and polaroid. Add to this the choice of 8 superb lenses, 5 viewfinders and many other accessories and you have one of the most versatile cameras on the market.

The Bronica SQA system is probably the most popular of the roll film medium format cameras, with its professional size format of 6 x 6cms. A format which is not only 3.6 times larger than 35mm but will also enable photographic composition to come to life with its superb definition and image quality.

There is a choice of 7 interchangeable backs including 6 x 6cm, 6 x 4.5cm, 35mm and polaroid coupled with a full range of lenses, viewfinders and other accessories.

With a format size of 6 x 7cms the GS-1 can perhaps be labelled as the most creative roll film camera on the market. It offers the professional just a little extra to create and capture his wildest photographic visions.

A wide choice of 9 film backs from 35mm up to 6 x 7cm are available as well as a polaroid back, a full compliment of lenses and many other interchangeable accessories.

BRONICA
MULTI FORMAT CAMERA SYSTEMS

BRONICA (UK) LTD., Priors Way, Maidenhead, Berks SL6 2HR. Tel: (0628) 74411.

Rayco

PRESENTS . . .

THE LATEST 'STATE OF THE ART' MICRO-ELECTRONIC DEVICES

Although RAYCO is the oldest established name in the business, with a world-wide reputation for traditional quality, we lead the field into new techniques and present our latest range of micro-electronic products, which take full advantage of the rapid advances in solid-state digital electronics.

Rayco

BRITISH MADE

*ELECTRONIC TIMERS

*AUTOMATIC VOLTAGE STABILISERS

*ELECTRONIC THERMOMETERS

*WE ALSO SUPPLY A VERY WIDE RANGE OF PHOTOGRAPHIC CHEMICALS

Rayco MICRO-ELECTRONIC TIMER-STABILISER

This is a development of the well established range of RAYCO TIMER-STABILISERS that are used in conjunction with most makes of colour enlargers to give accurate control of lamp voltage and exposure time in colour printing.

These latest units give highly stable voltages, controlled by solid-state electronics, together with times to millisecond accuracy.

All built into a single compact unit which occupies only a few square inches of bench space

These Timer-Stabilisers are supplied to operate with all the leading makes of colour enlarger.

Rayco MICRO-ELECTRONIC 'DIGIDIAL' TIMER

A development of the famous RAYCO

'Precision' Electronic Timer offering millisecond accuracy and solid-state switching.

Using the RAYCO 'Digidial' controls, which show the accurate selected time in digital form.

Any precisely repeatable exposure between 0.1 and 99.9 seconds may be selected.

Rayco ALSO PRODUCE

A wide range of electronic devices and control systems to meet customers' special requirements.
If you have any electronic problems in connection with photographic equipment or processes RAYCO may be able to help you.

JUST RING *Rayco*
'phone 0252-22725

RAYCO products are available from the leading professional suppliers or direct from the manufacturers. Send now for full details and prices to:

RAYCO INSTRUMENTS LTD.

BLACKWATER WAY, ASH ROAD, ALDERSHOT HAMPSHIRE

xiv

ILFORD

SNAP.

Ilford's reputation for making superb quality black and white film is second to none.

Now they're extending that reputation into the colour field with the introduction of a new high resolution film, the Ilfocolor HR.

Its high sensitivity and remarkable lack of graininess combine to produce pictures exceptionally faithful to nature's own colours.

Moreover, from one batch to another, Ilfocolor HR's quality never varies.

It's available in 35mm, 110 or disc formats and in either 100 or 200 ASA. So snap up a roll today.

Up to 20% more light through your slides and films with the new WOTAN XENOPHOT® lamps.

WOTAN XENOPHOT® lamps make your projection screen up to 20% brighter. They last just as long, consume no more power and directly replace conventional projector lamps. That means brighter pictures, more brilliant colours, more pleasure. Makes watching slides and films a real viewing experience.
Try one today!
For stockist information, contact: WOTAN LAMPS LTD., Wotan House, 1 Gresham Way, Durnsford Road, London SW19 8HU. Tel. 01-947 1261

WOTAN

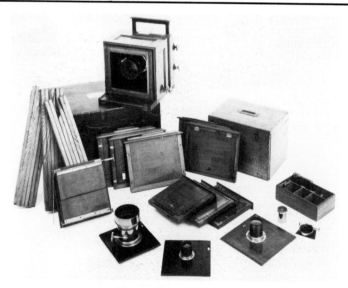

Photographic outfit of 1860. Manufactured by George Hare for the Maharajah of Punnah.
Other fine, unusual cameras from 1840 wanted to complete collection, particularly Leicas, Nikons, Makinette, Contax, Tropical Reflexes and Traveller Una by Sinclair.

COMPLETE COLLECTIONS PURCHASED
P. H. VAN HASBROECK
34 Bury Walk, London SW3 6QB. Tel: 01-352 8494

LOUIS GANDOLFI & SONS

Oldest Camera Makers in the World

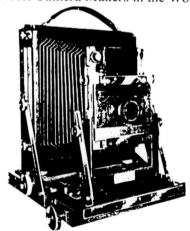

FIELD AND STUDIO WOOD TYPE CAMERAS

1880 – Family Centenary – 1980

PORTWAY HOUSE, WEST PORTWAY, ANDOVER, HAMPSHIRE SP10 3LF
Telephone Andover (0264) 61216

Rollei

Growing in Range and Reputation

NEW FOR '84 — ROLLEIFLEX 6006 — The only 6x6 medium format camera to offer TTL metering, TTL flash metering, 1½ fps motordrive and new style interchangeable magazines, all built-in.

The Rolleiflex SL66E

Launched at Photokina '82 the Rolleiflex SL66E medium format SLR camera incorporates electronic TTL light metering and dedicated flash metering.

The Rolleiflex SL2000F

With interchangeable magazines, two integral viewfinders, built-in motordrive, plus many more features, the launch of the SL2000F represents a major breakthrough in 35mm photography.

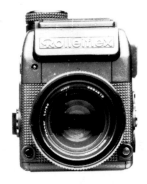

The Rolleiflex SL66

Incorporates built-in bellows with tilt facility, the SL66 is still one of the world's most unique medium format cameras (except for the SL66E).

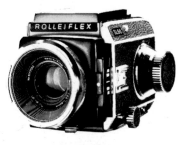

The Rolleiflex SLX

With full electronic control of all camera functions the SLX is without doubt the most advanced 6 x 6cm camera available.

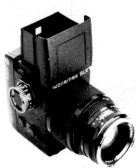

The Rollei range proves that in 1984 there is no better name to be seen with.

FOR FURTHER DETAILS PLEASE CONTACT A V DISTRIBUTORS (LONDON) LTD, 21 & 22 ST ALBANS PLACE, ISLINGTON, N1 0NX

End the controversy.

The Chimera lightbank ends the long debate between lightbanks and umbrellas. Though both change a hard direct light into a broad directional diffused

light, only lightbanks will give you the unobstructed even "window light" preferred by photographic illustrators. Yet until now, lightbanks tended to be "light monsters" — expensive, cumbersome, sometimes makeshift and because of their size and weight, limited to studio applications. Umbrellas, on the other hand, were the lightweight and portable choice. However, they left photographers with obstructed highlights and an intervening post which kept the diffusion surface much too far from the subject. Now Chimera combines the best of both, creating the lightbank that combines a durable lightweight break-down design with unexcelled light quality. No longer must a choice be made between two less-than-perfect options. Across America, and now worldwide, photographers are confirming that the quality of light from Chimera's lightbanks is ideal for both studio work and their assignments via plane, train or taxi. End the controversy — write for a catalog or ask your pro dealer.

KEITH JOHNSON PHOTOGRAPHIC LTD
KJP House
11 Great Marlborough Street
London W1A 3AF
Tel: 01-439 8811 Telex: 24447

Distributors of Professional Photographic Equipment
SOLE DISTRIBUTORS OF CHIMERA FOR THE UK AND IRELAND

CHIMERA
Lighting software for the photographer

BLACK & WHITE PRINTS FOR REPRODUCTION:
WE HAVE THE TECHNOLOGY.

Tantrums reproduction quality black and white prints, are all done by hand, still using techniques that haven't changed for 30 years. Printing up, holding back, soft-edged masking and the use of soft bleaches and ferricyanide is all done by some of the most skilful hands in the business.

And we're one of the very few labs to pioneer and specialise in the masking of transparencies for conversion to black and white.

When it comes to black and white prints for reproduction there's no machinery like no machinery.

Tantrums
WE NEVER SAY NO.
116 Old Street, London EC1V 9BD. 01-251 5242

Mechanical Shutters
Magnetic Shutters
Electronic Shutters
Cable Releases (over 30 types)
Industrial Control Cables
Tachistoscope
Projector Mounts

Imported and Distributed by:
Sutton Industrial Marketing Ltd
Home Tune House
Guildford Road, Effingham, Surrey KT24 5QS
Tel: Bookham 56656 Telex: 929933

TRADE ENQUIRIES ONLY

Fishwick's

Why do so many people choose to buy their photographic materials and equipment at Fishwick's?

Perhaps it's because we have very keen prices. We are among the most competitively priced companies in the country.

Or perhaps it is because we keep one of the widest selections of both equipment and materials. A *stocked* range of more than ten thousand different items.

Or maybe it is because we publish the largest photographic and AV Catalogue in Britain. Listing all of the products, with detailed specifications, illustrations and low, low prices.

Or could it be the *Fishwick Promise* — every order received today is despatched today. Yes, all orders for ex-stock items are on their way to you the same day we receive your order. And that is guaranteed!

Whatever the reason (or combination of reasons), we can proudly say that we are the country's leading photographic mail order supplier.

Eric Fishwick Ltd

Grange Valley, Haydock, ST.HELENS, Merseyside, WA11 0XE.
Telephone: St.Helens (0744) 611611 24hr. answerphone.

. . . Take Pride In Print

In the face of competition, shouldn't your name stand out in the crowd?

At Manor Park Press, we pride ourselves on the personal care and attention given to each and every job we handle, from single colour leaflets through to four colour brochures and journals.

Our complete in-house facilities from art-work right through to folding and binding allow us to cover the widest possible range of print, so that the workload on our one, two and four colour machines is divided almost equally between journals published on weekly, monthly, bi-monthly and quarterly bases and commercial once-off work which ranges from stationery to leaflets and brochures.

Even by using the most up-to-date equipment combined with all the latest techniques, we believe that the highest standards of print quality cannot be achieved unless human involvement plays a key role at every stage.

Our sales team are only a phone call away and are always pleased to help and advise on all print enquiries. Their knowledge and expertise will ensure that your artwork requirements, schedules and costs are all realistically quoted, allowing us time to give you a job to be proud of.

Feathers In Our Cap

As we said earlier, in the face of competition, shouldn't your name stand out in the crowd? Well, ours has done just that. Manor Park Press has consistently won numerous awards, trophies and international certificates of printing excellence, to make all the care and pride we take in our work worthwhile. Why not give us a chance to put your feather in our cap?

Manor Park Press Limited

Head Office: Unit 7, Edison Road, Highfield Industrial Estate, Hampden Park, Eastbourne, East Sussex BN23 6PT.
Telephone: Eastbourne 57474/5 (STD Code 0323).